ROMAN CIESLEWICZ

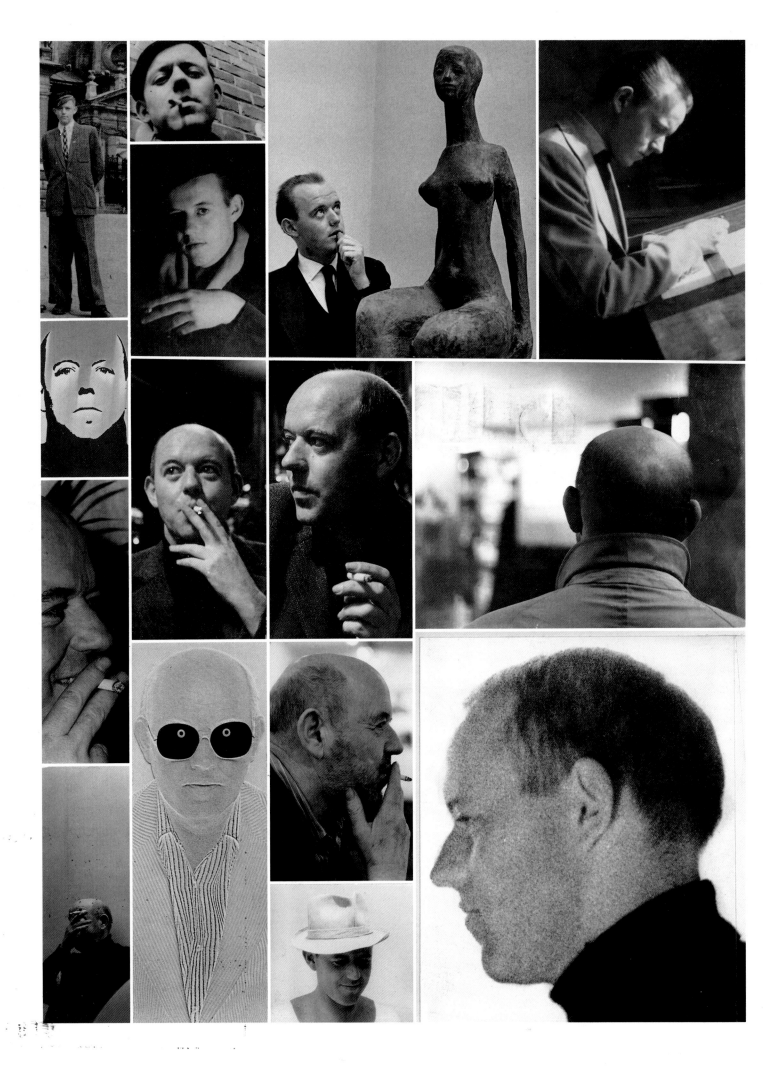

margo rouard-snowman

ROMAN CIESLEWICZ

THAMES AND HUDSON

ACKNOWLEDGMENTS

This book is dedicated to the memory of
Dominique Bozo, whose encouragement and
advice I have always greatly valued. My special
thanks to Chantal Petit and Nicholas Snowman
for their support and suggestions, and of course
to Roman for his patience and availability.
Thanks also to Carole Barthélemy for her help
with the layout.
All the photographic material comes from the
artist's own collection (photos P. Trawinski,
O. Wogenski, D. Besikian and J.-L. Losi), except
for the following:
Kamienne Niebo (16)
Grupa Laokoona (66)
Peinture moderne polonaise (77)
Biennale internationale d'art de Menton (182)
Panny z Wilka (200)
La France a du talent/Galeries Lafayette (318)
which were supplied by the Centre Pompidou –
MNAM/CCI (photos Jean-Claude Planchet,
Centre Pompidou – MNAM/CCI)

Translated from the French by Jacqueline Taylor

British Library Cataloguing-in-Publication Data

A catalogue record for this book is available
from the British Library

ISBN 0-500-27729-X

Printed and bound in Slovenia
by Mladinska Knjiga

CONTENTS

INTRODUCING ROMAN CIESLEWICZ

R.C. is never neutral. His images, his typography, his layouts never convey indifference. They look out at the world, characterize the age, bear witness, speak of disquiet and shame and sometimes of horror. They carry extreme critical exaltation into the realms of terror itself. They cut the easy conscience to the heart.

R.C. has played a full part in using and profoundly modifying the language of our time. From Eastern Europe he brings a double visual heritage of Constructivism and Expressionism, which after nearly forty years he has transformed, creating a totally individual body of work which has revolutionized contemporary graphic design.

R.C. rejects any idea of primacy among clients. He is equally happy to work for journals, publishers, department stores or museums. Whatever the product, his style is at the service of the message he has undertaken to transmit, distilling it, inscribing it in the positive clarity of his own vision.

R.C. is, like Godard, an 'eye of truth'. He selects and constructs, within the framework of a commission or in his own personal work, images of whose force he is well aware. He digests them, combines them, arranges and transforms them. His hand cuts out and pastes, halves, multiplies, reduces. Out of this montage of the ready-made visual image spring strange presences, faces sucked into the abyss, their identity lost only to find sharper definition as a unique point of vision or of blindness.

R.C. can count Witkiewicz, Schulz, Arrabal and Topor among the great solitary, moralistic, pessimistic witnesses whom he has helped to make known. He shares their critical irony and their sharp consciousness of the human drama. His panic is always a tonic. His output, far from swelling the great mass of media effluent, actively militates 'against eye pollution'.

R.C. is at home in the Pompidou Centre. Since the end of the 1960s he has played a worthy part in the gradual formation of its public image. Throughout he has never ceased to maintain his high artistic standards, bringing a creative contemporary contribution to bear on suggested acquisitions and exhibits. It is altogether appropriate that a very wide selection from his work as a graphic artist should now inaugurate the visual communication collection of the National Museum of Modern Art/Centre of Industrial Creation. Today, in displaying this impressive account of his work, the exhibition bears witness to this mutually satisfying collaboration.

GERMAIN VIATTE
Director of the Musée National d'Art Moderne/Centre de Création Industrielle

ROMAN CIESLEWICZ

Monographs or thematic exhibitions which are intellectually justifiable are rare. Even rarer are those which in some small way cast a fresh eye over a body of work, add to the store of knowledge or exert some influence on existing beliefs or opinions. While this book and the accompanying exhibition were conceived as the end-product of a work of research and its conclusions, they also become a springboard for other research, other questions. The book casts light on the little-known contacts which Roman Cieslewicz has kept up with the countries of Eastern Europe, with creators of collage and photomontage, poster artists, demanding intellectuals, international current affairs, and art. In addition, he has granted permission for the reproduction of unpublished posters, photomontages and researches reflecting the graphic achievements of the past thirty years, and contemporary documents which illuminate the work of a graphic artist about whom we thought we already knew everything.

Thus we find that he is clearly attracted to – in no particular order – the Italian Renaissance, the Russian Constructivists, images of the street and of nineteenth-century anecdotes and gossip, and the Dadaists. His sources of inspiration, his stock in trade, are made up of newspapers, advertisements, printed photographs, Dutch or Italian Old Master paintings. He trawls through them like a pirate. No French influence here, but great admiration for the 'Four Cs': Colin, Capiello, Cassandre, Carlu. To quote Cieslewicz himself, 'The hyper-realism of the fifteenth century replaces today's photographs. Figures painted by Carpaccio or the great Flemish masters were all of famous people of the age.' Or again, 'Photographs are the devotional images of the modern world' (1990).

Throughout his studies, and even today, he has been influenced by the Blok group. This Polish Constructivist group, founded in March 1924, affirmed the structural rules pertaining to painting, sculpture, posters, typography and architecture, rejecting the art of 'reproduction' and the 'decorative' aesthetic. It also looked into movements leading to new processes. A certain social order organically related to the work of art became the reference point of this

artistic structure. The Blok group published a manifesto, 'What is Constructivism?' in 1924, unsigned but probably produced by Szczuka. It ceased to exist in 1927 and was replaced by other groups – one centred on the artists' review *Praesens* and another, more politically militant, round the monthly *Dzwignia*.

Contemporary art in his milieu was also very important to Cieslewicz. Apart from pencil and brush he also used photography, completely mastering the difficult art of framing the image, making use of the conciseness of the language of advertising. In all his output, dominated more by cultural and political themes than by advertising matter (with only very few exceptions such as Prisunic, Klopman and Dayn), he draws on the techniques of the cinema, using close-ups, monumental enlargements of the chosen subject, simultaneous exposures, fade-in, all the techniques that give the illusion of movement. If he were to change his profession he would like to make films.

After the Second World War, Roman Cieslewicz was in Poland, where he studied at the Cracow Academy of Fine Arts. Then he worked for several years in a State agency, WAG, as a graphic artist, mostly making posters. In the 1960s he had a tremendous urge to visit Paris to see how his posters would look in the street, alongside others, lit by neon lights. His first commission came from Italy, from the Italsider company in Genoa. Then he met Peter Knapp, art director of the women's weekly *Elle*.

Thus began the extraordinary rise to fame of a graphic and photomontage artist and multitalented artistic director. He rapidly achieved a kind of worldly glory that was quite new to him. Out of his interest in this *vie parisienne* came a remarkably balanced flow of work and ideas. He showed a new interest in ready-made images, making use of a great many photographic prints to provide him with a starting-point or help him in carrying through his projects.

In the 1970s France was besotted with Roman Cieslewicz's images. His graphic art had a powerful impact on the

cultural and political scene and work poured out of him, convinced as he was that the spirit of modernity informed his sometimes disturbing output. He continued with his 'tidying-up' work – photomontages – cutting, pasting, colouring everything that came to hand, producing several series of photographic collages, quite apart from his commissioned work, and exhibiting them in the art galleries. The 1980s were very productive years, prolific in all media. A momentary halt in the flow was caused by an illness in 1984. As soon as he could get about he bounced back again, fined down his creations, rid himself of a certain mannerism and produced some astonishing images (*Pas de nouvelles – Bonnes nouvelles*); then he withdrew into a constructivist and pictorial minimalist phase in his illustrations for posters and publishing work. He was teaching again, and enjoying teaching. A difficult period followed at the end of the decade and the beginning of the 1990s, with commissions harder to come by for Cieslewicz as for all French graphic artists. Untiringly active as always, he produced images for his own pleasure while he waited for better days to come.

The aim of this book is to show the evolution of Cieslewicz's work in a chronological, though fragmentary, way. We have included examples from all the areas to which he devoted much creative energy. His works have no consistent political content. Some are satirical, poetic, metaphorical, fantastic. They present a combination of the descriptive intentions and the associative and figurative imagination of the artist. It is hard to describe the density of his images, which are part of a world of enigmas on the edge between reality and madness. Some images are created not to frighten but to reactivate our perception. They raise questions and constantly touch on the permanent division between our inner world and the world outside.

The sense of frustration at having to be selective conflicts with the generous impulse to include something of everything and to show the results of all the research. But technical limitations must be observed. This selection from thirty years of graphic art seeks to reflect not only the artist but also the man, whose portrait may be sketched in these

words: Roman Cieslewicz is a curious mixture of insatiable curiosity and tremendously wide culture. He makes a point of being provocative and shows a pronounced taste for current affairs at any given moment. In a mixture of spontaneity, scepticism, buffoonery and rigour, he sets out in wonderment to find trends, theories, forms and textures. He rummages in dustbins and recomposes a page to 'unlock' its reality. His tools could be summed up as 'snapshots and scissors'.

A great creative artist, outside any period, he peers into strange things, draws us into a not always comfortable phantasmagoria. He dreams up some windows that open on to the future. Cieslewicz does not produce recognizable 'Cieslewiczes', so we are left with no conclusions to draw about his oeuvre as a whole. The notice on his door says 'Work in Progress'!

MARGO ROUARD-SNOWMAN

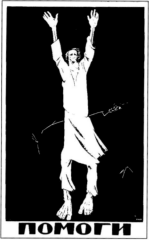
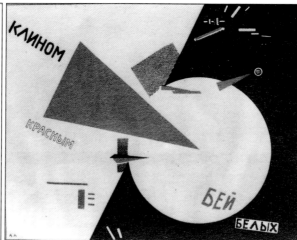
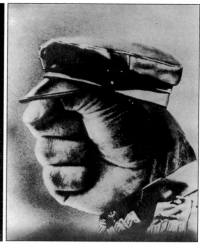

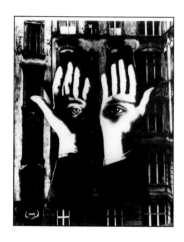
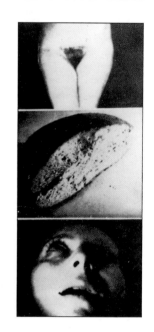

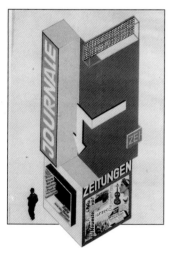

Some of Roman Cieslewicz's major influences
Clockwise from top left:

Bruno Schulz, 'Self-Portrait', 1926
Denis Moor, 'Help!', poster, 1921
El Lissitzky, 'Beat the Whites with the Red Wedge', poster, 1930
Mieczyslaw Berman, 'Pilsudski', photomontage, 1944
Franciszka and Stefan Themerson, 'Europa', photogram, 1932
John Heartfield, 'Berlin Dialect', photomontage, 1929
Mieczyslaw Szczuka, typographic composition, 1924
Alexander Rodchenko, cover for Mayakovsky's 'Pro Eto' (About That), photomontage, 1923
Herbert Bayer (Bauhaus), 'Lonely', photomontage, 1932
Mieczyslaw Berman, 'Meinkampf', photomontage, 1943
Herbert Bayer (Bauhaus), 'Newspaper Kiosk', collage, 1924
Herbert Bayer (Bauhaus), 'Self-Portrait', photomontage, 1932

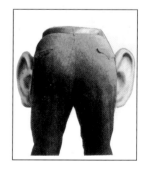

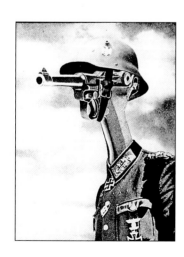
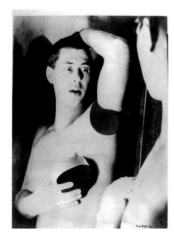
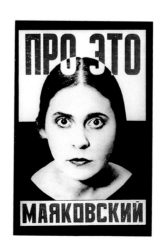

INTERVIEW

MARGO ROUARD You have been a graphic artist for over thirty years. What were the influences on you and how did you train?

ROMAN CIESLEWICZ I believe there was no particular influence on me, but a very thorough training with a teacher who meant everything to me: George Karolak, a Professor at the Academy of Fine Arts in Cracow (Poland), where I studied for four years. A poster artist and graphic designer of the same generation as Henryk Tomaszewski, and inspired by the same philosophy, he was one of the few who resisted Socialist Realism. Shunned by the establishment because he refused to modify his projects in line with the changes demanded by the powers that be, he still produced some superb posters for the Cracow theatre. His course on graphic composition taught us how to bring together all the indispensable elements needed to create a good poster. He taught with absolute freedom. This was frowned on by the institution, which was under observation from all sorts of outsiders. Apart from that I studied typography under Professor Gardowski, and did courses in illustration and painting. Tadeusz Kantor taught at the school. The two hours a week spent on a stage-design course brought us into contact with news of what was happening in the West, a window opening into other countries. In that cultural desert, and at that zero level of information, the only refuge was the Cracow library, where I used to search through the publications of the Blok group (a revolutionary association of Polish poets, typographers and photographic artists) devouring the work of the Polish avant-garde. Then I used to meet regularly with a very committed graphic photomontage artist and friend of John Heartfield, Mieczyslaw Berman. He was Polish, living in Warsaw, and he employed me in his photographic studio. He was a real Communist and had spent five years in the Soviet army after fleeing from anti-Semitic Poland during the war. In the USSR he was influenced by Zytomirski, a satirical Russian photomontage artist, and by Alexander Rodchenko, who had yet to be published. By using satire and a humorous view of serious situations, Berman managed to hold out against official Socialist Realist art. So my studies were very strongly shaped and influenced by Karolak, Kantor, Gardowski, Berman and the Blok group.

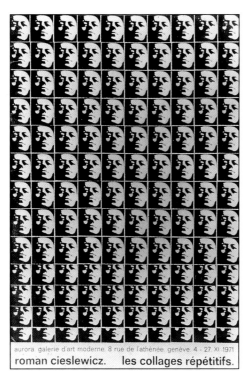

roman cieslewicz. les collages répétitifs.

Geneva, 1971

My activity with them was my first exercise in focusing on proportions, with all elements being well balanced without necessarily being centred: my apprenticeship in the art of unbalanced composition.

M.R. Apart from commissioned work, you have been engaged in a very personal quest. What do you feel about painting?

R.C. I have always loved images that had an immediate impact. I have always had a fondness for the graphic arts and I have never claimed to be a painter. I dislike the 'image for its own sake' and I am always attracted by the icons of the street and the present moment, current affairs. Nineteenth-century engravings, gossipy and anecdotal, for example, or torn posters. The war provided a lasting and excellent visual lesson, and whatever the tendencies in graphic art, the seriousness of the situation gave rise to an incredible number of posters.

M.R. To what extent does your creative work draw on your origins? What was your family background?

R.C. My parents were very simple people who had no importance except for their insistence on encouraging me to work. My father was an artisan who built fireplaces and the job included making drawings of old ones so as to be able to rebuild them. As a child I drew circles, always circles. I have been partly conditioned by the circle. It probably goes back to the round loaves which my mother sent me to buy every morning. I can still remember the magnificent lettering over the grocer's shop. Already, at six years old, every fixed image of the street was a joy to me.

M.R. You studied at the Cracow Academy of Fine Arts. How did your professional career begin?

R.C. At the end of my studies, in 1955, I was taken on by an

advertising agency, a propaganda agency in Warsaw. The agency, WAG, was the only national organization which produced political, social and cultural posters: people's festivals, job security, circus, theatre ... every national campaign was accompanied by posters. Most of the time the purpose of the poster was illogical, unreasonable. Twenty draughtsmen produced about a hundred posters a year, printed in offset in four colours, on 90/100 gram paper. In 1960–61, after WAG, I worked for a magazine, *Ty i Ja* (You and I), a sort of Polish *Elle*. I created the graphic design, basing it on Western magazines. This 64-page journal, with a print run of 10,000, was the most popular family reading and the subjects chosen by the editor-in-chief were new and far-removed from the twenties: Steinberg and Mayakovsky had their place!

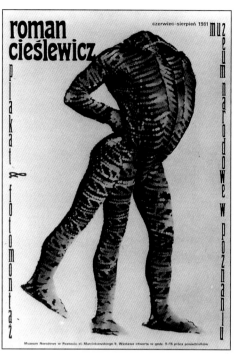

Poznan, 1981

M.R. Since you were so absorbed in your professional life, how did you come to decide to leave Poland?

R.C. I wanted to leave Poland to see how my posters would show up in the West, under neon lights. I dreamed about Paris, but I went to Italy first after meeting Eugenio Carmi in Warsaw. He was the artistic director of a big Genoese iron and steel firm, Italsider. He came to Poland for an exhibition of Italian painters, invited me to Genoa and commissioned me to make five photomontages measuring 3 x 2 metres for the entrance halls of the steelworks. The technical work was based on small items photographed one by one, enlarged and assembled into the required large format. Later, in Paris, I met Peter Knapp, a photographer and art director of *Elle*, the women's weekly. After seeing the magazine *Ty i Ja* and liking it, Peter Knapp ordered photomontages from me each week for several columns, one of them the horoscopes. Very soon he asked me to become the magazine's layout designer. Masking photographs and sticking up columns of text in a dummy didn't strike me as very creative. Still, I was dazzled by this journalistic machine: an editorial staff of two hundred to bring out 250 pages which ended up in the dustbin the next day! During this period and the following one when I was art director of *Elle*, I met a number of professionals who passed on commissions to me. La Hune publications, Christian

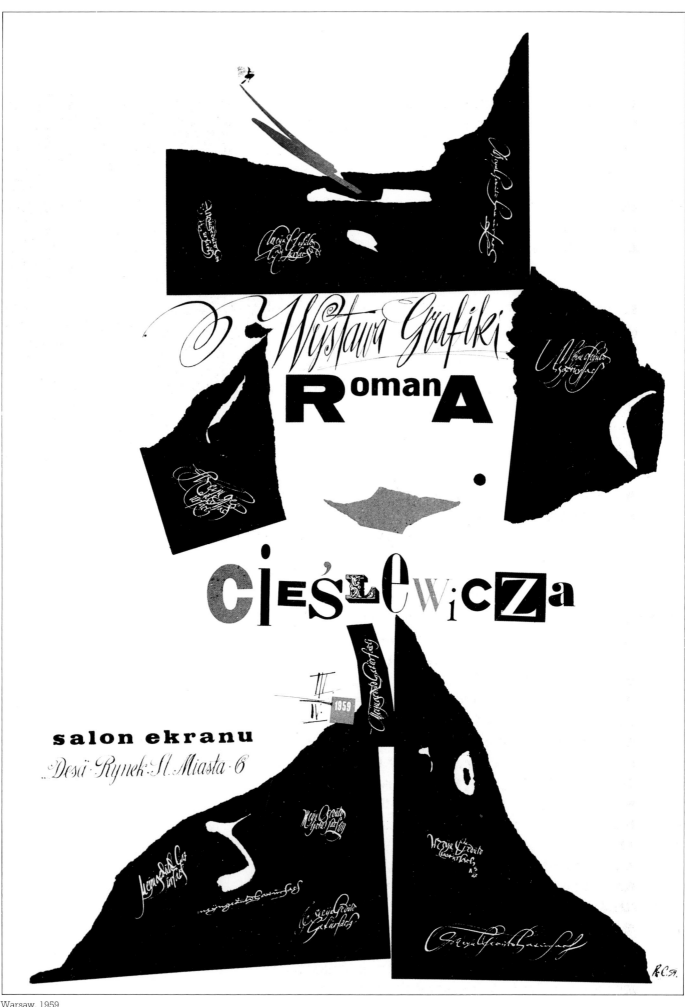

16

Bourgois (Collections 10/18), Maïmé Arnodin, Hélène Lazareff, Edmonde Charles-Roux among others, big names in the world of press and publishing at the time.

M.R. Although you practise different forms of graphic art, you are mainly known as a poster artist. What do you think of this art form, in particular that of the 'Polish School'?

R.C. The world role of the 'Polish School' in the evolution of this medium is just as important as that of Soviet posters in the twenties or French posters of the thirties. These three cultures have had a powerful influence on the quality and culture of visual communication. It is difficult to assess their influence in a creative milieu which may be very distant in the purely geographical sense.

M.R. You produce a great deal of work. How do you work? What is your professional method, what are your special tools?

R.C. I use all techniques – photography, paint, watercolour, but not drawing. I have one constant inspiration: the circle, the round figure. I often use a screen, which I discovered at *Elle* when I was making photographic enlargements to focus on a detail. I like the flexibility of the offset screen and its circular shape which allows you to bring in each spontaneous movement of the line. The impossibility of silk-screen prints paying for themselves led me to repeat myself, to fill some spaces between screens with the points of felt-tipped pens. I have made thousands of screens by hand. It was the lack of means, the need for an immediate response to my ideas, which led me to the repetitive reproduction of mechanical techniques. I delight in their numerous imperfections. My favourite colours are black and red. I don't like blue and I adore lemon yellow, which produces such startling effects when used with black. For all my projects I make sketches to scale: 8 x 12 cm or 4 x 6 cm for 40 x 60 cm posters. First I create the format. I begin with the four corners, draw a slanting vertical and the diagonals from the outside edges. After that I place the figurative

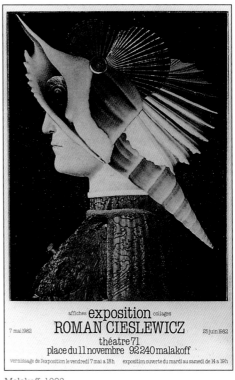

Malakoff, 1982

17

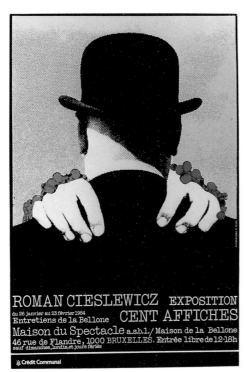

Brussels, 1984

elements, framing them more and more tightly, sometimes cutting down. This classic compositional technique suits my eye perfectly. My professional choices and my responses to commissions are driven by impatience – a drawn line or a pencil conveys my ideas more swiftly than any mechanical tool.

M.R. You make much use of typography in your projects. What are your typographical preferences?

R.C. I think of typography as a visual whole, never in detail, when I am designing a poster. Even when I am working to the same size I imagine everything enlarged. I don't agree with the idea of reducing a poster to the size of a matchbox because I am firmly convinced that every image has a spatial function, a reading distance relating to the body. My favourite letter-forms are also linked to movement: the wooden lettering that used to be used for municipal signs, the founts from the Bertold press in Vienna, one of which, oddly enough, is called Blok, the same name as the Polish avant-garde artists' group. I find that type-face beautiful because it is thick and has marvellous proportions for printing short words, making a good impact. I also use the Milton face, designed by Milton Glaser, which is a sort of cousin to Bifur designed by Cassandre. It has been modernized and stripped of all the lines that blurred the lettering. For books, I often use Rockwell for running text [as in this book].

M.R. At what point did photography come into your creative work in an important sense?

R.C. In the sixties. I think photography is the best way of recording an image. It allows me to arrange it as I please and to transform the preliminary image into what I wish to create.

M.R. In a highly developed technological context, how do you get on with computers?

R.C. You can imagine everything, try out every image on a computer. But the image will never have the perfection of hand-done work. That freedom is so important to me. I don't like to use the square, aggressive teeth of the computer screen. Except when it is used within a composed image. The future development of new images is linked for me with the accidental effects brought about by hand. In spite of some modestly rewarding experiences with a 'paint-box', I see no use for computers in my personal work. I prefer the Polaroid because it is candid, ephemeral and instantaneous and it brings everything down to the bare truth, stripped of superfluities.

M.R. You have lived in France since 1963. What do you think of French graphic art?

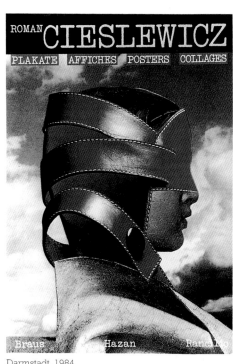

Darmstadt, 1984

R.C. French graphic artists are in a bad way because they don't have enough work. There are not enough graphic designers and the influence of Neville Brody does not enjoy the place it deserves. France does not have a strong typographical tradition. It has always rejected the influence of the English school, which avoids mannerisms while remaining informative, and rejected the Viennese and German schools, preferring instead to assimilate Italian aestheticism and over-politeness. Over-politeness because the image is given centre stage, predominating to the detriment of signs and writing. After the war, and also now, American influence was and is strong, particularly in the press. In the sixties, Swiss typography, particularly Helvetica, tidied up the French taste for 'tutti frutti' and frills.... I can see that typography in France, with all these outside influences, does not easily find its place in the cultural scheme of things. There are still big problems of articulation between text and image. And I deplore the lack of social recognition of graphic art as a profession.

M.R. Did coming to France in 1963 influence your work?

R.C. Fundamentally. The profusion of technical means available opened up new possibilities with the written

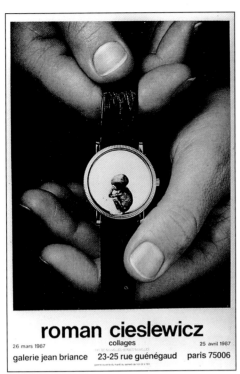

roman cieslewicz

26 mars 1987 collages 25 avril 1987

galerie jean briance 23-25 rue guénégaud paris 75006

Paris, 1987

word and a fabulous saving in time. Without forgetting the use to be made of technical influences in relation to the specific character of my own imagination.

M.R. Do you think the art of the poster is dying out in the 1990s?

R.C. Yes. The poster is no longer the means of expression it once was. Because of television, which competes with outdoor advertising and because of the anodyne subjects dealt with by posters – electrical gadgets, food and cleaning products don't stimulate the creative process. Posters need powerful occasions and significant subjects, which they don't find at the moment. As a means of communication they belong to another age and have very little future.

M.R. What are the links, the barriers, the interaction between your work as a poster artist and your experiments in photomontage?

R.C. My personal work is parallel to my professional work and the indispensable complement to it. I do not think of myself as an artist. Rather as a graphic designer making use of all technical forms, be they illustration, logo, posters or newspapers. My visual rules are different but the means of expression are the same. Photomontage, the 'tidying-up operation' is vital to me. It is not usually commissioned work, but sooner or later it finds its way into my printed work.

M.R. How do you explain the fact that your recent illustrations, particularly for the press, have been much more unadorned, minimalist, than some of your posters?

R.C. I am first and foremost a poster artist and have branched out into journalistic work because of a lack of poster work. A poster artist who talks too much says

nothing. The relationship with a magazine reader is more intimate and he doesn't need to be 150 metres away, as he does to read a poster. The economy of means, the range of expression that might be called minimalist, is linked to the size and distance from the reader. After forty years at this trade I have become more stingy....

M.R. What started you working on photomontage again?

R.C. After *Kamikaze* in 1975–76, the use of black and white got me interested in working again on photomontage, not on collages as has often been written. Montage gives richer effects than hand-drawn work. An image is naked without a word to back it up. It is a form of expression that I find contemporary, perfectly suited to current mass media.

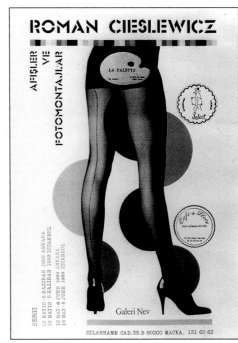

Istanbul and Ankara, 1989

M.R. Many themes recur constantly in your work, forming series. How does that come about?

R.C. I have an obsession with circles and that finds its way into my work. That apart, themes such as hands, eyes, jaws or legs are suggested by the commission. When no commission is involved, it's a game to see how far I can go without falling into a routine. Contrary to what some people think, I do not make distorted images of women. I treat them candidly, without judging.

M.R. Do you have a permanent fascination with anything, something you admire, an influence on you?

R.C. I have always been fascinated by mass. In my childhood it was the mass of German Stuka bombers. Later the mass of Tupolev aeroplanes seen near Novosymbirsk. In Paris, the mass of printed paper excited me in 1963, when I arrived here. And then the mass of information, of newspapers, circulars, packaging ... which fills our dustbins. The mass of ephemeral material, reflecting the times we live in.

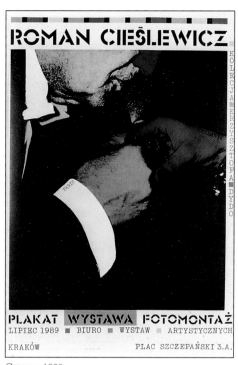

Cracow, 1989

M.R. You have worked with the great Polish masters. What influence have they had on you?

R.C. They have not influenced me. The only one who has had a very strong influence on me after I finished studying was the photomonteur Mieczyslaw Berman. None of the others, surprising as it may seem.

M.R. What in your opinion makes a good poster?

R.C. An image, a word. And the permanent interaction between the two. The idea is contained in the image and it is the relation between text and image that gives it power.

M.R. You teach in a graphic-arts school in Paris. What advice do you give your students?

R.C. My third-year graphic-art students at the Ecole Supérieure d'Arts Graphiques (ESAG) have to work to become graphic artists. They develop their creativity within a framework of research and production linked to a given theme. They devise a functional and effective visual message in relation to the set problem. They develop their critical sense by suggesting solutions to the problem from the first to the final stage. They experiment with forms, techniques, processes and materials.

M.R. What do you dislike most?

R.C. Mediocrity and irresponsibility.

M.R. What do you like most?

R.C. Newspapers, the present.

M.R. You work alone. What are your aims?

R.C. To get commissions for posters. To have a chance to comment on news and current affairs in all my favourite newspapers, to create, to create more, and to pursue my researches as a 'sharpener of the eye'.

Malakoff, 1992

1955

Cieslewicz concentrated on posters for most of this period. While Socialist Realism reigned, creative artists were cut off from information on the art world and out of contact with advertising, which anyway was banned. These posters make use of the association of ideas in very varied fields – films, theatre, concerts, circus. Seeking a strong relationship between content and form, Cieslewicz worked in all pictorial media, including gouache and watercolour, torn paper and already, though hesitantly, photomontage and typography. His first photomontages date from 1958; he attached no importance to them. They were *Deliryk* (Portrait of the Delirious), *Krol* (The King) and *Krolowa* (The Queen). This was a 'distraction' to take his mind off posters, nothing more. In the one year 1955 he produced forty posters for WAG (Wydawnictwo Artystyczno-Graficzne), the State advertising agency and art publisher. Rapid action and intensive work were combined with great creativity, a creativity impregnated with influences from the art world of the fifties and the graphic forces which had brought the 'Polish School' into being with all its characteristics: use of strong lines, sparse pictorial material, monochrome treatment, great originality in exaggerated expressiveness. In this flourishing climate of the Polish School, particularly in Warsaw, Cieslewicz holds a separate place, distancing himself pictorially from contemporary poster artists.

COLLAGES

1960

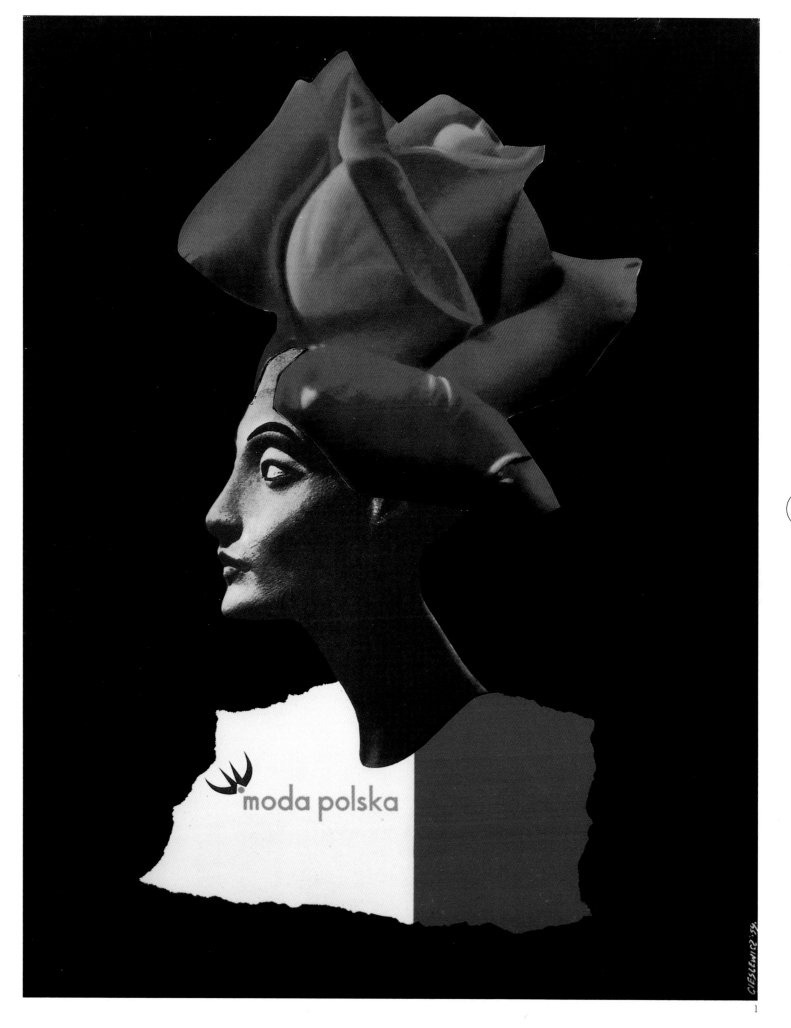

POSTERS

When Cieslewicz began making posters, this field of work was expanding rapidly and the Polish School expressed its own particular style – romanticism, poetry, association of ideas, a strong emotional element. The Polish poster artists ran into a series of apparently insurmountable barriers – an absence of comparison, omnipresent censorship, lack of information, deficiency of technical means. Yet the pioneering poster artists – Joseph Mroszcak, Starowieyski, Tomaszewski, Jan Lenica, Woytek Fangor, Mieczyslaw Berman, Julian Palka, Woytek Zamecznik, to name only a few – as well as Cieslewicz himself, managed to achieve freedom within these restraints. Graphic quality, pointed anecdotal material, visual openness, were all qualities serving the needs of urgent expression. With lucidity, irony and inventiveness, the Polish poster artist found the answer to the problem confronting him. Cieslewicz broke the taboos of classic typography, as did Tomaszewski and Lenica, and each one developed his own personal way of treating the text.

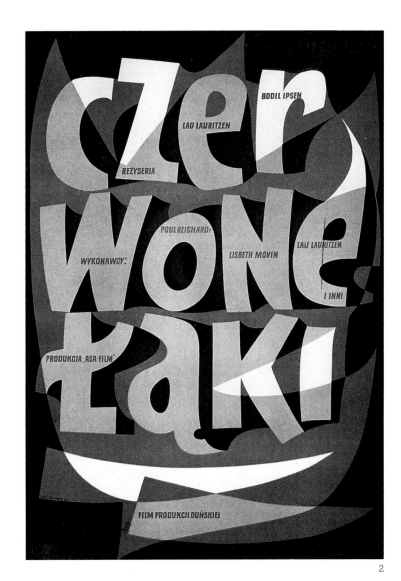

2

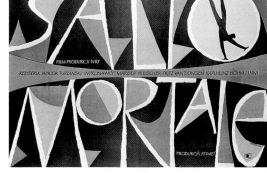

3

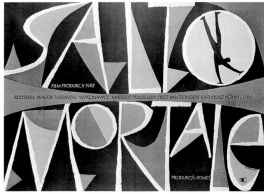

4

1
Moda polska
Polish Fashion
Advertising poster
Colour offset, 68 x 48 cm
Photomontage, 68 x 48 cm
1959

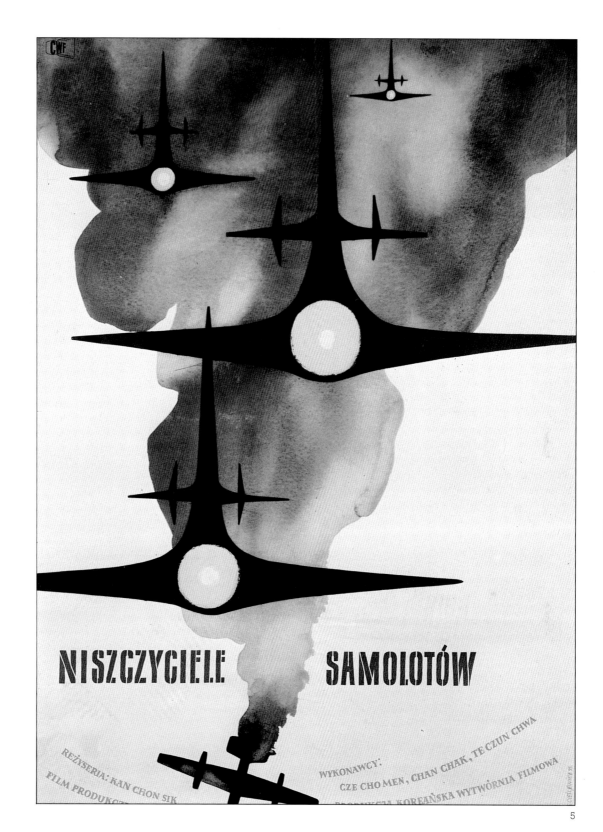

2
Czerwone laki
The Red Fields
Danish film directed by Bodil Ipsen
Colour offset, 86 x 58.5 cm
1956

3
Salto mortale
Somersault
German film directed by Wictor
Turzanski
Offset, 58.5 x 86 cm
1956

4
Niebezpieczne sciezki
Dangerous Roads
Soviet film directed by Alexeiev
Offset, 59 x 86 cm
1955

5
Niszczyciele samolotow
The Destroyers of Aeroplanes
Korean film directed by Kan Chon Sik
Offset, 83 x 59 cm
1955

5

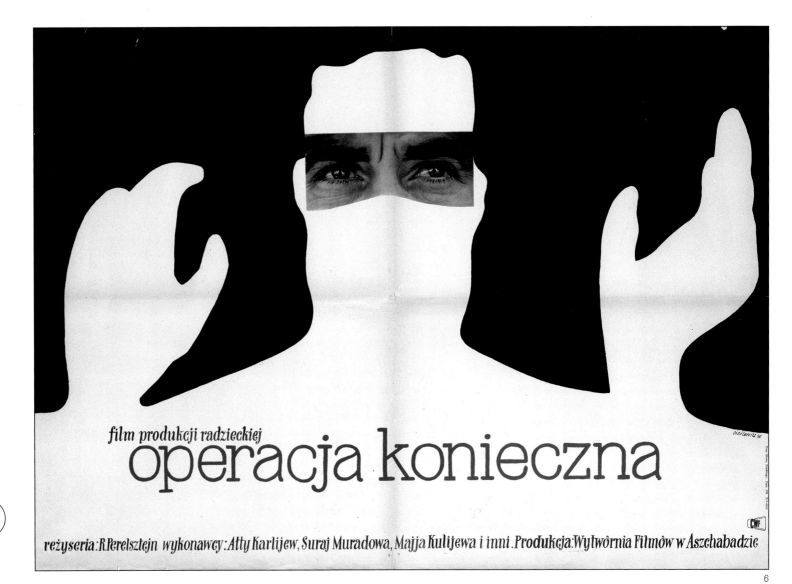

6

6
Operacja konieczna
Necessary Operation
Soviet film directed by R. Perelsztejn
Colour offset, 61 x 86.5 cm
1956

7
Wujaszek z Ameryki
Uncle from America
German film directed by Carl Boese
Colour offset, 85 x 58 cm
1957

8
Zanim Simon ujrzal swiat
When Simon Was Born
Hungarian film directed by Zoltan
Varkonyi
Colour offset, 86.5 x 50.5 cm
1955

9
Eroica
Polish film directed by Andrzej Munk
86.5 x 50.5 cm
1957

10
Wystawa rysunkow Kulisiewicza
Exhibition of drawings by Tadeusz
Kulisiewicz
Colour offset, 67 x 47.5 cm
1957

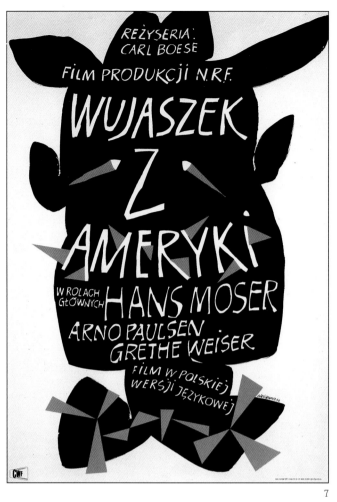

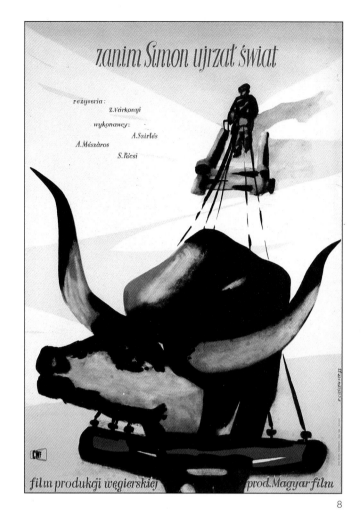

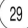

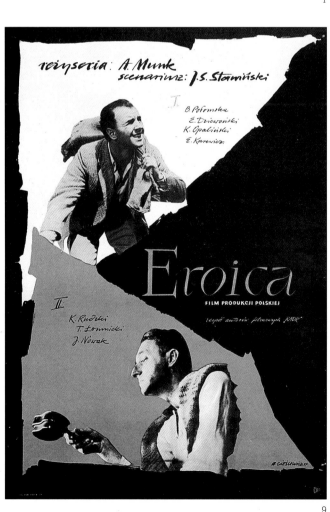

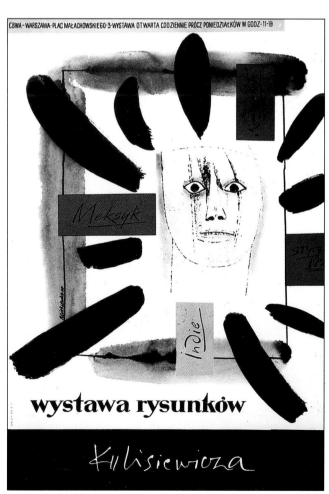

7

8

9

10

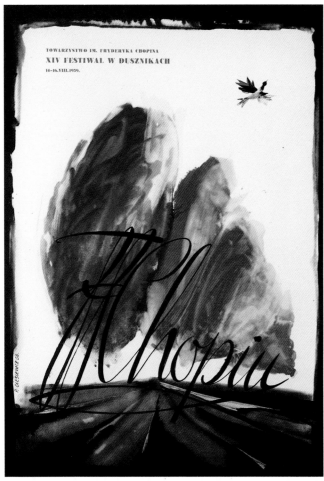

11

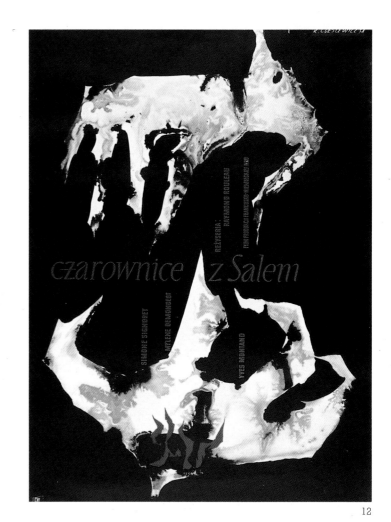

12

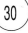

30

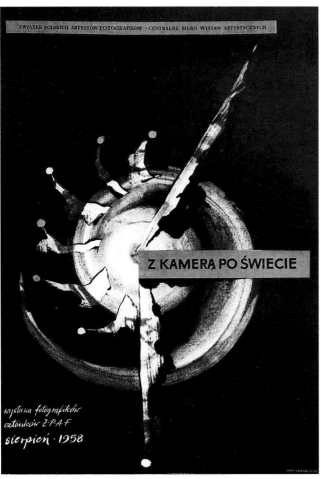

13

11
XIV Festiwal w Dusznikach
14th Chopin Festival
Colour offset, 99.5 x 68 cm
1959

12
Czarownice z Salem
The Witches of Salem
French film directed by Raymond
Rouleau
Colour offset, 81 x 58.5 cm
1958

13
Z Kamera po Swiecie
Around the World with a Camera
68 x 47.5 cm
1958

14
Stracone Zludzenia
The Fallen Idol
British film directed by Carol Reed
Colour offset, 81 x 57.5 cm
1958

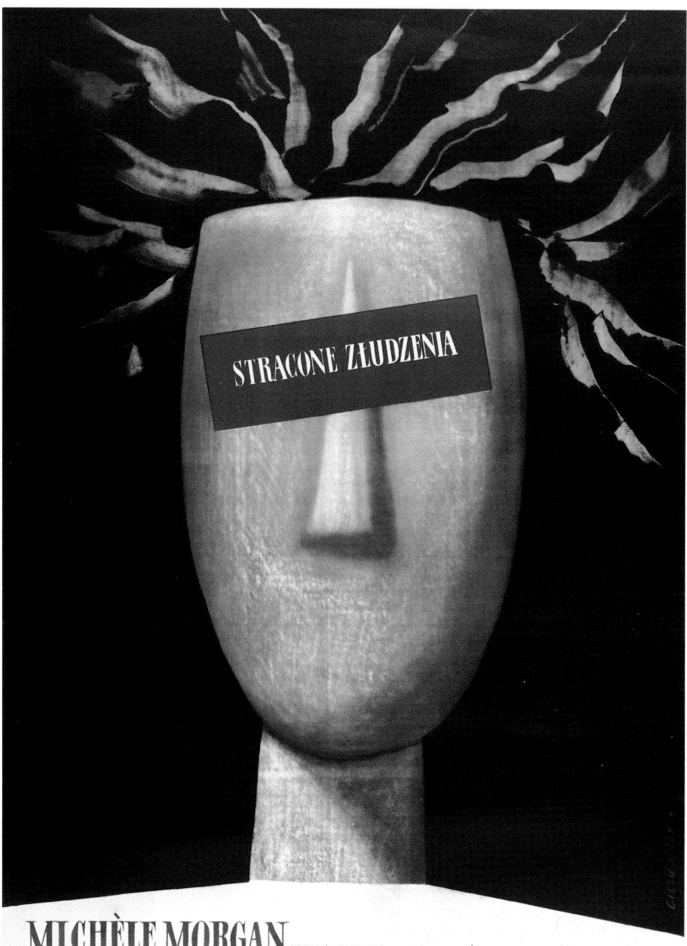

STRACONE ZŁUDZENIA

MICHÈLE MORGAN
W FILMIE PRODUKCJI ANGIELSKIEJ · REŻYSERII CAROLA REEDA „LONDON-FILMS"
RALPH RICHARDSON I JACK HAWKINS

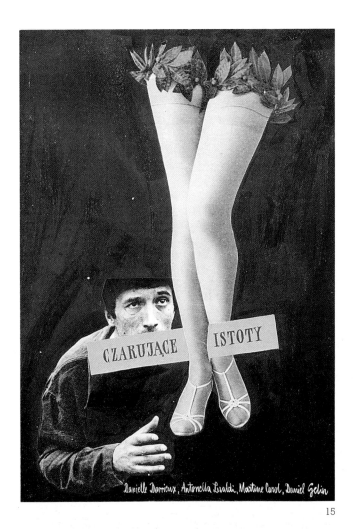

15

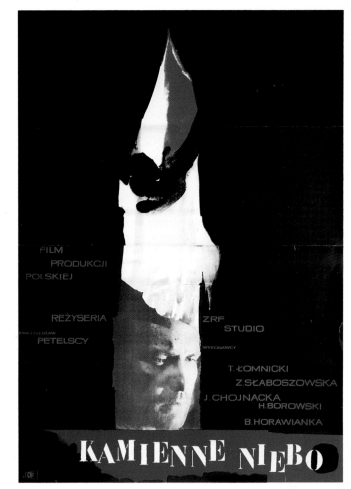

16

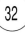

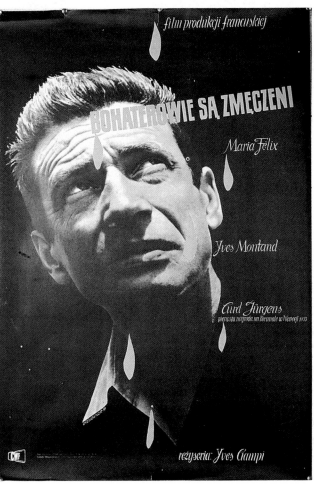

17

15
Czarujace Istoty
Adorable Creatures
French film directed by Christian Jacque
Offset, 82.5 x 58 cm
1958

16
Kamienne Niebo
The Stone Sky
Polish film directed by Ewa and Czeslaw Petelscy
Colour offset, 112 x 84.5 cm
1959

17
Bohaterowie sa zmeczeni
Heroes and Sinners
French film directed by Yves Ciampi
1959

COLLAGES

Juggling with bottles of spirits (and other drinks) and their labels, Cieslewicz takes the moustache of a general from one label to enable him to create a new portrait in this collage. By cannibalizing advertisements, an assortment of collage work later culminates in compositions appearing on the cover of the monthly magazine *Ty i Ja* (You and I). Two other collages in the same spirit, *Krol* (The King) and *Krolowa* (The Queen), are now known to be the artist's very first collages, dismissed by him as entirely unimportant at the time.

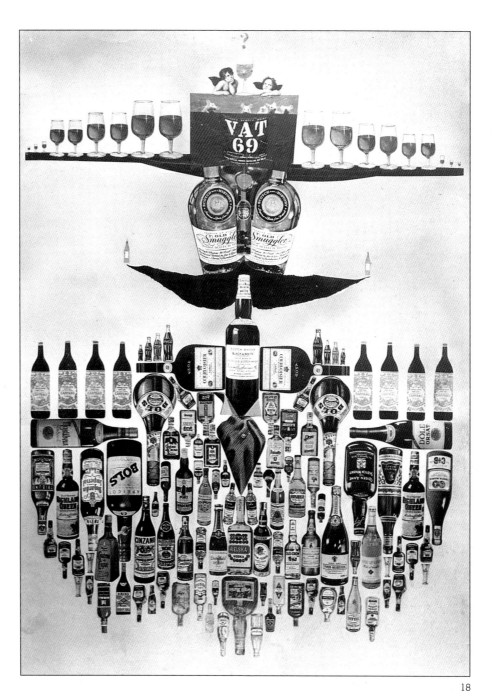

18

18
Deliryk
Portrait of the Delirious
64 x 46.5 cm
1958

1960

ILLUSTRATIONS

COLLAGES

POSTERS

PUBLISHING

1970

Cieslewicz arrived in Paris in 1963. Although Paris has the reputation of being a difficult place for graphic artists, who have to struggle to survive and to achieve social recognition, he very quickly made a name for himself. The ideas of this young Pole, his mastery of the image and his grasp of the medium had a stimulating and innovative effect on the principal French magazines and periodicals. At *Elle* his first job was as layout designer and illustrator; later he was made art director, a post he held until 1969. He also worked as layout designer with Antoine Kieffer, who was art director of the fashion magazine *Vogue Paris* (1965–66). After spending three years in the world of advertising with the agency MAFIA (Maïmé Arnodin Fayolle International Associés) as art director 1970–72, he set up in business on his own. Working for various clients, he concentrated on photomontage, photo-collage and other photographic possibilities. He proved himself very inventive, innovative and even revolutionary. His experiments focused on photo-collage: for posters, advertisements, book jackets, illustrations, screen prints and all his free creative output, he explored endlessly the possibilities offered him by photographic prints, taking chances and handling them successfully. It was a period of black and white, of repetitive collages and silk-screens. From Paris he also continued to collaborate in his native country, creating posters for Polish cinema, theatre and opera.

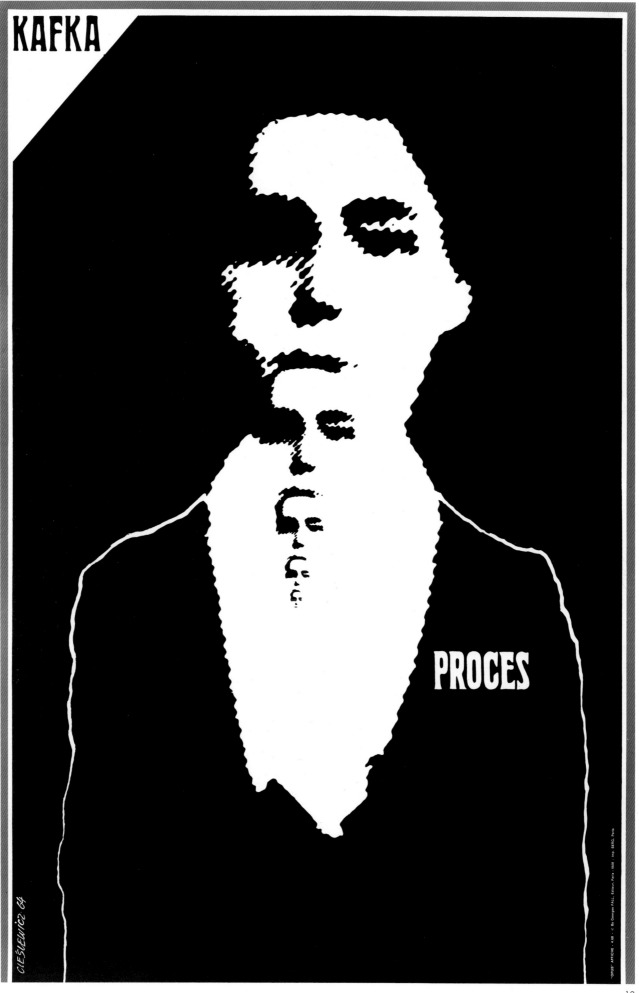

ILLUSTRATIONS

These highly important works for Cieslewicz comprise a series of thematic illustrations linked to the writings of the Polish author Bruno Schulz (1892–1942). The sculptural treatment is perfectly suited to the literary vision of the writer in *Traité des mannequins* (Treatise on Mannequins), which brings together a selection of extracts from *Sklepy Cynamonowe* (Cinnamon Shops) and *Sanatorium pod Klepsydra* (The Undertaker's Sanatorium), published in 1934 and 1937 respectively. Schulz depicts subjects that are closer to hell than heaven, with frequent recourse to the grotesque and to expressionist distortion. Fictitious scenes and dreams emanating from the subconscious are interwoven with real-life events, all described with naturalistic precision. The visual equivalent of the written word draws on metaphor but also on many details with the clarity and precision of photography. Cieslewicz makes use of contemporary documents – old newspapers, postcards, prospectuses, advertisements, industrial packaging. With these 'accessories' he visually re-transcribes the dual aspects of reality: gravity and mockery, the dramatic and the grotesque, providing a subjective visual context for the literary content. These illustrations were never published, yet some of them have been reproduced so often that they now form part of the Polish cultural heritage. In *Nemrod* (Nimrod) Cieslewicz uses for the first time the symmetrical composition which led to a succession of posters: *Arrabal*, *Dziady* (Ancestors), and in the 1960s the collection of photomontages entitled *Figures symétriques* (Symmetrical Figures). The colours of these montages are predominantly acid purples and yellows heightened with black, painted in watercolour that is sometimes dense and sometimes washed out.

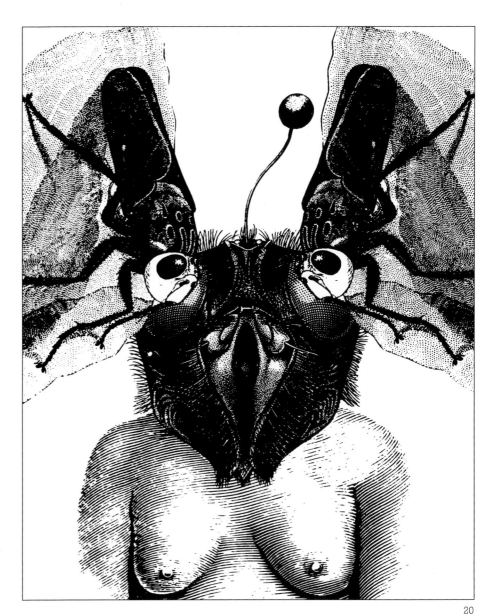

20

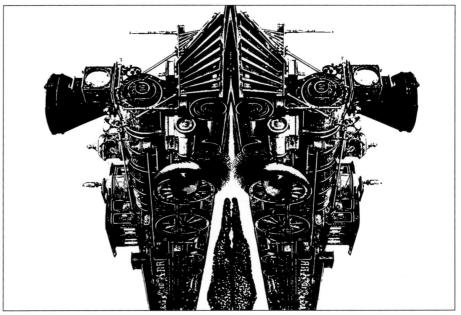

21

19
Procès Kafka
The Trial, play by Franz Kafka,
Warsaw Drama Theatre
Colour offset, 82 x 52 cm
1964/1968
This poster, commissioned by the
Warsaw Drama Theatre before
Cieslewicz left for Paris, was
published in France by Georges Fall
in 1968, based on the original of
1964.

Traité des mannequins
Treatise on Mannequins
Bruno Schulz
Series of illustrations for a book
published in 1961.

20
Tłuja
The Village Madwoman
50 x 35 cm
1962

21
Lokomotywa
Locomotive
30 x 39 cm
1962

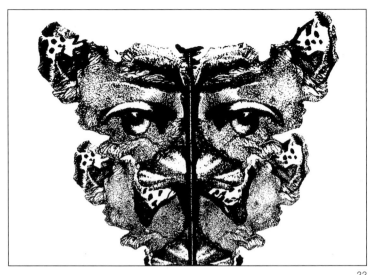

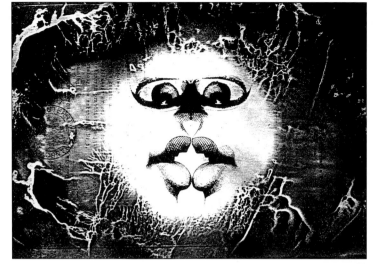

22

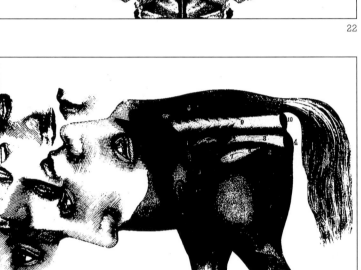

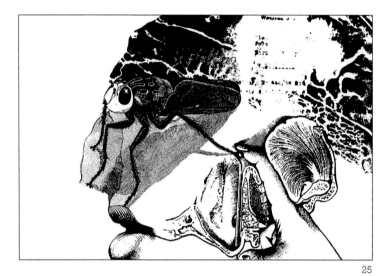

24

25

22
Nemrod
Nimrod
39 x 30 cm
1962

23
Samotnosc
Solitude
35 x 50 cm
1963

24
Ulica Krokodyli
Street of Crocodiles
35 x 50 cm
1963

25
Sierpien
August
35 x 50 cm
1963

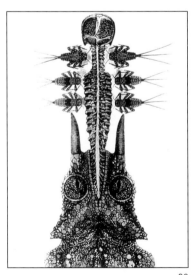

26

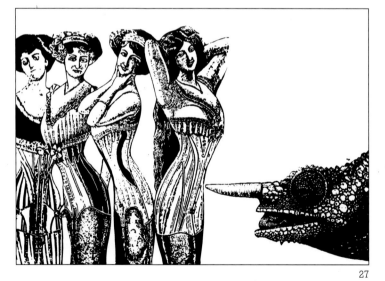

27

26
Tarakany
Black Beetles
50 x 35 cm
1963

27
Manekiny
Mannequins
35 x 50 cm
1963

28

28, 29
Italsider Iron and Steel Company
5 panels for company factories in
Italy
230 x 150 cm
1963
Commissioned by the artistic
director Eugenio Carmi, these mural
panels decorate the reception halls in
the factories at Taranto, Conigliano,
Piombino, Lovere and Genoa. The
artist took huge pieces of machinery
which he composed into workers'
faces, giving the impression of steel
constructions shaped into human
form. These very large collages
were made from small-size (21 x 30
cm) photographic montages entirely
in black and white.

29

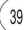

30

31

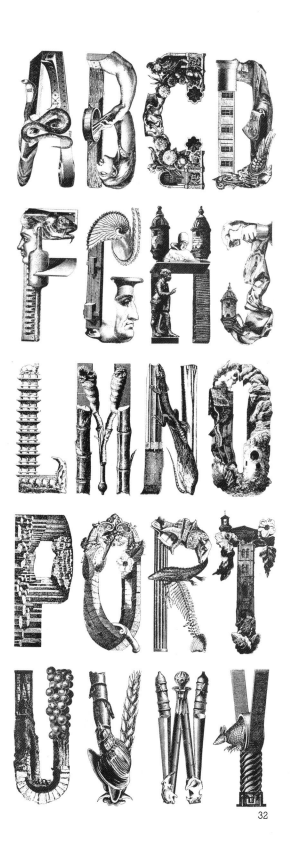

32

33

34

30–34
Alphabet
For the 'Guide de la France
Mystérieuse' published by Claude
Tchou
1964
The entire alphabet is composed of
19th-century images reworked by
the artist in screen print. It was
printed in red using small-size (21
x 10 cm) originals on a white oval
framed in a black rectangle. On the
verso of each letter Claude Tchou
wanted a tailpiece in collage, as the
page was blank. About 20 collages
measuring 5 x 5 cm.

35

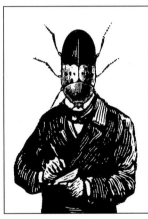
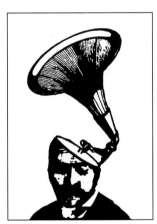

36 37

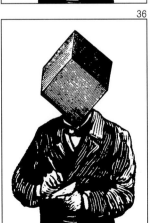
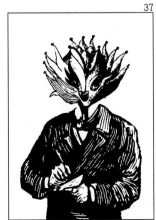

38 39

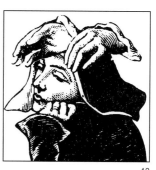

43

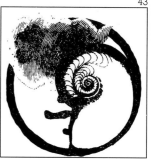

44

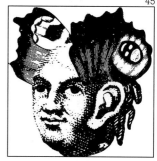

45

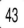43

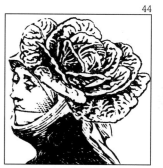

46

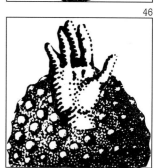

47

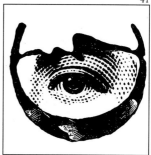

48

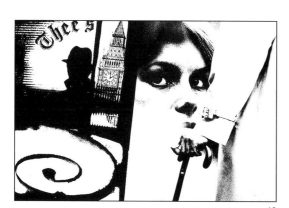

40

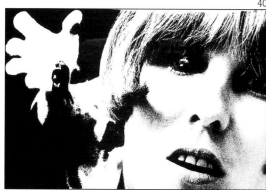

41

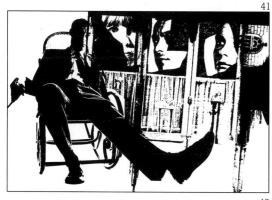

42

40–42
Illustrations for the novel 'Double coeur', as double-page illustrations in 'Elle'
22.5 x 33.5 cm
1964

43–48
Collages for the article 'Conjuration et sortilèges' in 'Elle'
5.5 x 5.5 cm
1964

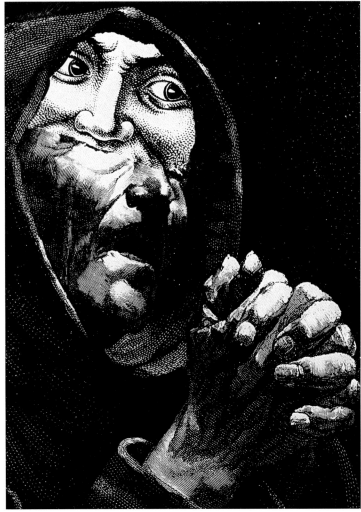

49

49
Collage/illustration
Opening page of the article
'Conjuration et sortilèges' in 'Elle'
29 x 23 cm
1964

50
Tailpiece for 'Le Courrier du coeur'
in 'Elle'
10 x 10 cm
1964

51
Le Voyeur ou 'Louis multiplié'
The Voyeur or 'Louis Multiplied'
Photomontage/illustration for
'Le Livre de la Santé'
Editions Sauret, Paris
24.5 x 17 cm
1965
These works in black and white are
the first of the repetitive collages.

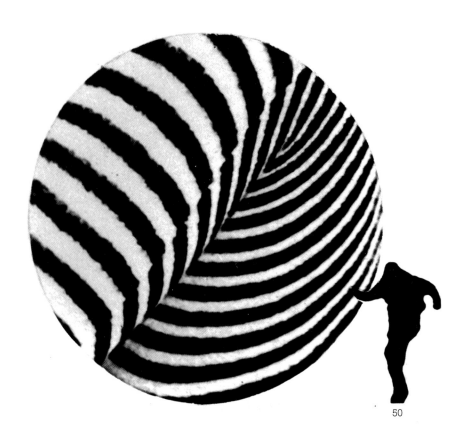

50

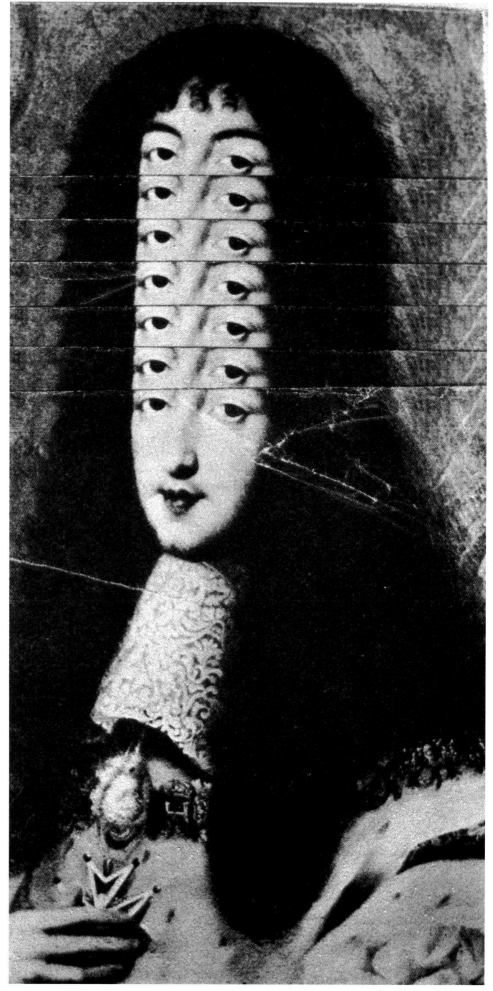

45

COLLAGES

Recomposed from elements we had thought familiar, these collages (which were Cieslewicz's first in colour) evoke another world. They present a jigsaw-puzzle of scraps, of fragments of memories. Comfortable or otherwise, they unfold along the thread which separates the real from the unreal. Usually, Cieslewicz does not work with photographic negatives, but uses printed reproductions whose screen is essential to his creative process and technique. He seems to attach greater importance to posters and illustrations than to his collages, which he makes without being commissioned. He cuts out, pastes up with malice aforethought, and claims to be simply recording his dreams. For a number of years he regarded them as a pastime to 'clear the head' and take his mind off his rigorous, structured work as a poster artist. It gave him pleasure to create without constraint, dipping into old printed advertisements which he cheerfully cannibalized. 'Life itself is a very weird – and frightening – collage', he declared in an interview with Patrick Roegiers published in *Le Monde*. 'How am I to understand it otherwise than in the form of this strange mixture inside my head, which comes out of it in different shapes? I could just as well turn it into a photomontage as a poster.'

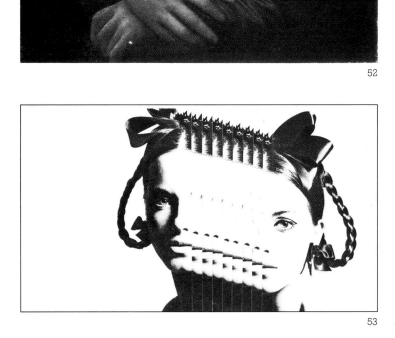

52

53

52
Mona travesti
Transvestite Mona
Collage, 15 x 10 cm
1968

53
Rita de Berlin
Black and white photomontage
20 x 30 cm
1965
A photomontage made from multiple pages of the magazine 'Elle'. Rita de Berlin, actually Rita Scherer, was a famous model of the time.

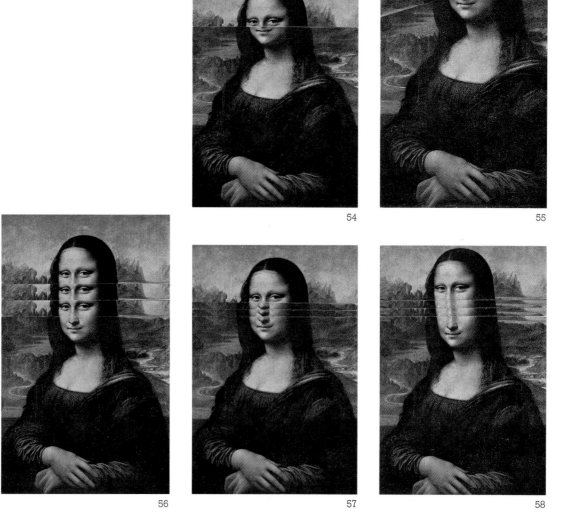

54

55

56

57

58

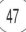

47

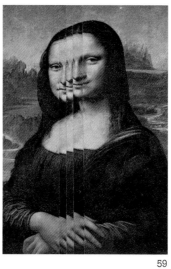

59

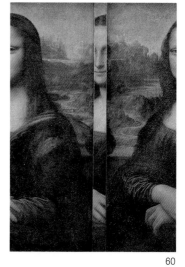

60

54–60
Les Mona's Lisa's
The Mona Lisas
14 x 10 cm
1969

54
M.L. Horizontal IV
55
M.L. Diagonal I
56
M.L. Horizontal V
57
M.L. Horizontal I
58
M.L. Horizontal II
59
M.L. Vertical I
60
M.L. Vertical II
This series came into being by pure
chance. Cieslewicz had bought some
postcards at the Louvre and they
were lying jumbled on his work
table. The effect aroused his interest
and led to his formalizing this
accidental image.

POSTERS

At the same time as the very personal series of collages, Cieslewicz produced a large number of posters. They all have great plastic power, without decoration, and intellectual relevance. Cieslewicz, although working alone, still belonged to the great Polish School of graphic art. On this subject, let us quote Jan Lenica, writing in *Opus International* in April 1969:

'The language of a poster functions through association. The narrative illustration, full of anecdotal detail, is stripped of any background ornamentation or other superfluous elements. The tendency to synthesize, to condense ideas, visual shorthand and the use of signs rather than images are a way of thinking poster.... The multiple aspects of poster art once divided poster artists into two camps, the visuals and the cerebrals. The first introduced elements of fantasy which took posters into the realm of decorative art. The second, less numerous but extremely active (the Bauhaus period, the Vkhutemas group in Russia, the Swiss School), introduced a new kind of typography into posters which derived from the Dadaists, insisting on the use of abstract signs. Geometric abstraction led to an ascetic, rigorous attitude that was foreign to the spirit of decorative stylization. Road signs are like a series of ideal posters. Awareness of this fact was characteristic of the attitude which stopped speaking to the spectator's feelings and took no account of his emotional state.'

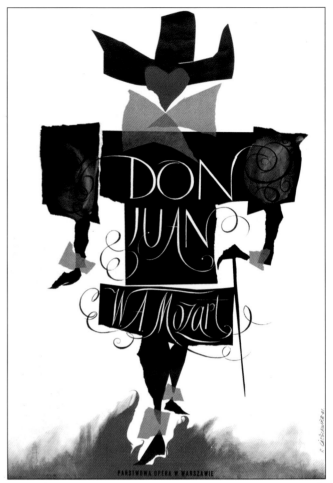

61

61
Don Juan
Don Giovanni
Opera by W.A. Mozart,
Warsaw Opera
Colour offset, 98 x 66.5 cm
1961

62
Persefona
Persephone
Opera-ballet by Igor Stravinsky,
Warsaw Opera
Colour offset, black/white/brown,
100 x 70 cm
1961
The lettering used in this important poster carries its entire content.

63
Murzyn zrobi swoje – Murzyn kaze odejsc!
The Black Man Has Done His Work – The Black Man Says Go!
Offset, red/black, 100 x 70 cm
1961
This political poster takes up and twists a racist and colonialist slogan: 'The black man can go, he has done his work.' One of the rare political posters in which Cieslewicz comments on the text by underlining the idea of the departure of the colonist – represented by a top hat, to which Africa appears to have contributed a helpful kick.

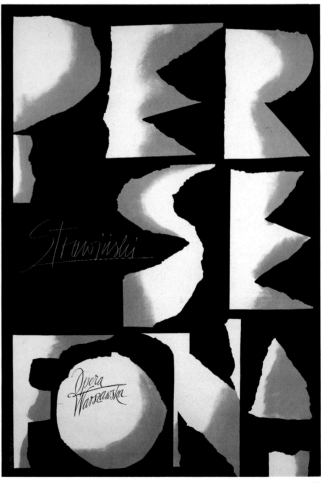

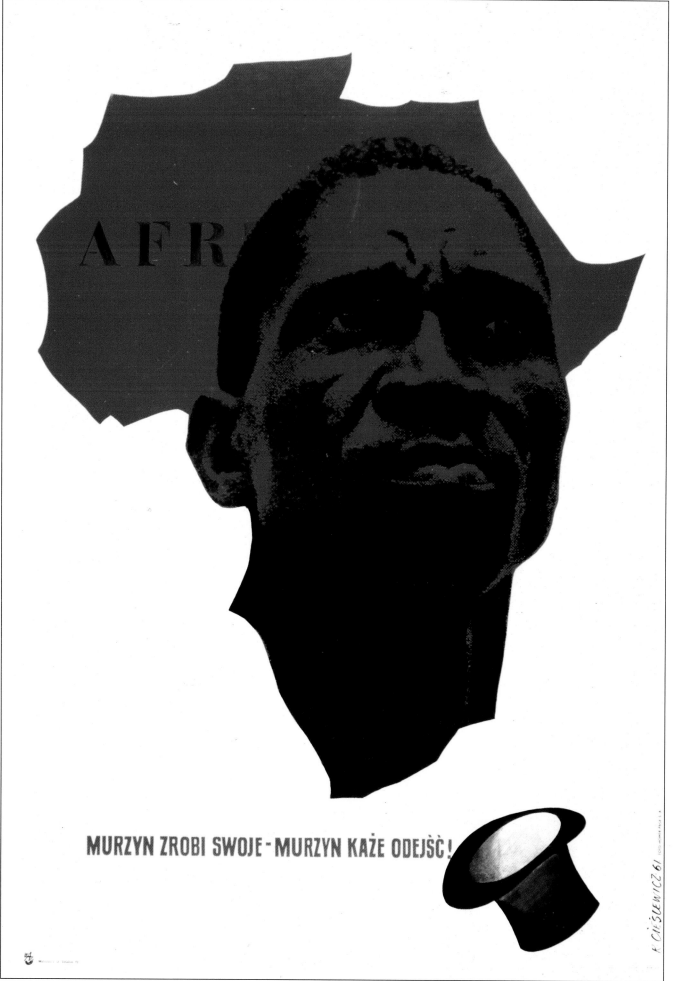

MURZYN ZROBI SWOJE - MURZYN KAŻE ODEJŚĆ!

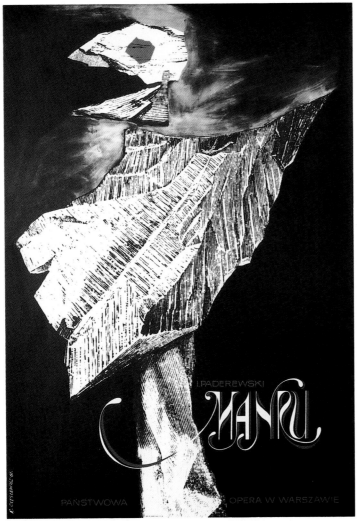

64

65

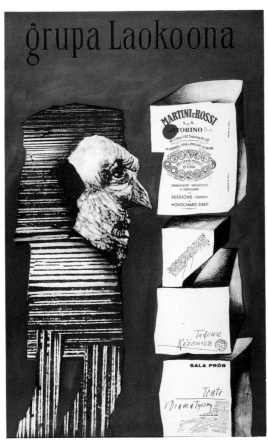

66

64
Manru
Opera by I. Paderewski,
Warsaw Opera
Colour offset, 97 x 66 cm
1961

65
Katastrofa
Catastrophe
Hungarian film directed by
Zoltan Varkonyi
Colour offset, 97 x 59 cm
1961

66
Grupa Laokoona
The Laocoon
Play by Tadeusz Rozewicz,
Warsaw Drama Theatre
Colour offset, 84.5 x 59 cm
1962

67
Cyrk
Circus
Poster for the Cyrk Konie
(Horse Circus)
Colour offset, 97 x 67.5 cm
1962

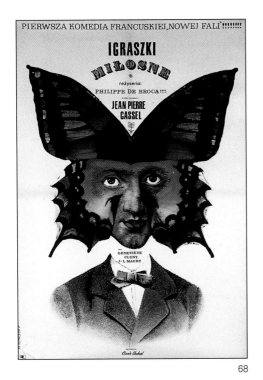

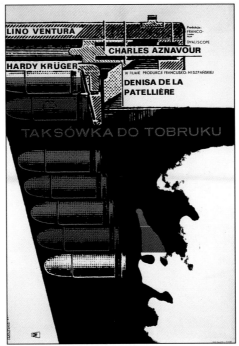

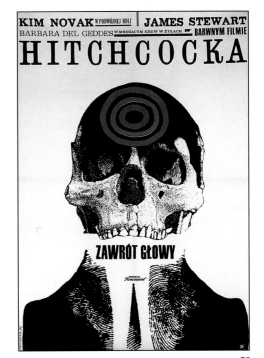

68

69

70

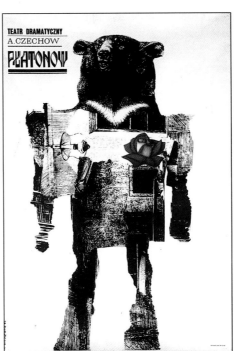

71

72

73

68
Igraszki Milosne
The Love Game
French film directed by Philippe de Broca
Colour offset, 85 x 58.5 cm
1963

69
Taksowka do Tobruku
Taxi for Tobruk
Franco-Spanish film directed by
Denis de la Patellière
Colour offset, 83.5 x 58 cm
1963

70
Zawrot Glowy
Vertigo
British film directed by Alfred
Hitchcock
Colour offset, 83.5 x 58 cm
1963

71
**XVI Miedzynarodowy kolarski
Praha–Warszawa–Berlin**
16th International Race
Prague–Warsaw–Berlin
Colour offset, 97 x 67.5 cm
1963
Note that, already, the computer
screen is used to give the cyclist
speed and precision.

72
Platonow
Platonov
Play by Anton Chekhov,
Warsaw Drama Theatre
Colour offset, 85.5 x 60 cm
1962

73
Spartakiada zimowa
Winter Spartakiad
Colour offset, 67.5 x 47.5 cm
1964

74
Wiezien
The Prisoner
Opera by Luigi Dallapiccola,
Warsaw Opera
Offset, 97 x 67.5 cm
1962

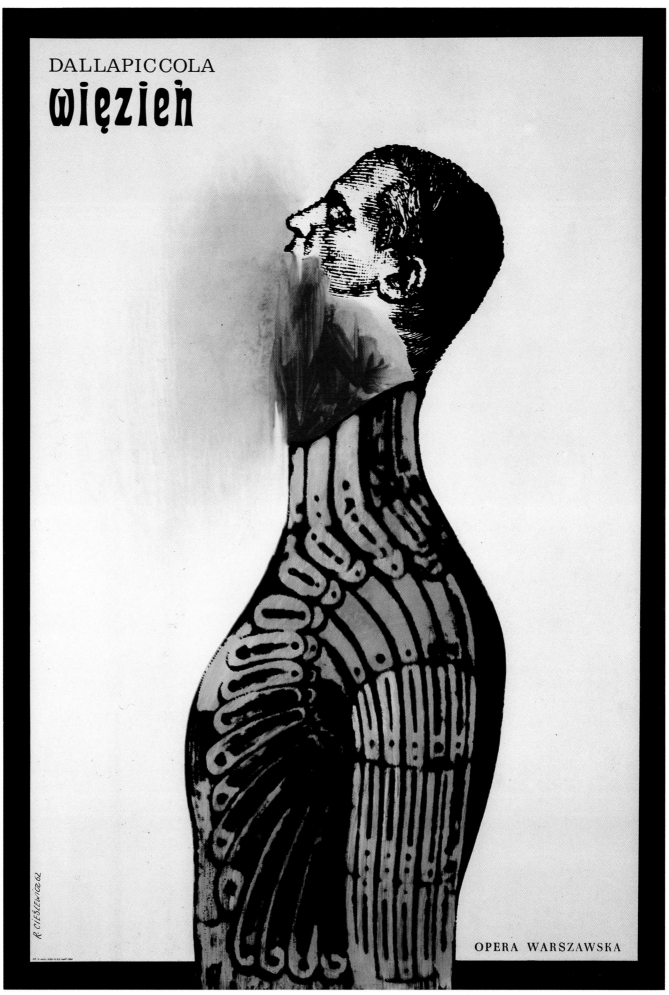

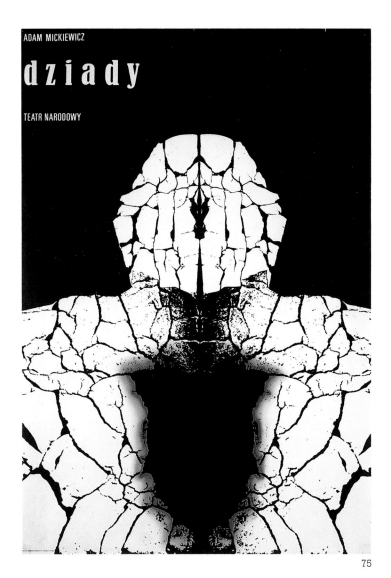

75

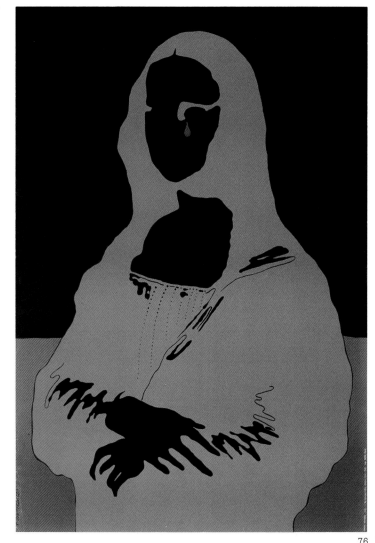

76

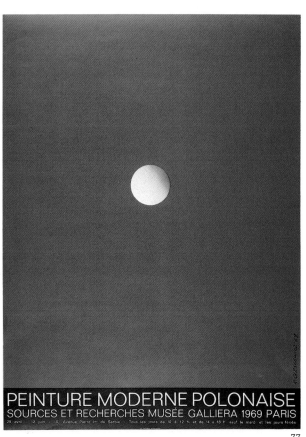

77

75
Dziady
Ancestors
Play by Adam Mickiewicz,
National Theatre, Warsaw
Offset, 97 x 67 cm
1967

76
Sztuka i Technologia
Art and Technology
Cultural poster for 'Opus
International' and cover for the
magazine
Offset, 82 x 55 cm
1967

77
Peinture moderne polonaise
Modern Polish Painting
Exhibition at the Musée Galliera,
Paris
Offset, 64.5 x 47.5 cm and
100 x 150 cm
1969

78
Aïda
Opera by Giuseppe Verdi,
Grand Theatre, Warsaw
Offset, 97 x 67.5 cm
1966

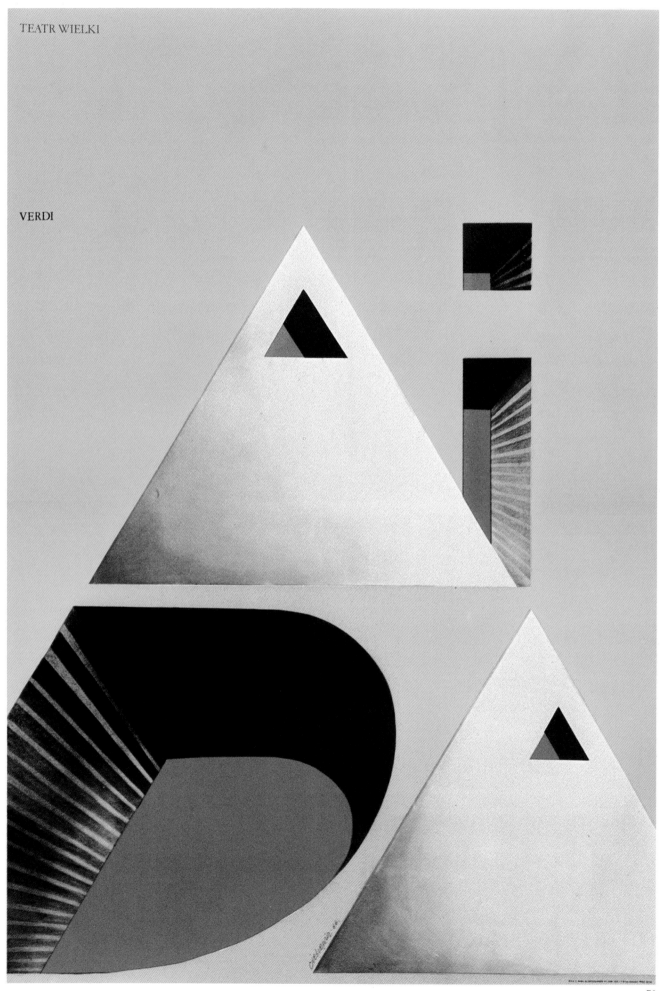

VERDI

TEATR WIELKI

55

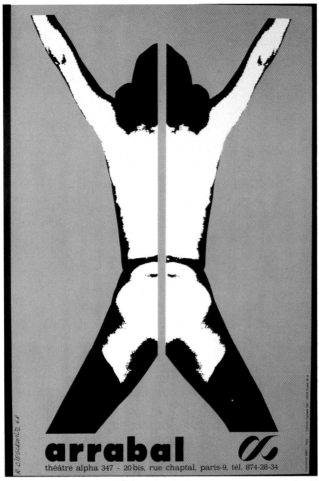

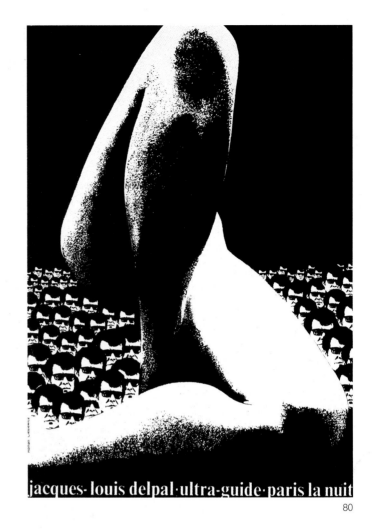

79

80

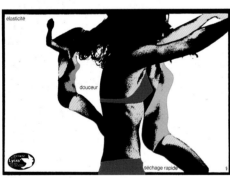

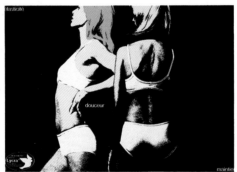

81

82

79
Arrabal
Théâtre Alpha 347, Paris
Offset, 82 x 52 cm
1968

80
**Jacques-Louis Delpal – Ultra-guide
– Paris la nuit**
Advertising poster for launch of the
series of 'Ultra-guides'
Published by Jean-Louis Gouraud,
Paris
Offset, 54 x 37.5 cm
1967

81, 82
Advertising posters for Lycra
Elasticité, douceur, séchage rapide
(Elasticity, Softness, Fast Drying)
Elasticité, douceur, maintien
(Elasticity, Softness, Support)
MAFIA Agency, Paris
Offset, 40 x 58.5 cm
1971

PUBLISHING

Work on page layout and covers during these years also applies the fundamental principles of the relationship between image and text. This publishing work is suffused by the technique of photomontage together with drawing and flat tints. Sometimes Pop Art is the inspiration.

83

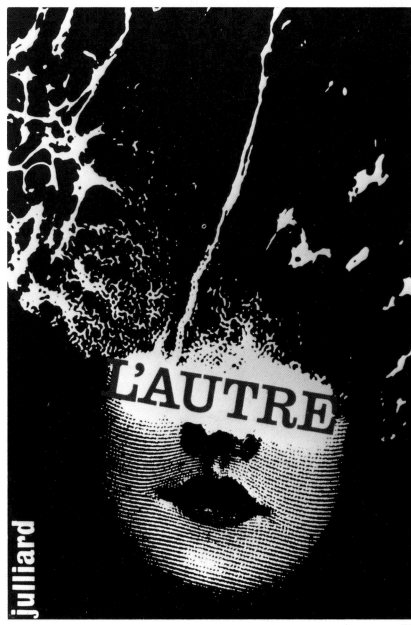

84

83
Book jacket for 'L'Anti-Soleil'
(The Anti-Sun) by Serge Kancer
Editions Julliard, Paris
20 x 27 cm
1965

84
Book cover for 'L'Autre' (The Other)
by Lothar Streblow
Editions Julliard, Paris
19.5 x 13.5
1963

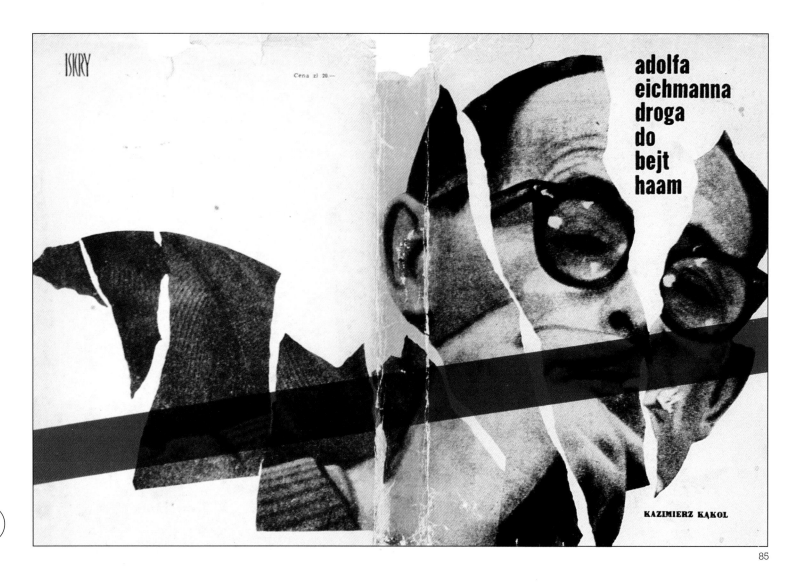

ISKRY

Cena zł 20.—

**adolfa
eichmanna
droga
do
bejt
haam**

KAZIMIERZ KĄKOL

85

85
Book jacket for 'Adolfa Eichmanna
droga do Bejt Haam'
(Adolf Eichmann's Road to Beit
Haam) by Kazimierz Kakol
12 x 18 cm
Published by Ksiazka i Wiedza,
Warsaw
1962
Cieslewicz's first book jacket.

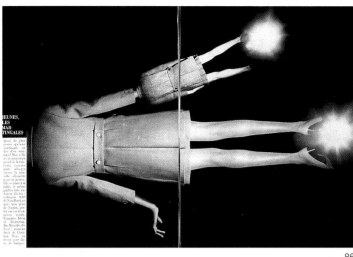

86

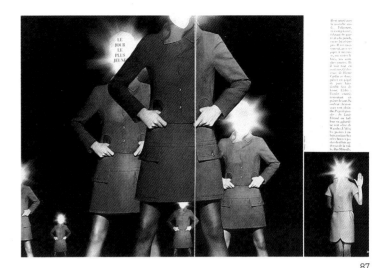

87

86
Vogue
Condé Nast, Paris
Photomontage with photographs by
Ronald Traeger
33 x 50 cm
1966

87
Vogue
Advertisement for dress materials
33 x 50 cm
1965

88
Vogue
Photomontage with photographs by
Ronald Traeger
33 x 25 cm
1966

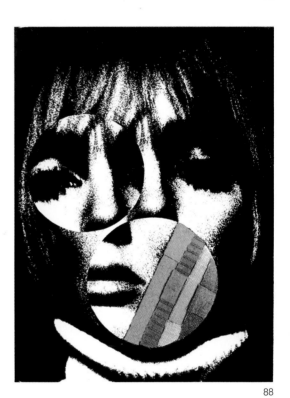

88

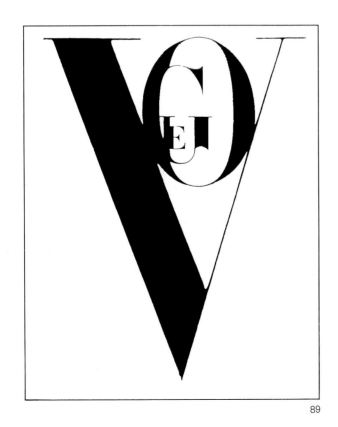

89

89
Vogue
Logotype. Unpublished project
21 x 30 cm
1966

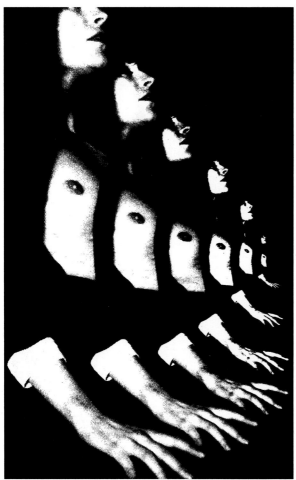

90

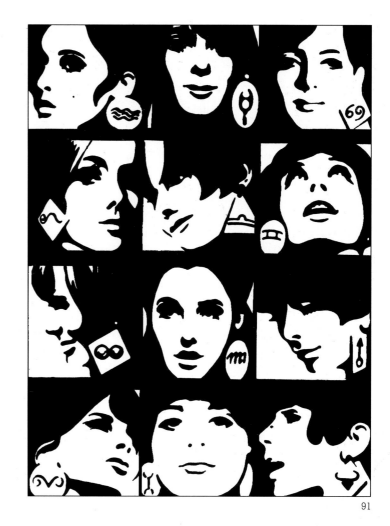

91

92

90
Photomontage illustration for a
poem by Joyce Mansour, 'L'Ombre
de la folie' (The Shadow of Madness),
in 'Opus International' No. 7
27 x 18 cm
1968

91
Horoscope for 'Elle'. The twelve
signs of the zodiac. Published weekly
from 1965 to 1980.
This commission for vignettes led
Cieslewicz to work in black and
white, eliminating all detail. The
creative process was simple:
reduction in size of the originals,
cleaning up the images by
retouching, repetition of the motifs
before enlarging them again and
printing. These horoscopes led to
further experiments and collages on
other subjects.

92
Photomontage illustration
Marcel Duchamp
Photograph by Marie-Laure de
Decker
'Opus International' No. 6
27 x 18 cm
1968

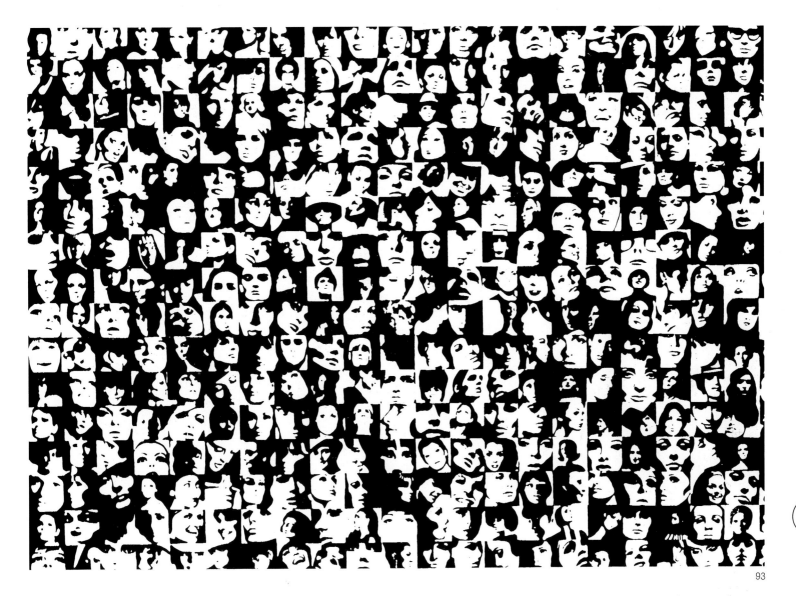

93

93
Diary for Prisunic stores
Design based on a silk-screen print
entitled 'Harem'
225 x 311 cm
1968
Commissioned by the MAFIA
Agency.

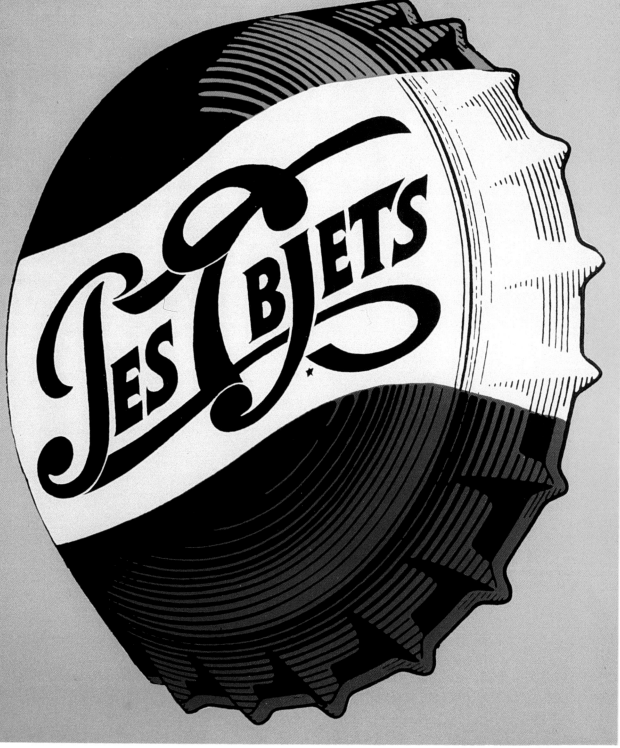

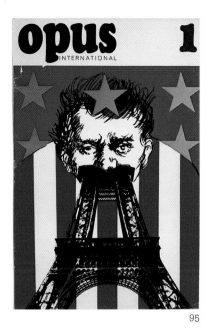

95

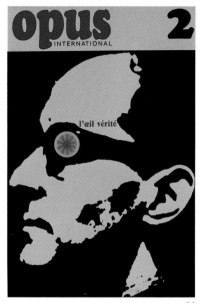

96

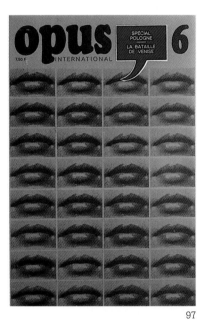

97

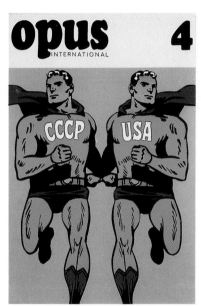

98

OPUS

International art review published by
Georges Fall, Paris. These images
are both magazine covers and
posters. Cieslewicz gives the subject
space, into which he introduces a
hiatus, a touch of irony, for example
the red tear of the Mona Lisa or Jean-
Luc Godard's kinetic eye.
27 x 18 cm

94
Opus International No. 10/11
Les Objets
Objects
1968

95
No. 1 L'Art américain en France
American Art in France
Montage with drawing by Roland
Topor
1967

96
No. 2 L'Oeil vérité. Cinéma de
Godard
The Truth Eye. Godard's Cinema
1967

97
No. 6 Spécial Pologne
Poland, special number
1968

98
No. 4 Art soviétique/Art USA
Soviet Art/USA Art
1968

99
No. 7 Violence/Mai 68
Violence/May '68
Drawing by Roland Topor
1968

100
No. 9 Tchécoslovaquie
Czechoslovakia
1968

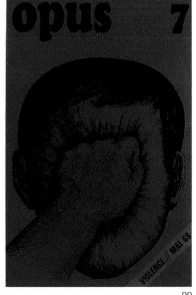

99

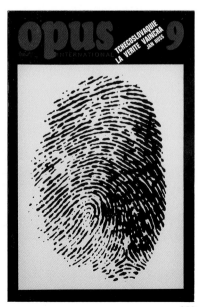

100

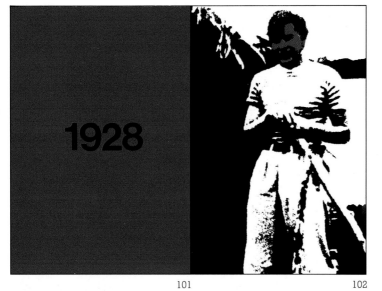

101

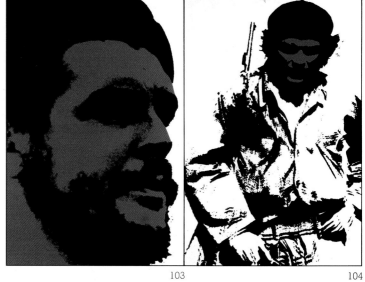

102

103

104

105

106

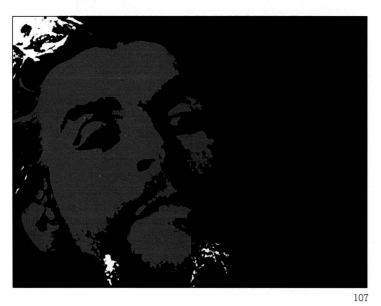

107

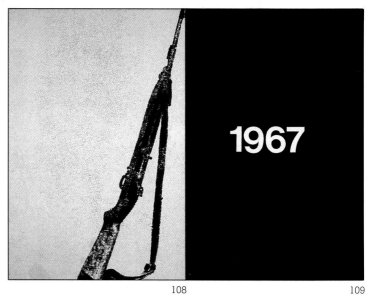

108

109

110

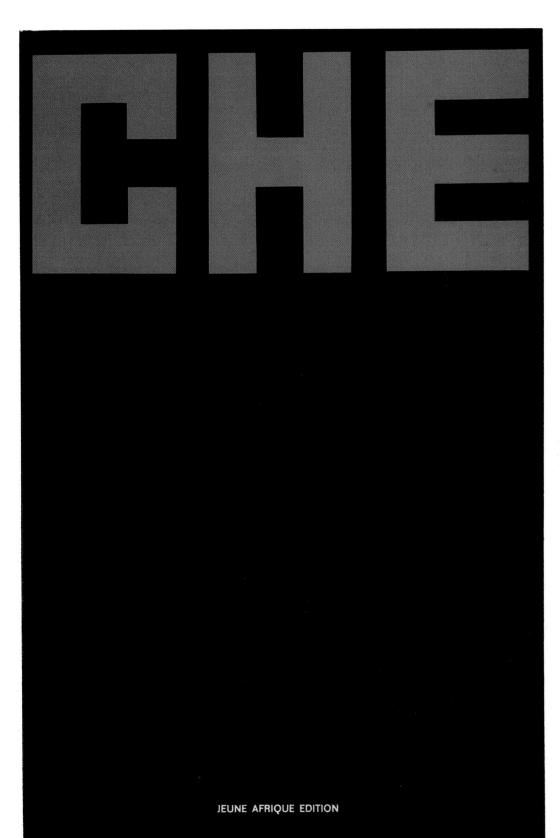

JEUNE AFRIQUE EDITION

111

CHE
This 48-page album devoted to the
revolutionary leader Che Guevara
is exemplary. In all the images
throughout the book, his face alone
appears as a patch of red. No text. It
is the various angles of vision which
allow the author to say what he has to
say. The book was rejected by Fidel
Castro because his face was not
coloured red!
Double page 26 x 34 cm
1968

101–109
Inside double-page spreads

110
Cover (and poster) of 'Opus
International' No. 3

111
Front cover
Jeune Afrique Edition, Paris

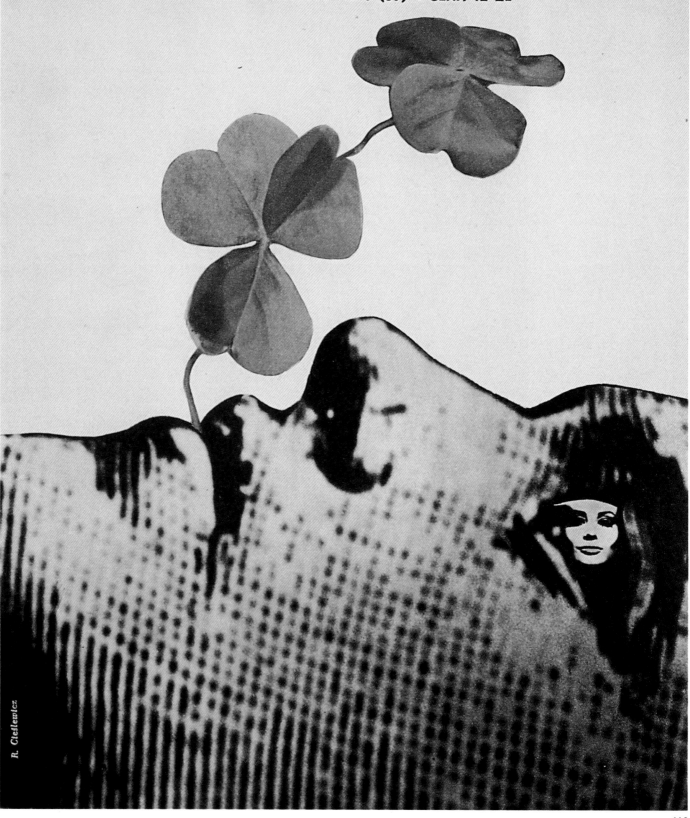

WIOSNA
KONKURS
STRONA 56

TY i JA

MAJ 1963 • MAGAZYN ILUSTROWANY • NR 5 (37) • CENA 12 ZŁ

R. Cieślewicz

66

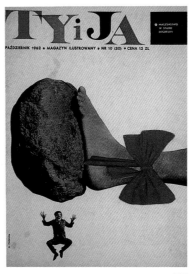

113

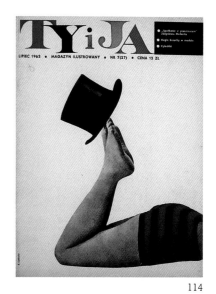

114

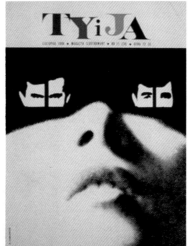

115

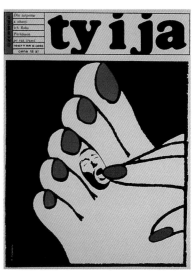

116

Ty i Ja (You and I)
A 64-page magazine with a print run
of 10,000
Published by R.S.W. Prasa, Warsaw
Double page 25 x 33 cm
Editor-in-chief: Roman Jurys
Editorial director: Teresa Kulczynska
Art director: Roman Cieslewicz
First published in Warsaw, May 1960
Covers in four colours, printed in
offset
This was the only monthly cultural
review in Poland. A popular
magazine devoted to literature,
science, design, poetry, fashion and
graphic art. Frequently censored, it
ceased to appear at the end of the
1980s. Cieslewicz was its art director
from 1960 to May 1963. After that he
continued to design covers for it from
Paris until 1975.

112
May 1963, No. 5 (37)

113
October 1962, No. 10 (30)

114
July 1962, No. 7 (27)

115
November 1966, No. 11 (79)

116
June 1967, No. 6 (86)

117
August 1967, No. 8 (88)

118
February 1968, No. 2 (94)

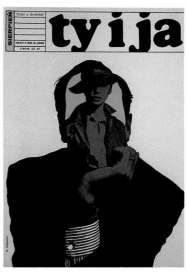

117

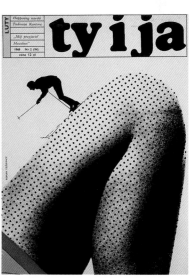

118

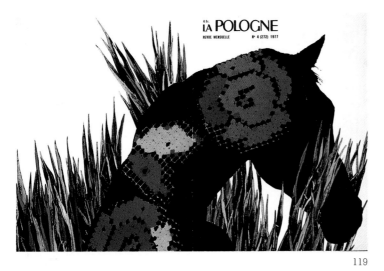

119

120

121

122

123

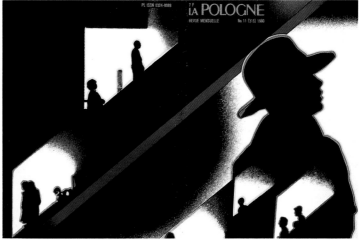

124

POLAND
ILLUSTRATED MAGAZINE No. 11 (231) · 1973 · PRICE

125

Polska/La Pologne/Poland, etc.
Double page 28 x 43 cm
Popular official magazine with a
large circulation, founded in 1946,
published in Polish, German, Russian,
Spanish, French and English. The
articles were many and varied – big
shipbuilding works, interviews, etc.,
but always predominantly cultural.
The covers designed by Cieslewicz
corresponded to given themes –
spring, autumn, youth. He had absolute
freedom of choice in interpretation. All
the great names of the Polish School
contributed to this magazine. At the
time, these covers were extremely
daring for a socialist country.

119
April 1977, No. 4 (272)

120
September 1972, No. 9 (217)

121
November 1975, No. 11 (255)

122
June 1980, No. 6 (310)

123
August 1967, No. 8 (156)

124
November 1980, No. 11 (315)

125
November 1973, No. 11 (231)

1970

Cieslewicz, whether making use of images from the past or from the present day, by means of colour, screens or typography, beckons us towards his ideas with violence and clarity, with a sharp sense of strongly focused framing. He distorts reality the better to illuminate it. He frees himself from utilitarian graphic art and rediscovers the essence of a skilfully realized search for plasticity. He provokes the spectator and shakes him out of his complacency. Now a period of success is beginning for the artist: he has many clients both for posters and for publishing work. These ten years are notable for an obsession with photomontage, and the series *Changements de climat* (Changes of Climate) marks an important turning-point in his work. It expresses his thirst for colours, since black and white had become too mechanical for him. The technique of photomontage now dominates all the work he creates. He makes less and less use of pencil, chalks and paintbrush, preferring the camera and the printing screen. The term 'photomontage' was invented after the First World War, when the Dadaists had to find a name for their new technique which consisted of introducing photographs into their paintings. Throughout this whole decade Cieslewicz was still very much influenced by the Blok group, and in particular by Mieczyslaw Szczuka whose definitions of photomontage he applied with zest, even if sometimes in a rather mannered way.

PUBLISHING

COLLAGES

SILK-SCREENS

POSTERS

1980

'PHOTOMONTAGE
The kind of poetry that is most condensed within its form.

PHOTOMONTAGE
Plastic poetry.

PHOTOMONTAGE
Offers the phenomenon of the reciprocal penetration of the most diverse events that occur in the universe.

PHOTOMONTAGE
The mutual penetration of two and three dimensions.

PHOTOMONTAGE
Enlarges the possibility of means – it makes it possible to use phenomena inaccessible to the human eye and which can be captured on a sensitive photographic plate.

PHOTOMONTAGE
The modern epic.

PHOTOMONTAGE
The objectivity of forms.'

Mieczyslaw Szczuka
in the review 'Blok', 1924, No. 8/9

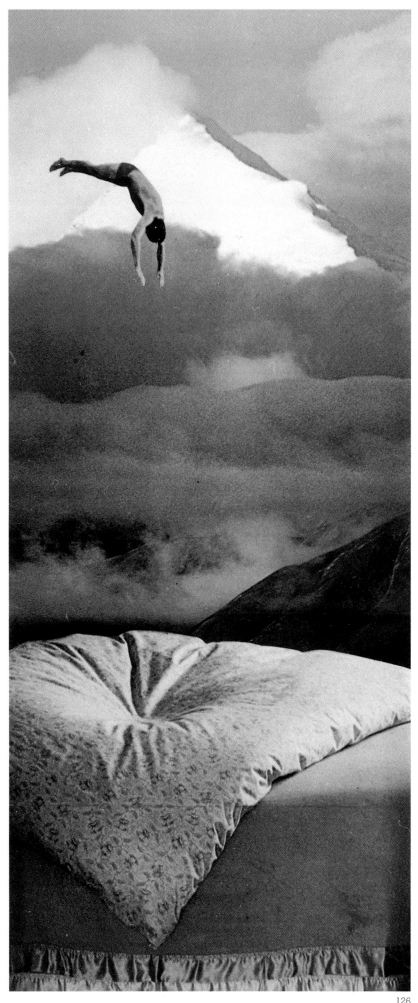

PUBLISHING

These cover designs and page layouts continue the search for the relationship between text and image with a logic that is close to Constructivist thinking. In this series of publications and exhibition catalogues typographical forms predominate, enriched with colour which becomes an element entirely apart from the composition of the page. The presentation of the themes is made with photography or with a scrap of a real document, selected rationally. Emotional elements are abandoned in favour of the logic of information and the visual structure of the page.

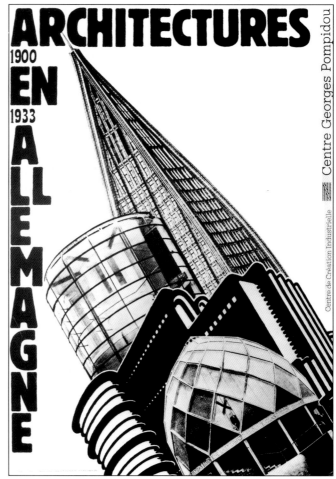

127

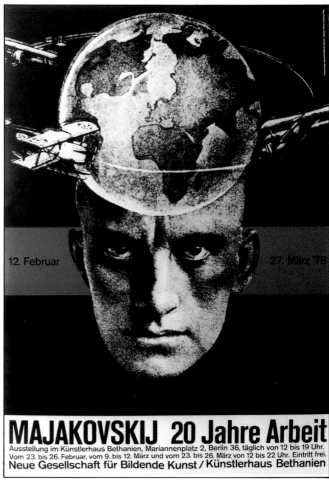

126
Sans Risques
Risking Nothing
31 x 13 cm
1977

128

127
Exhibition catalogue, 'Architectures
en Allemagne 1900–1933'
(Architecture in Germany
1900–1933)
Centre Pompidou/CCI, Paris
1979
24 x 20 cm, 92 pages
Printed poster with the same visual,
95 x 66 cm

128
Exhibition catalogue, 'Majakovskij –
20 Jahre Arbeit' (Mayakovsky – 20
Years' Work)
Photo by Alexander Rodchenko
Künstlerhaus Bethanien, Berlin
1978
Originally Centre Pompidou/CCI,
Paris
1975
30 x 21 cm, 94 pages
Printed poster with the same visual,
158 x 116 cm

129
Exhibition catalogue, 'L'Espace
Urbain en URSS 1917–1978' (Urban
Space in the USSR 1917–1978)
Centre Pompidou/CCI, Paris
1978
24 x 20 cm, 52 pages
Printed poster with the same visual,
67 x 50 cm

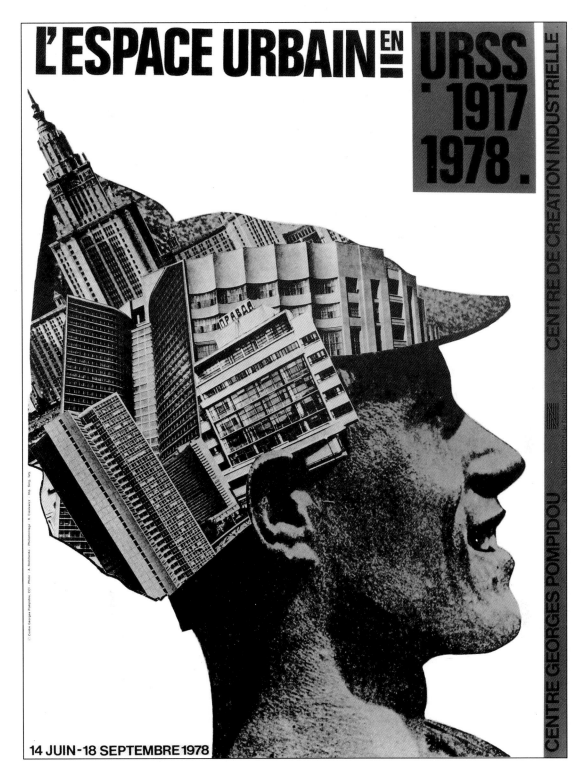

129

nouvelle série

cnacarchives

bellmer 1

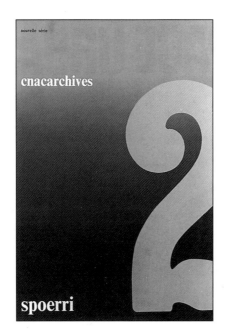

nouvelle série

cnacarchives

spoerri 2

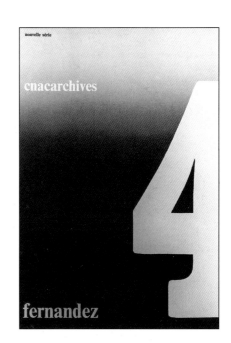

nouvelle série

cnacarchives

fernandez 4

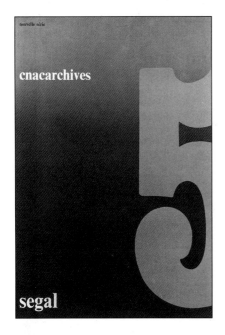

nouvelle série

cnacarchives

segal 5

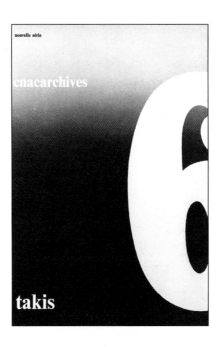

nouvelle série

cnacarchives

takis 6

nouvelle série

cnacarchives

pol bury 7

nouvelle série

cnacarchives

agam 8

nouvelle série

cnac/archives

sanejouand 9

nouvelle série

cnac/archives

réquichot 10

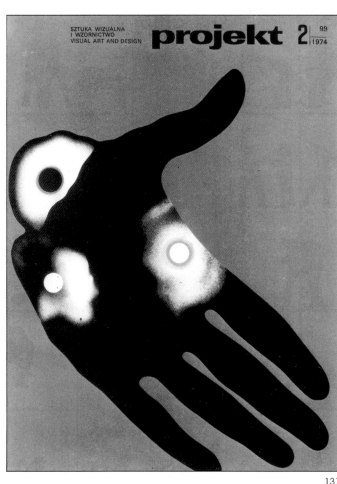

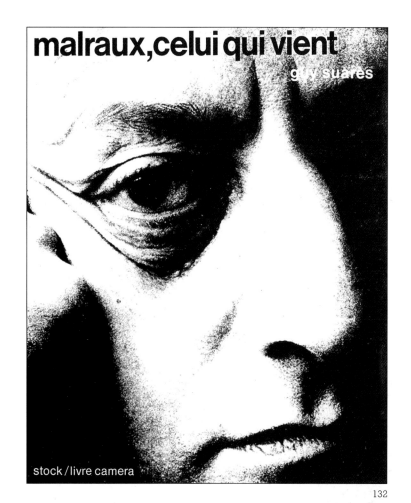

131

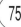

75

130
Covers for 'Cnac-archives',
monographs of the Centre National
d'Art Contemporain, under the
direction of Blaise Gautier and
conforming to the initial concept of the
Pompidou Centre.
Cieslewicz, in addition to finding the
name, also conceived the basic design
for the invitations and catalogues.
28 x 19 cm
1971

131
Cover for the Polish magazine
'Projekt' (Project)
32 x 24 cm
1974
This magazine is the equivalent of the
Swiss trade publication 'Graphis'.
The only design magazine in Poland,
it disappeared for a while, but has
been back in business since 1993.
Similar magazines of the same
period were: 'Neue Werbung' (New
Publicity) in East Germany; 'TVAR'
(Creation) in Czechoslovakia;
'Dekorativnoie Iskusstvo'
(Decorative Arts) in the USSR.

132
Cover and page layout for the book
'Malraux, celui qui vient' (Malraux,
He Who Comes) by Guy Suarès
Editions Stock/Livre Camera, Paris
32 x 30 cm
1975

133
Cover for the 'Guides bleus'
Standard cover design
Editions Hachette, Paris
18 x 12 cm
1973

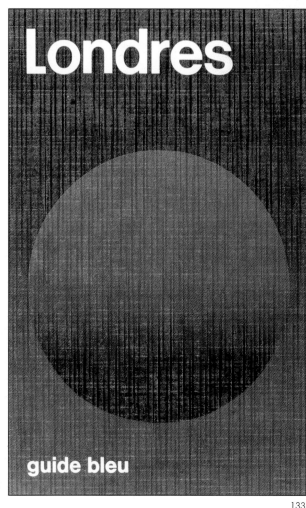

133

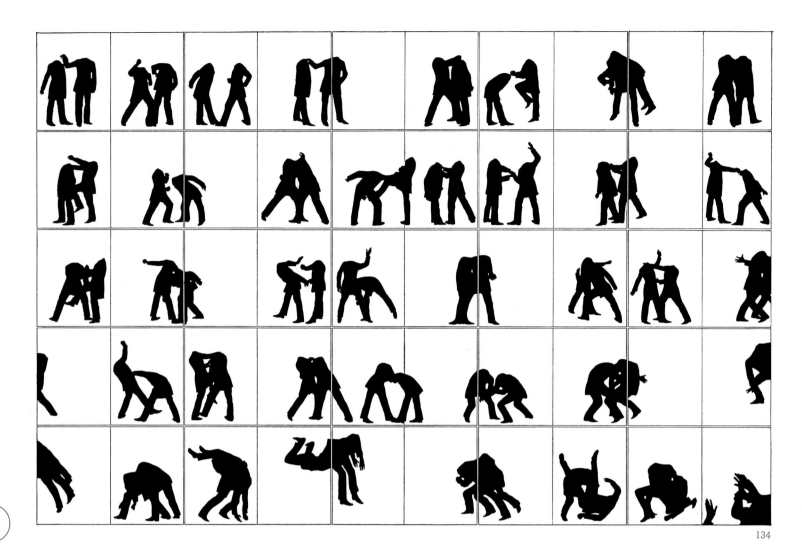

134

134
Ne (No)
A book for children
Published by GZH and Galerija SC
Zagreb, Croatia
Double page 29 x 44 cm
1974

'An important message for children
only:
Adults are so sure of being right that
they do not hear anything. However,
they talk a great deal of rubbish!
Children listen to them. And to make
their parents ashamed, they make
the two characters in this book say all
the silly things that adults say. Like a
comic strip. It is easy to make them
talk. All you need do is keep your
ears open or search your memory.
Then write it all down. Yes! On
the pages of this book! Like a real
writer ... who has become a war
correspondent, alas!'

Preface by Roland Topor
Illustrations and layout by Roman
Cieslewicz
Printed in black-and-white offset.
This is a sort of sketchbook which
leaves the child free to add his or her
own drawings and writing, to create
a sort of commentary, on the pages
of the book itself, on dialogues
between adults.

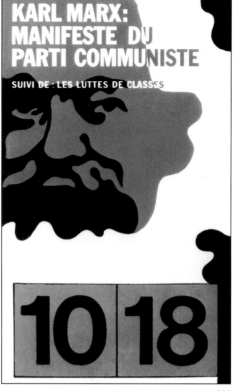

135

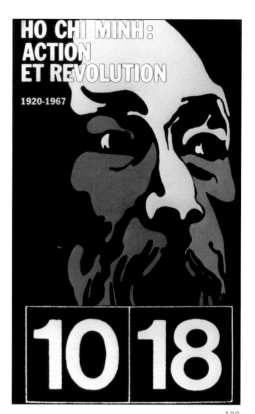

136

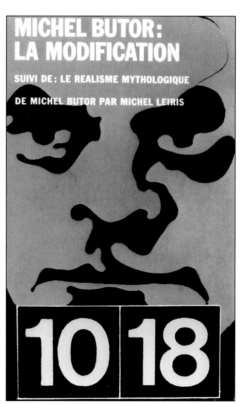

137

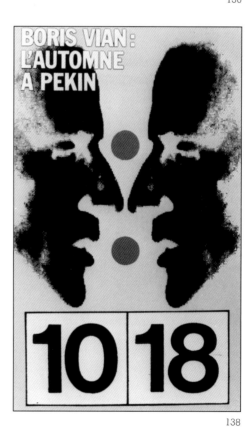

138

135–138
Covers for the paperback collection
'10/18'
Basic design for the series
Editions Christian Bourgois
18 x 10 cm
1968
These covers, very innovative in
their style of drawing and in the use
of a standard panel for the series title,
enjoyed a great success and were
much imitated from the moment they
appeared.

COLLAGES

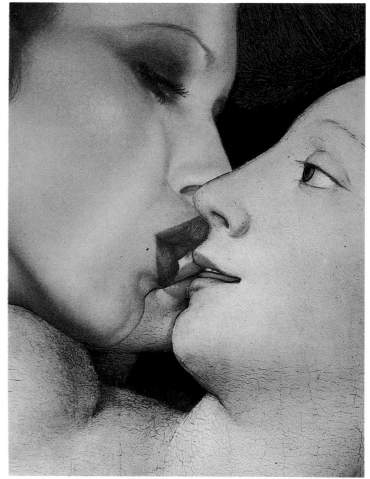

Changements de climat
Changes of Climate
1976
This series of almost two hundred photomontages, not made on commission, uses a new technique. Cieslewicz selects illustration material from various centuries, drawing new meanings from it with a strong sense of three-dimensional humour and minute observation of the environment. The titles play an important role and are inspired by the brevity of poster language. In spite of the variety of the original material, these photomontages retain a homogeneous character and a sense of very personal expression. The laws which underlie these creations seem to be imagination and association of ideas, sometimes with a certain limitation linked to mannerism and chance. Following his black-and-white period, Cieslewicz is now using very intense colours. Some of the photomontages were later used in posters announcing individual exhibitions of his works.

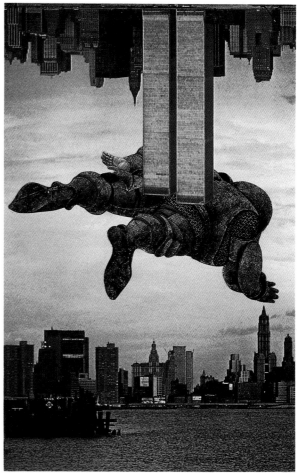

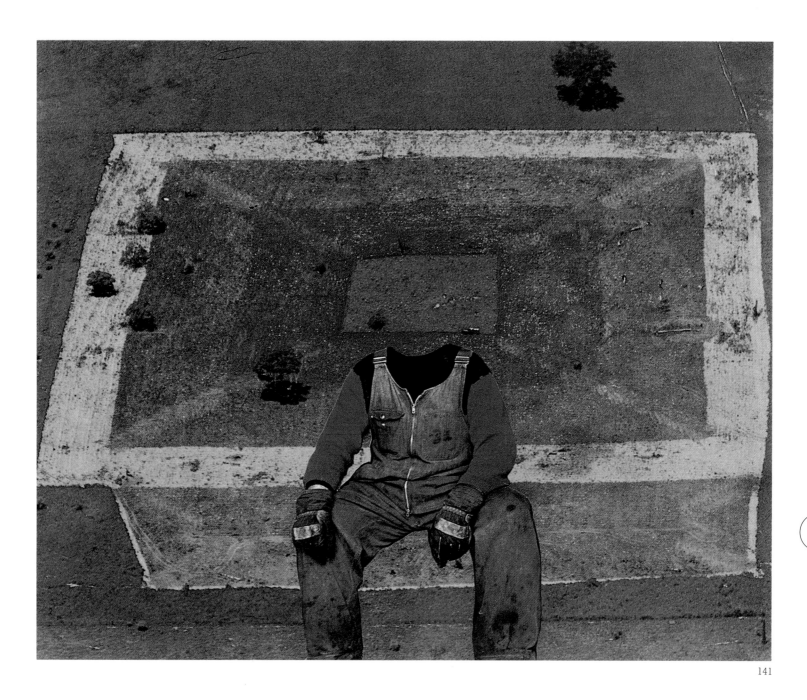

141

139
Party
40 x 30 cm
1976

140
Suspendu malgré lui
Hung Up in Spite of Himself
31 x 19 cm
1977

141
**Le Repos mérité d'un ouvrier
spécialisé**
The Well-Earned Rest of a Specialist
Worker
1976

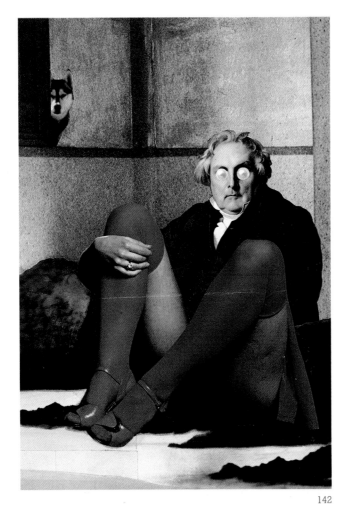

142

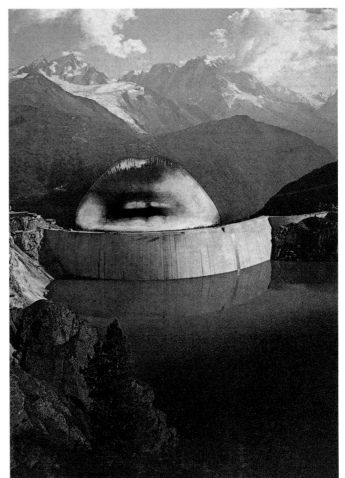

143

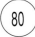

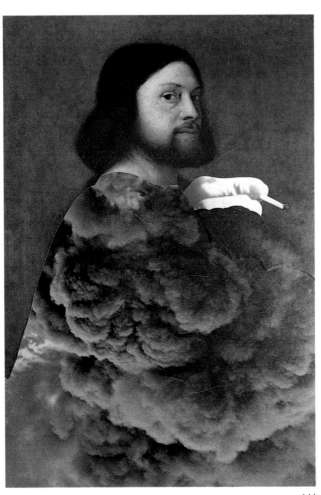

144

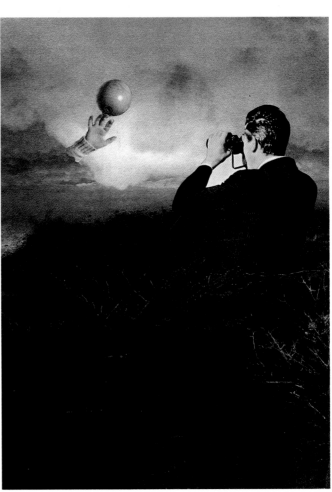

145

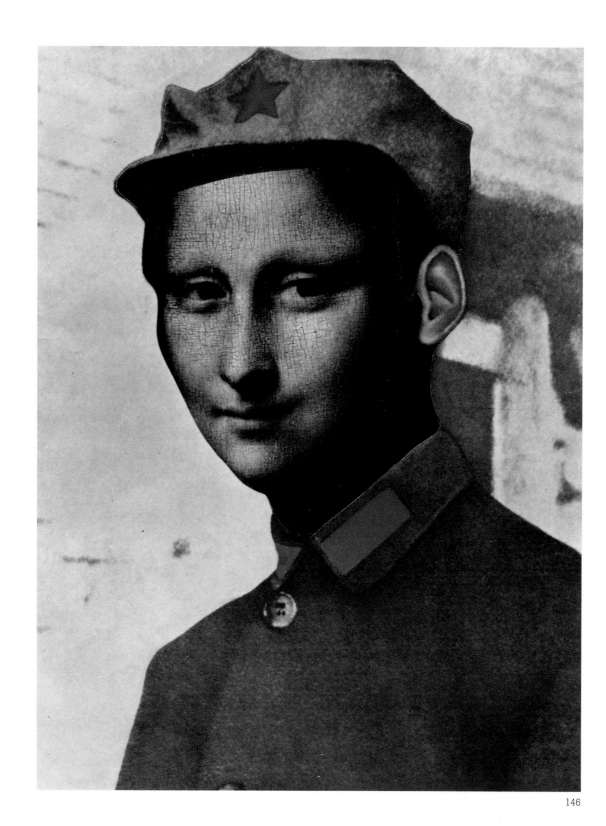

146

142
Gâteux au bas Dim
Old Dotard in Dim Stockings
31 x 22.5 cm
1976

143
Bouche délavée
Washed-out Mouth
31 x 22.5 cm
1976

144
Pyromane
Pyromaniac
31 x 19.5 cm
1976

145
Bilboquet céleste
Celestial Cup-and-Ball
31 x 21 cm
1976

146
Mona Tsé-Tung
Mona Tse Tung
55 x 40 cm
1977

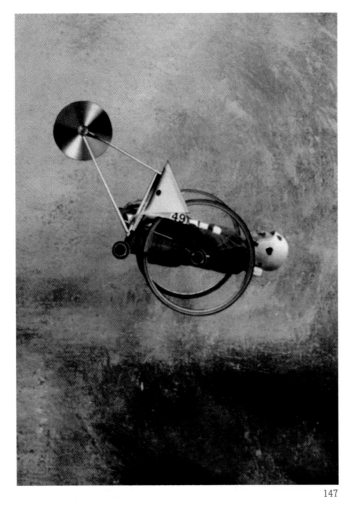

147

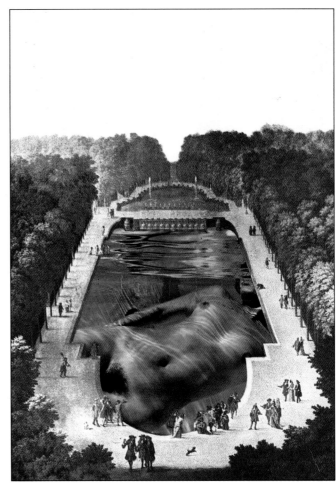

148

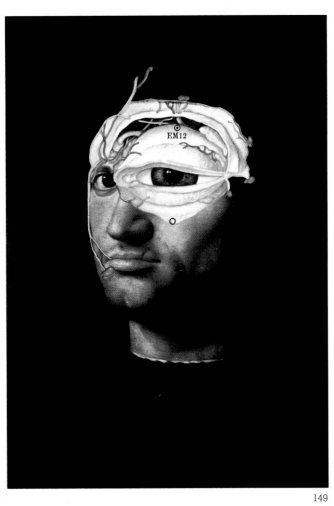

149

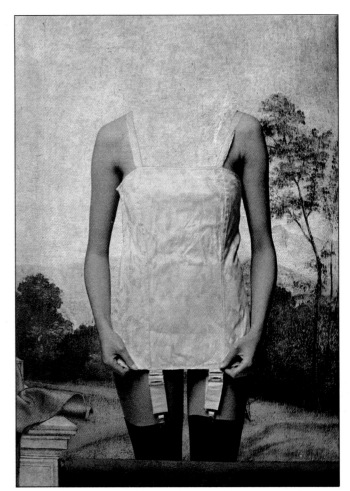

150

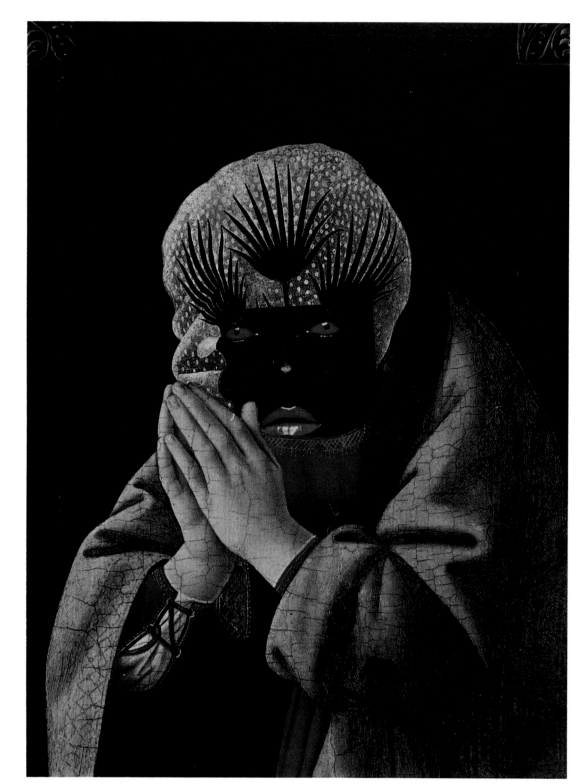

151

147
Handicapée de l'espace
Disabled Space-Woman
31 x 22 cm
1979

148
Suzanne au bain
Susanna Bathing
31 x 22.5 cm
1977

149
Saint écorché
Flayed Saint
31 x 22 cm
1979

150
Mademoiselle âge tendre
Young Miss of a Tender Age
31 x 21.5 cm
1976

151
Sainte Marie de la Peur
Saint Mary of Fear
31 x 23 cm
1977

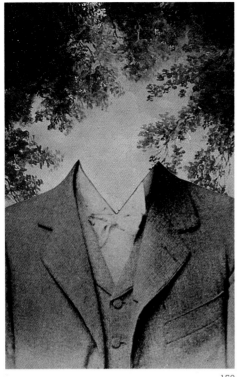

152

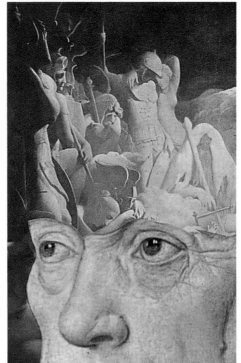

153

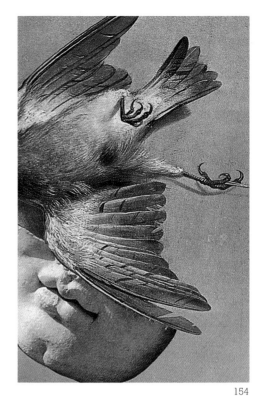

154

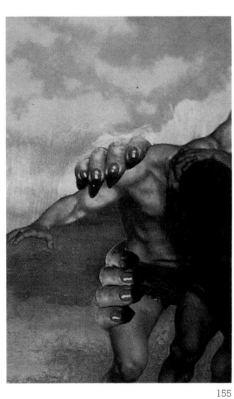

155

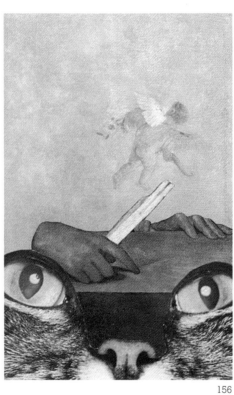

156

Tajemnice Zamku Udolfo
The Mysteries of Udolpho
Novel by Ann Radcliffe
Panstwowy Instytut Wydawniczy
(National Publishing Institute),
Warsaw
20.5 x 13 cm
1975
Cieslewicz created twenty-six
illustrations for this gothic novel of
adventure and love. They are
photomontages in colour based on
details taken from reproductions of
old paintings. This is a very personal
synthesis of the atmosphere of the
book, not a series of illustrations
reflecting motifs in the text. Although
they are ascribed to different
chapters, these 'illustrations' are in
marked contrast to the exalted
narrative style of the novel.

152
Saint Aubert
18 x 11 cm
1975

153
M. Du Pont
18 x 11 cm
1975

154
Peur d'Emilie
Emily's Fear
18 x 11 cm
1975

155
Expédition
Expedition
18 x 11 cm
1975

156
Saint Fox
18 x 11 cm
1975

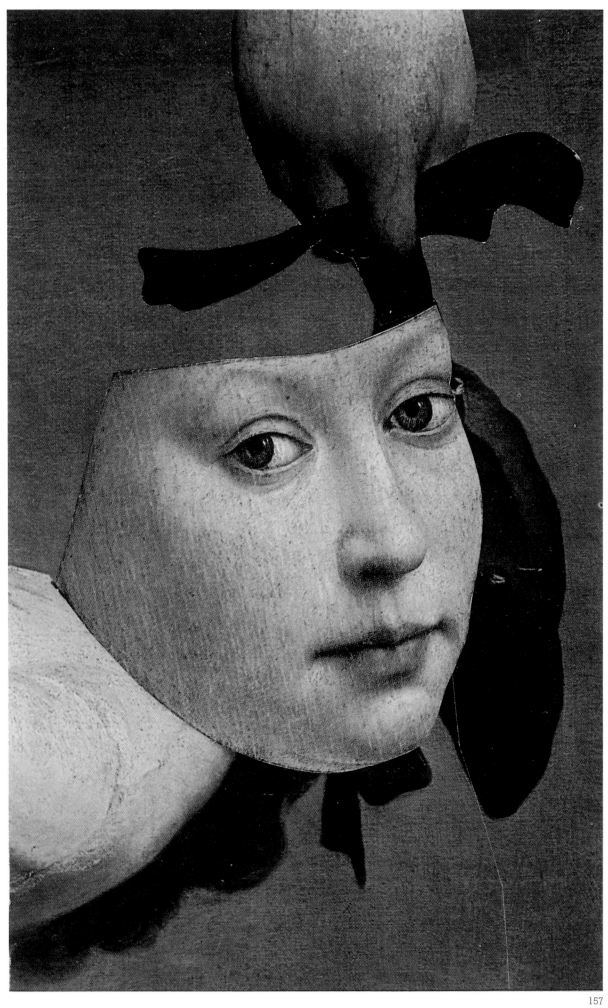

157
Lady Blanche
18 x 11 cm
1975

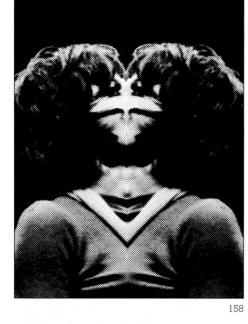

158

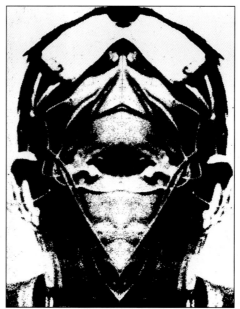

159

160

161

162

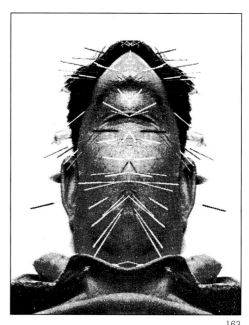

163

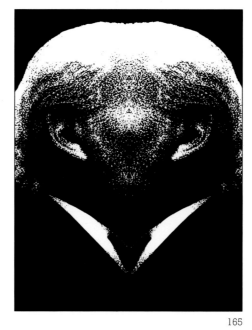

164

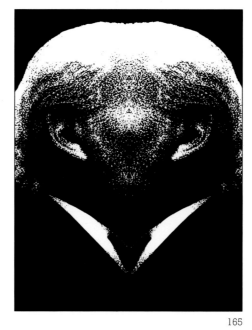

165

166

In this series of photomontages printed in silk-screen Cieslewicz deforms and discloses the features of a face to create a short-circuit. These hybrids disturb our cultural certainties, giving rise to dreams as strange as they are unreal. The originals are in a small format and were conceived spontaneously before being shown later in many art galleries. The starting-point of this investigation was a commission for a press advertisement from the MAFIA agency, for the magazine 'Zoom'. Having produced the advertisement, Cieslewicz, who liked the technique, amused himself by producing systematic series with the same materials and the same tools. After twenty images he gave up, since he was getting bored with the formula. Some years later, in 1976, in contrast to so much black and white, he created the richly coloured series 'Changements de climat' (Changes of Climate).

158
Judith
50 x 50 cm
1974

159
Skylabmann
60 x 50 cm
1977

160
Look
60 x 50 cm
1973

161
Pieds paniques NR 2
Panic Feet No. 2
60 x 50 cm
1973

162
La Panthère très noire
The Very Black Panther
64 x 50.5 cm
1974

163
Acupuncture
65 x 50 cm
1973

164
Fernando Arrabal
65 x 50 cm
1973

165
Arturo
50 x 50 cm
1971

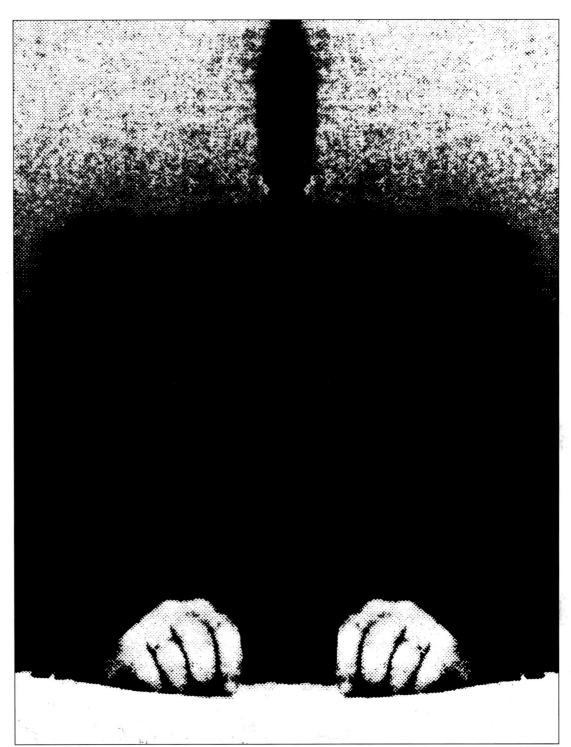

167

166
Pieds paniques (III)
Panic Feet No. 3, dedicated to
Olivier O. Olivier
50 x 65.5 cm
1974

167
Empreinte
Imprint
65 x 50.5 cm
1973
Also poster, 40 x 60 cm
1974
For the exhibition 'L'Homme et son Empreinte' (Man and His Imprint) at the Musée d'Art Moderne, Paris.

168

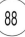

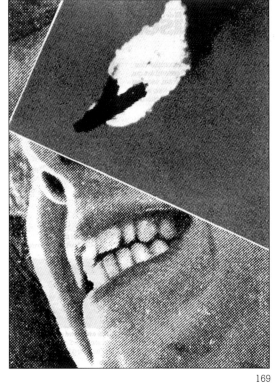

169

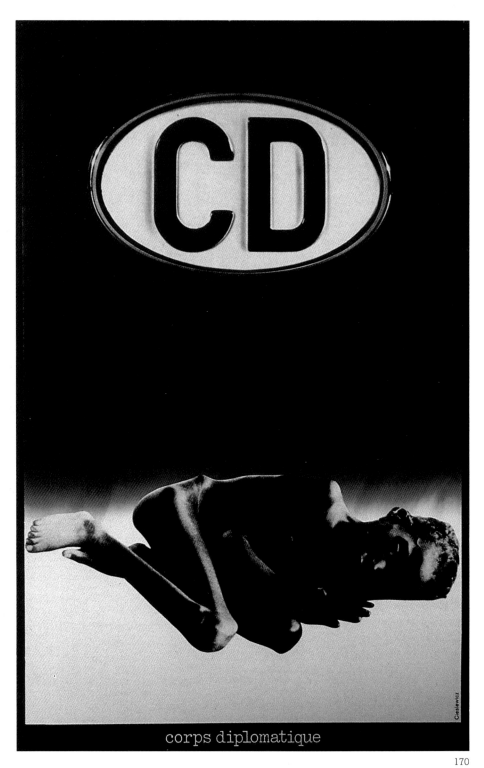

corps diplomatique

170

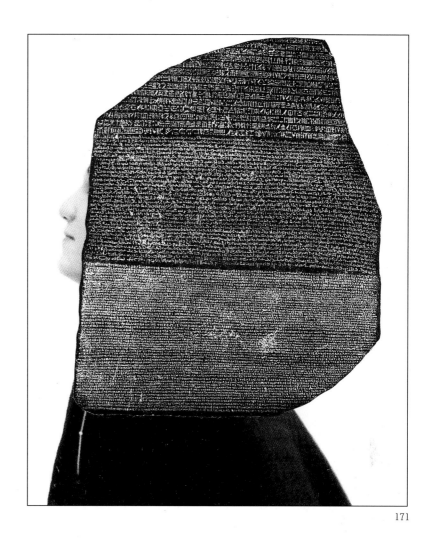

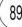

168
Cruci-Fiction
Photomontage
Black and white, 30 x 20 cm
1976

169
Soyez bien venu à bord
Welcome Aboard
Photomontage for 'Marie Claire'
32 x 24 cm
1980

170
Corps diplomatique
Diplomatic Corps[e]
28.5 x 18.5 cm
1974

171
Portrait de Carole Naggar
Portrait of Carole Naggar
Black and white, 29.7 x 21 cm
1978

172
Roland Topor/Yves Saint Roland
Black and white, 29.7 x 21 cm
1978

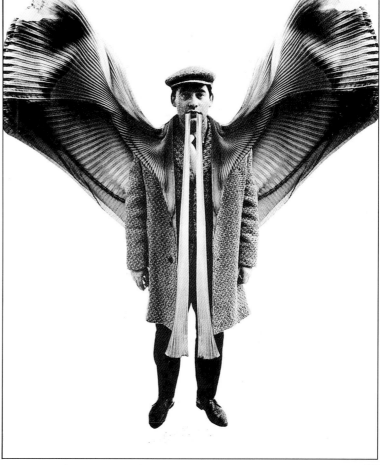

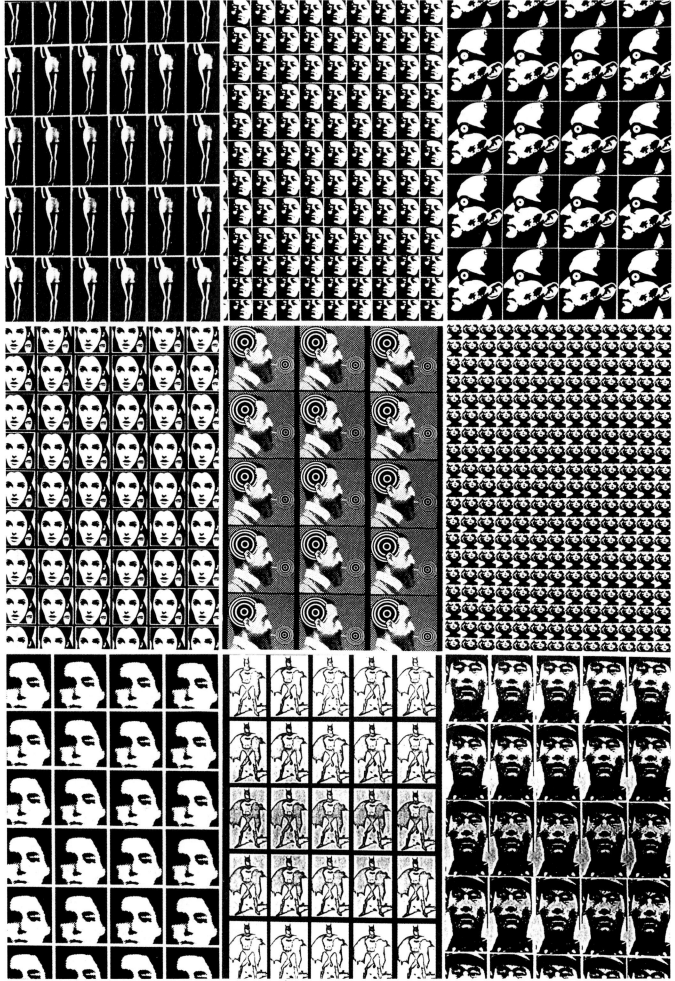

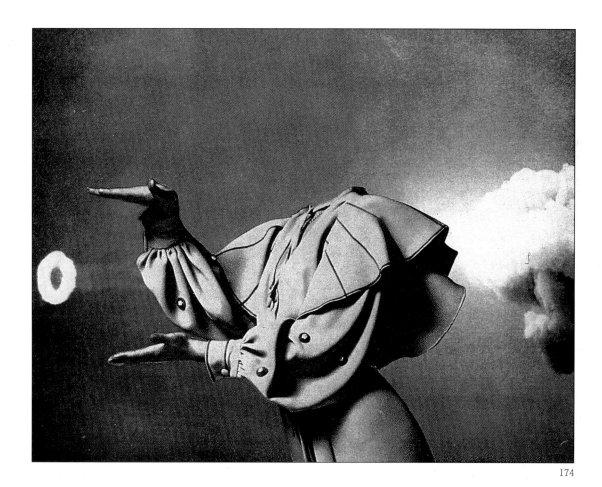

173
A group of various repetitive collages in black and white. Left to right, top to bottom:
Nu
Nude
Offset collage, 181 x 98 cm, 1971
L'Autoportrait
Self-Portrait
Photographic collage, 248 x 180 cm, 1971
Jean-Luc Godard I
Offset collage, 281 x 184 cm, 1968
Horoscope III
Photographic collage, 270 x 180 cm, 1966
Magicien
Magician
Offset collage, 240 x 180 cm, 1965
Cheryl
Photographic collage, 263 x 173 cm, 1966
Franz K. I
Offset collage, 247 x 171 cm, 1968
Batman II
Xerox collage, 265 x 180 cm, 1970
Garde rouge
Red Guard
Offset collage, 255 x 135 cm, 1970

174
Echappée belle
Narrow Escape
Offset collage, black and white, 20 x 30 cm, 1972

175
Prêt à voler
Ready to Fly
Offset collage, black and white, 1972

176
Roman Cieslewicz arrêté par la police française en 1910
Roman Cieslewicz Arrested by the French Police in 1910
Offset collage, black and white, 20 x 30 cm, 1972

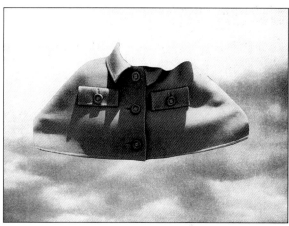

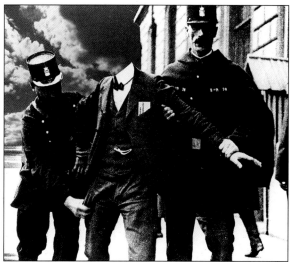

POSTERS

While continuing his work based on symmetry, Cieslewicz also created posters which recalled Constructivism, such as the famous posters for the multidisciplinary exhibitions at the Centre Pompidou, *Paris–Moscou*, *Paris–Berlin* and *Paris–Paris*. These were to influence many posters and also catalogues and invitation cards. The representational elements are eliminated in favour of the logic of typographical forms, enriched by colour which is also treated as a compositional element. The introduction of 'figures' is effected only by means of photography or by a rationally selected documentary detail (for example, the posters for the films of Raymond Depardon).

92

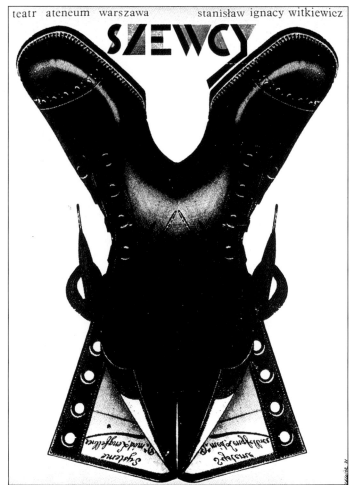

177

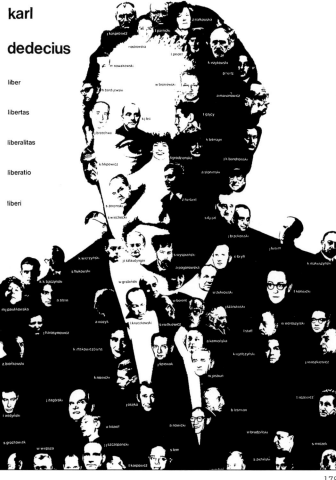

178

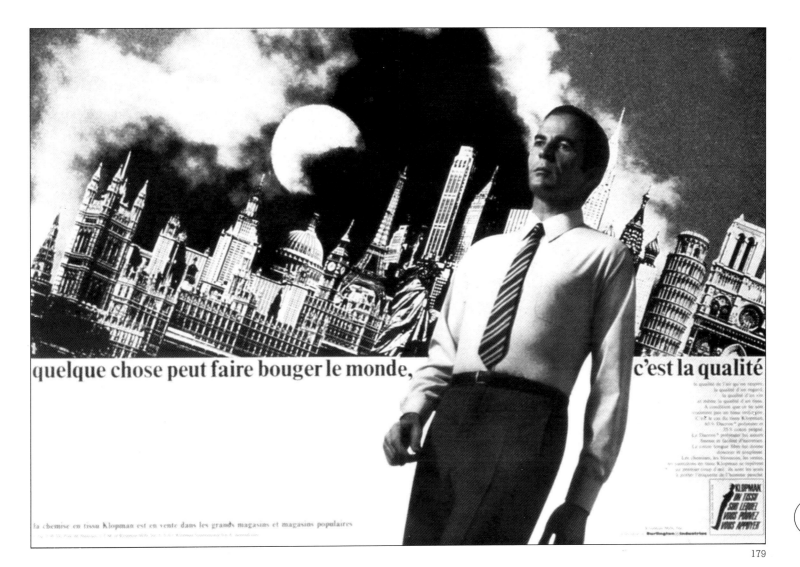

quelque chose peut faire bouger le monde, c'est la qualité

la chemise en tissu Klopman est en vente dans les grands magasins et magasins populaires

93

179

177
Szewcy
The Cobblers
Play by Stanislaw Ignacy Witkiewicz,
Teatr Ateneum, Warsaw
Offset, 80 x 58 cm
1971

178
Karl Dedecius. Liber, Libertas,
Liberalitas, Liberatio, Liberi
Offset, 59 x 42 cm
1973

179
Advertising poster for the Klopman
company, MAFIA agency. This
poster measuring 4 x 3 m was also
reduced to a smaller poster and
newspaper advertisements for men,
women and children
1971
MAFIA (Maïmé Arnodin Fayolle
International Associés), was an
advertising agency with which
Cieslewicz was art director for two
years (1970–72).

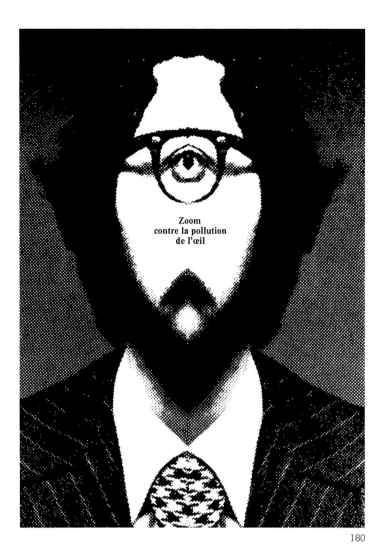

180

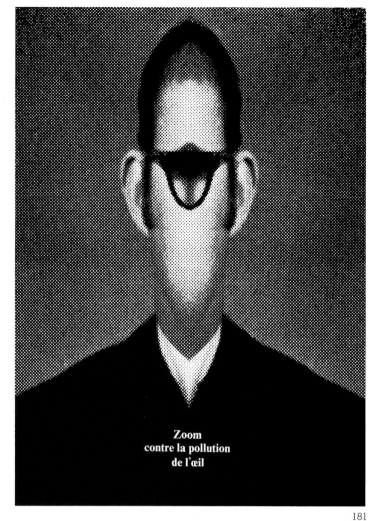

181

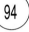

182

180
Zoom contre la pollution de l'oeil
Zoom against Eye Pollution
(Zoom II)
Silk-screen print, 101 x 71 cm
1971

181
Zoom contre la pollution de l'oeil
Zoom against Eye Pollution
(Zoom I)
Silk-screen print, 101 x 71 cm
1971
Initially intended to launch the new
style for 'Zoom', these two images
(180, 181) were printed by silk-
screen (100 copies) by Cieslewicz
at his own expense.

182
Biennale internationale d'art de Menton
Palais de l'Europe, Menton, 8 July–
17 September 1978
Offset, in versions on yellow, red,
green and blue backgrounds
102 x 77.5 cm
1978
This visual was also used on
invitation cards and paper bags.

183
L'Attentat
The French Conspiracy
Film by Yves Boisset
Offset, 157 x 115 cm and 4 x 3 m
Also 40 x 60 cm record sleeve for the
film music track
1972

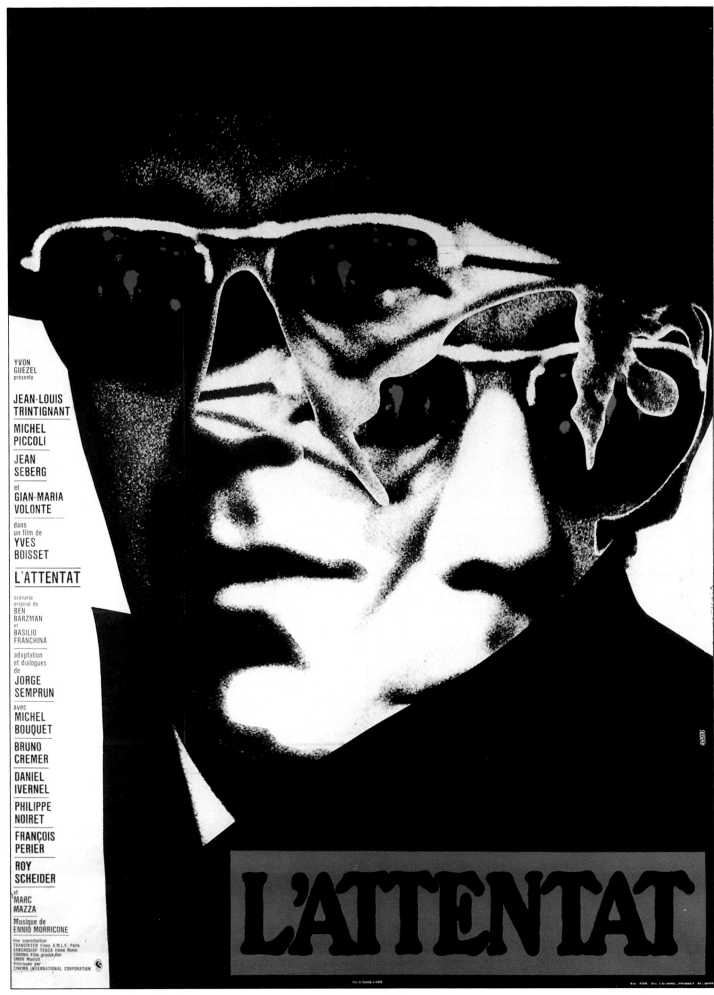

YVON
GUEZEL
présente

JEAN-LOUIS
TRINTIGNANT

MICHEL
PICCOLI

JEAN
SEBERG

et
GIAN-MARIA
VOLONTE

dans
un film de
YVES
BOISSET

L'ATTENTAT

scénario
original de
BEN
BARZMAN
et
BASILIO
FRANCHINA

adaptation
et dialogues
de
JORGE
SEMPRUN

avec
MICHEL
BOUQUET

BRUNO
CREMER

DANIEL
IVERNEL

PHILIPPE
NOIRET

FRANÇOIS
PERIER

ROY
SCHEIDER

et
MARC
MAZZA

Musique de
ENNIO MORRICONE

Une coproduction
TRANSINTER Films A.M.L.F. Paris
SANCROSIAP TERZA Films Rome
CORONA Film production
GMBH Munich
Distribuée par
CINEMA INTERNATIONAL CORPORATION

L'ATTENTAT

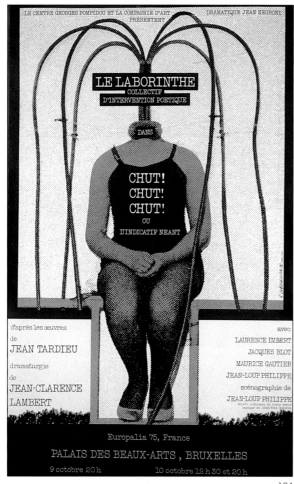

184

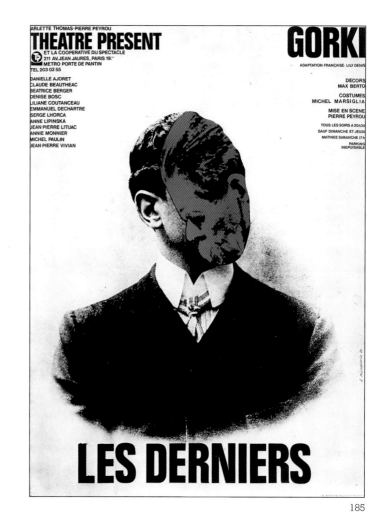

185

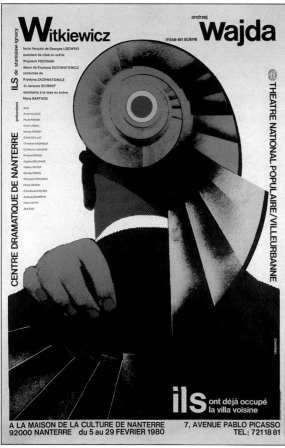

186

184
Le Laborinthe. Collectif d'intervention poétique dans Chut! Chut! Chut! ou l'indicatif néant
The Laborinth [*sic*]. Collective of Poetic Intervention in Sh! Sh! Sh! or Nothing Indicative
Play by Jean Tardieu, directed by Jean-Clarence Lambert, Palais des Beaux-Arts, Brussels
Offset, 80 x 49 cm
1975

185
Les Derniers
The Last
Play by Maxim Gorki, Théâtre Présent, La Villette, Paris
Offset, 110 x 80 cm

186
Ils ont déjà occupé la villa voisine
They Have Already Occupied the Next-Door Villa
Play by Stanislaw Ignacy Witkiewicz, directed by Andrzej Wajda, Maison de la Culture de Nanterre/Théâtre des Amandiers
Offset, 60 x 80 cm
Also cover 40 x 60 cm
1981

187
Gdy Rozum Spi
When Brains Sleep
Play by Antonio Buero Vallejo, Teatr na Woli, Warsaw
Offset, 84.5 x 59 cm
1976

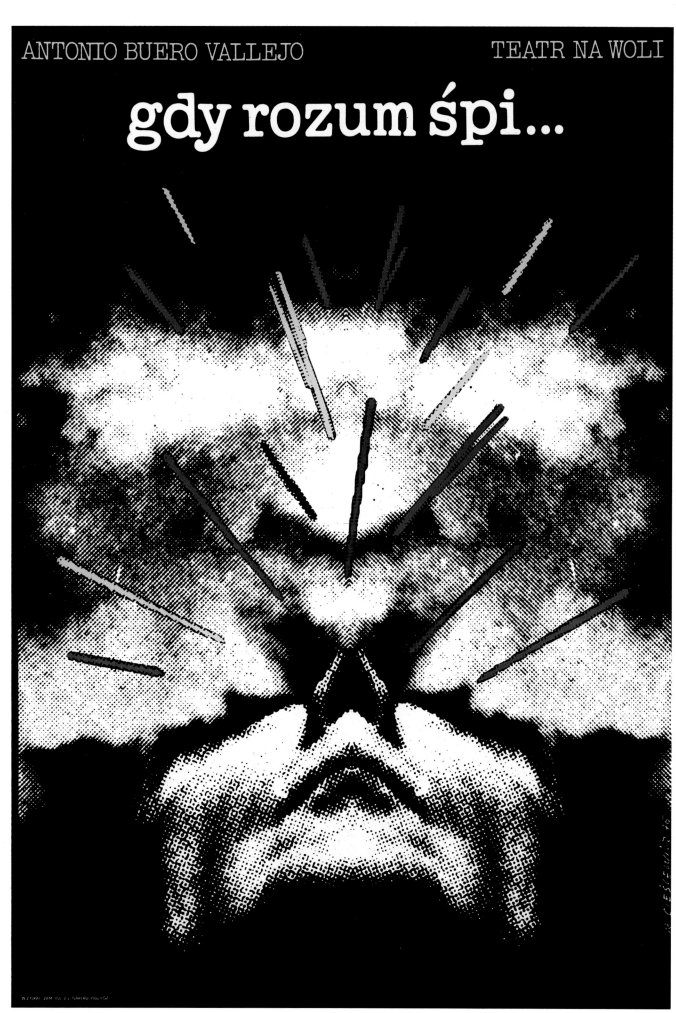

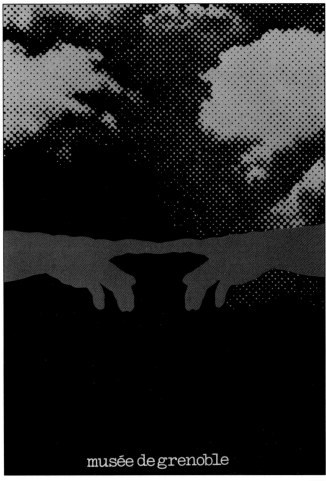

musée de grenoble

188

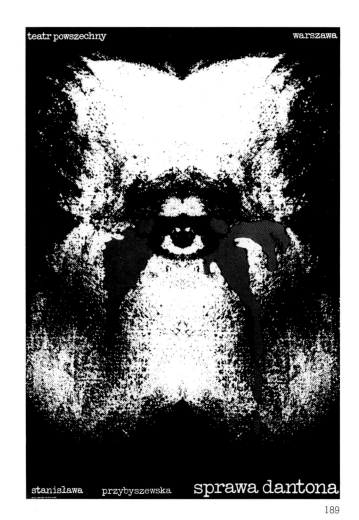

teatr powszechny warszawa

stanislawa przybyszewska sprawa dantona

189

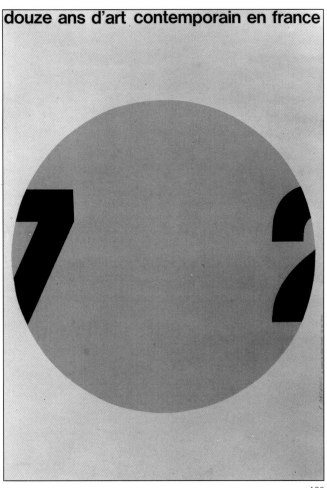

douze ans d'art contemporain en france

190

188
Musée de Grenoble
Grenoble Museum
Offset, 65 x 50 cm
1972

189
Sprawa Danton
The Danton Affair
Play by Stanislawa Przybyszewska,
Teatr Powszechny, Warsaw
Offset, 97 x 66.5 cm
1979

190
Douze ans d'art contemporain en France
Twelve Years of Contemporary Art in France
Expo 72 (commissioner François Mathey)
Exhibition at the Grand Palais, Paris
1972
Offset, 157.5 x 115 cm; also catalogue cover

191
Amnesty International
Political poster
Offset, 86 x 63 cm. French version in silk-screen
1975
Part of a commission from Amnesty International USA to 80 international poster artists.

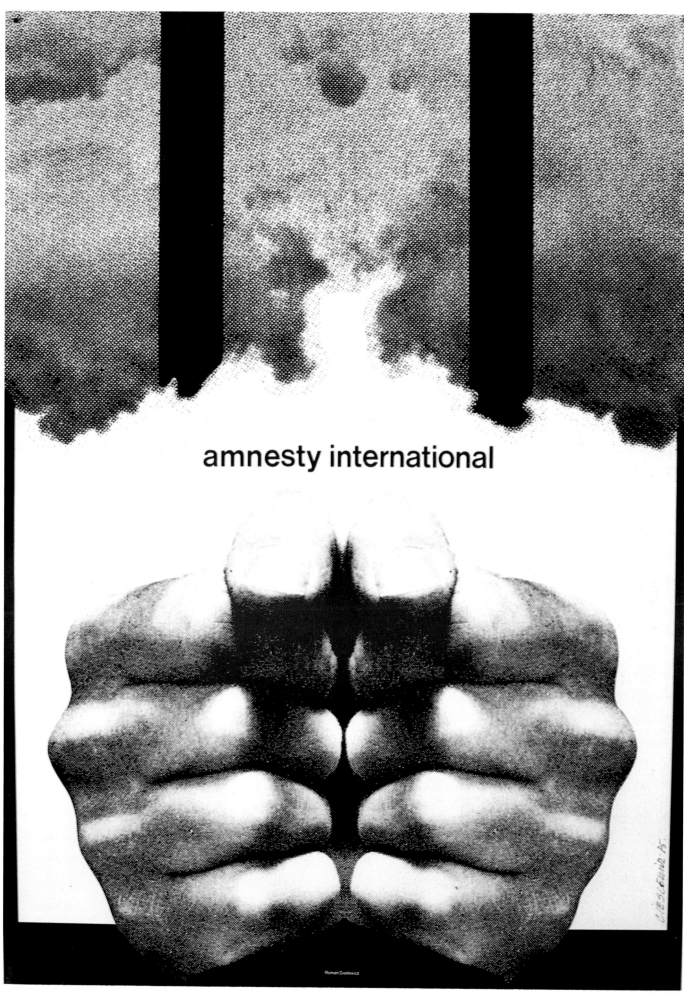

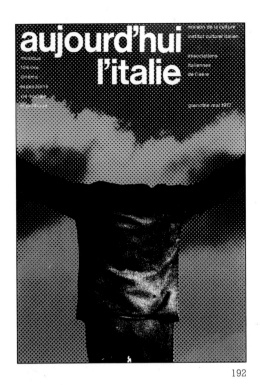

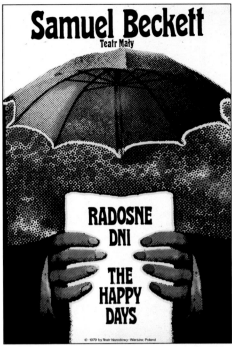

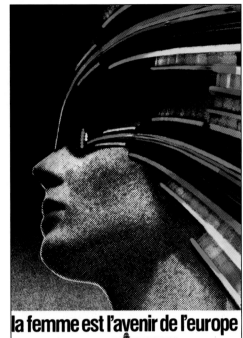

192

193

194

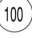

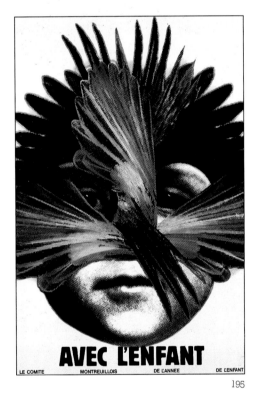

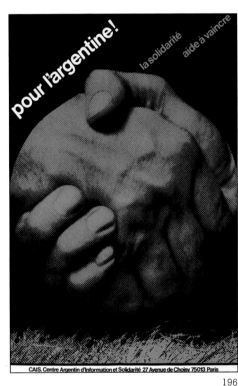

195

196

192
Aujourd'hui l'Italie
Italy Today
Poster for a festival of music, folklore,
cinema, exhibitions, social and
political life
Institut Culturel Italien, Grenoble
Silk-screen print, 160 x 120 cm
Offset, 40 x 60 cm
1977

193
Radosne Dni
The Happy Days
Play by Samuel Beckett, Teatr Maly,
Warsaw
Offset, 96 x 76.5 cm
1979

194
La Femme est l'avenir de l'Europe
Woman Is the Future of Europe
Socialist Party poster, commissioned
by Jack Lang
Offset, 90 x 65 cm
1978

195
Avec l'enfant
With the Child
Poster for Montreuil town council
Offset, 116 x 75 cm
1979

196
**Pour l'Argentine! La Solidarité aide
à vaincre**
For Argentina! Solidarity Helps to
Conquer
Political poster for the CAIS
(Argentine Centre for Information
and Solidarity)
Offset, 92 x 64 cm
1977

197
J.M.K. Wscieklica
H.M. the Shrew
Play by Stanislaw Ignacy Witkiewicz,
Teatr Maly, Warsaw
Offset, 95 x 66 cm
1979

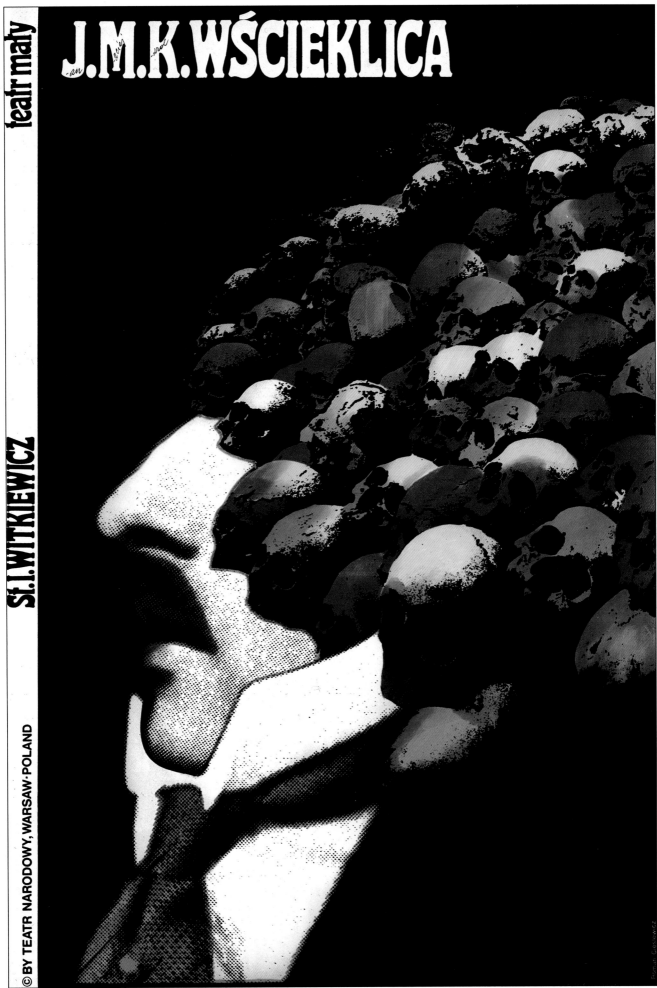

J.M.K. WŚCIEKLICA

teatr mały

St.I.WITKIEWICZ

© BY TEATR NARODOWY, WARSAW·POLAND

101

197

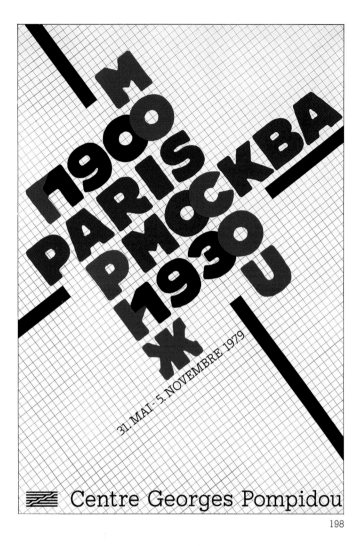

198

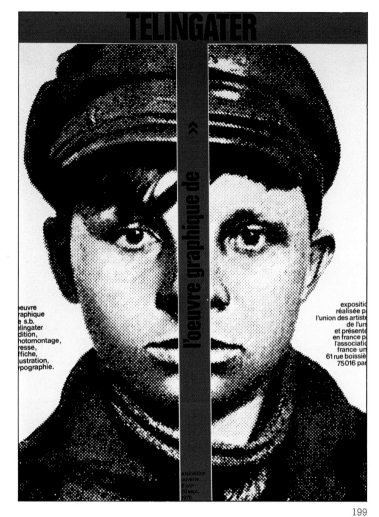

199

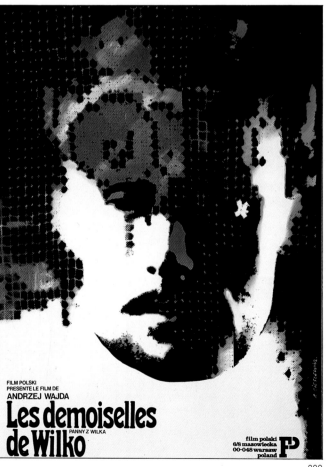

200

198
Paris–Moscou Paris–Moskva
1900–1930
Paris–Moscow
Multidisciplinary exhibition at the
Centre Pompidou, Paris
Offset, 140.5 x 100 cm
1979
This visual was also used on the
catalogue cover, T-shirts, etc.

199
L'Oeuvre graphique de Telingater
The Graphic Work of Telingater
Exhibition organized by the
association Amitié Franco-Soviétique
(Franco-Soviet Friendship)
Offset, 60 x 40 cm
1979

200
Panny z Wilka
Les Demoiselles de Wilko
The Girls from Wilko
Polish film directed by Andrzej
Wajda from a novel by Jaroslaw
Iwaszkiewicz
Offset, 94 x 67 cm
1979

201
Paris–Berlin 1900–1933
Rapports et Contrastes
France–Allemagne
Franco-German Links and Contrasts
Multidisciplinary exhibition, Centre
Pompidou, Paris
1978
Offset, 150 x 100 cm, 40 x 60 cm and
50 x 70 cm
Also silk-screen print (100 copies)
As with 'Paris–Moscou', this visual
was also used on all material aimed
at the public. Cieslewicz also
designed the layout for the catalogue
and the 'Petit Journal'.

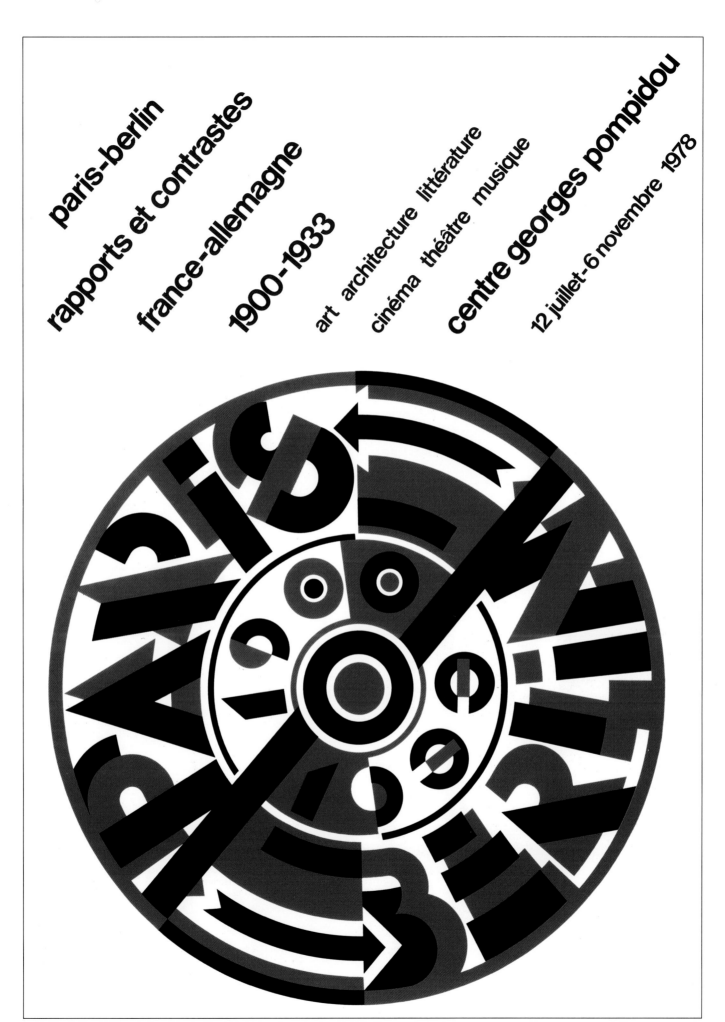

paris-berlin
rapports et contrastes
france-allemagne
1900-1933
art architecture littérature
cinéma théâtre musique
centre georges pompidou
12 juillet-6 novembre 1978

PARALLEL EXPERIMENTS

A 'review of panic information', No. 1, published by Christian Bourgois. For the first time Cieslewicz is using photography without reworking it. The reader is challenged by an assortment of news items uncompromisingly juxtaposed in succession or confrontation, leaving no room for comfort or complacency. Black and white, in a landscape format of 32 x 50 cm, these 32 pages call into question the events of the moment.

A series of twenty photomontages measuring 150 x 50 cm, 1986. Each brings together two or three press photographs placed side by side, punctuated by a few red dashes and a 'ready-made' phrase which accentuates the friction caused by these arbitrary categorizations: Hunting Scene; On the Same Wavelength; Your Money Interests Me; Pay Cash, etc. – the language is as forceful as the images. All the world's violence and humour flash through, and the ironical titles are important.

'I used newspaper photographs livened up in this way to stimulate the imagination of the viewer to a consciousness of a new and different set of rules for looking at the world.... I want to animate literature, so thrilling in its boundlessness, as self-defence against routine.' – Roman Cieslewicz, 1972, in the review *Contrejour*, no. 13.

Cieslewicz wanted to bring the 1976 review *Kamikaze* (No. 1) up to date. The news in 1989 provided rich material (the Berlin Wall, antisemitism, Gorbachev, for instance, were journalistic and political matters overflowing with images). At the same time, Agnès B., director of the Galerie du Jour, in line with her policy of giving commissions to artists, offered him 'freedom and total creativity'. *Kamikaze 2* appeared at the same time as the resulting exhibition in 1991.

1976
KAMIKAZE 1

1986
PAS DE NOUVELLES – BONNES NOUVELLES

KAMIKAZE 2
1991

numero 1
et unique

KAMIKAZE

juin, 1976
prix 50 F

revue d'information panique

réalisation: ROMAN CIESLEWICZ CHRISTIAN BOURGOIS éditeur

202

202
Cover of the first and only number
of the original 'Kamikaze', a 'review
of panic information', published by
Christian Bourgois
Double page 32 x 50 cm
1976

bruit

passage de la conférence prononcée par Arrabal à Tokyo le 30 Novembre 1974

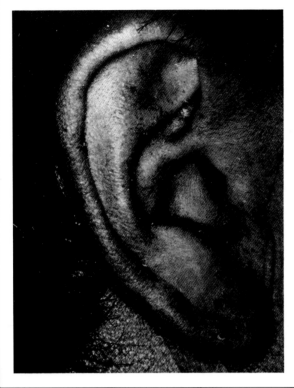

Il y a un mois
Topor,
le physicien Lopez Campillo
et moi,
nous avons constaté :

a) que la Panique avait joué
un rôle insoupçonné
de ses créateurs
les oeuvres d'art paniques
(et les études
qui leur furent consacrées)
ont été conçues
sans que quiconque
à aucun moment
se soit senti astreint
à une ligne dogmatique
b) que la Panique,
avec sa théorie
de la confusion,
sa revalorisation
de la mémoire,
la pluralité
de ses centres d'intérêt
et son fanatisme
de la tolérance
avait été le plus fidèle
miroir
de la société d'abondance
qui s'est achevée en 1974.
c) que le moment était venu
de tracer le nouveau schéma
de la société d'aujourd'hui.

Voici le fruit
de mes premières réflexions
quant au nouvel art
de voir et de sentir :
- les choses sont ...
et se dégradent
- Il n'y a donc pas
d'éternel retour
- Le désordre croissant
est provoqué par le bruit
- Le bruit est l'ensemble
des perturbations permanentes
impossibles à éliminer
Il y a un mystère apparent
lorsque l'on constate que :
- Le non-bruit
serait la non-vie,
- le bruit c'est la vie,
- la vie c'est l'information,
- mais le bruit cependant
lutte contre l'information.

$I \rightleftharpoons N$

(Dans Cybernétique et Société
Wiener nous montre
les mécanismes
de l'auto-régulation
- le principe de rétroaction -
et signale que l'information,
pour parvenir à en de bonnes
conditions,
a besoin d'une énergie).

Il serait impossible
d'étudier
les mécanismes
de l'information
sans s'appuyer
sur la notion d'entropie :
- Le bruit
est un phénomène aléatoire,
dû au hasard
- Le bruit est parallèlement
une énergie qui s'élimine
- Le bruit est donc
le facteur essentiel
du désordre croissant
- Le bruit produit l'entropie
(L'entropie
n'est que la tendance
du monde à l'égalisation
La nature dégrade les choses,
les nie, les pulvérise,
les égalise.
La vie tente
de vaincre ce courant).

Le bruit ne peut
être planifié.
Il est normal

que toute planification
soit erronée.
Un plan réalisé à 100 %
est un échec :
on ne peut prévoir
les perturbations
occasionnées par le bruit.
Le récepteur le plus apte
à composer avec le bruit
c'est l'homme,
l'homme non manipulé
l'homme non tenu
à une seule information.
l'homme a l'avantage
sur l'ordinateur
le plus perfectionné
de pouvoir
"piloter à vue",
d'appréhender
par intuition
le sens ou l'origine
du bruit imprévu
et de flotter sur lui,
(La théorie sur
les mécanismes du cerveau
fondée sur les connaissances
d'électronique
et sur
la théorie de l'information
- telle que par exemple
la décrit Ashby
dans Desing for a brain -
confirme ce point).

Le mystère du bruit
nous permet de saisir
la misère de la science,
le côté fort limité
des "connaissances"
scientifiques.
L'épistémologie,
dans sa réflexion
sur la science
ne peut démontrer
qu'une seule chose,
que la science
n'explique rien,
que jamais la science
ne peut donner
une explication absolue,
donc l'expression
"vérité scientifique"
est une contre-vérité
par laquelle
l'homme de science
voudrait cacher sa nudité
par la terreur.
(Popper dans sa
Logique
de la découverte scientifique
affirme que,
pour qu'une théorie
soit utile à la science
il faut
qu'elle soit "falsifiable")
La science est incapable
de se mouvoir en un monde
où l'entropie
n'est pas un phénomène
secondaire mais essentiel.

Le théâtre japonais
traditionnel
le kabuki,
est un théâtre de simulation
et non de représentation
à $(N_0 \times T) : \beta$
(Face à la science brutale
existe l'art de composer
avec l'entropie)

Dans une pièce kabuki,
le cheval est un faux cheval,
l'arbre est artificiel
(ce cheval et cet arbre
étant reproduits
avec une minutie
d'un réalisme hallucinant),
puisque ce théâtre
supprime les caractéristiques
les plus spectaculaires
de l'entropie
(un cheval pourrait
se livrer

à des manèges imprévus
ce qui distrairait
l'attention du spectateur)
pour lui garder
sa valeur la plus subtile.

La détérioration croissante
dans l'univers
suscite un sentiment
de nostalgie mélodramatique
qui jusqu'à présent
a poussé les hommes
(l'expérience
en apportant des preuves)
à souhaiter leur mort
et enfin à mourir un jour,
L'entropie
et même la mégentropie
s'éclairent plus aisément
au fond de nos sentiments
que dans les éprouvettes
des laboratoires.

L'art est le seul moyen
d'approcher les lois
de l'entropie,
sous une forme allégorique,
l'art dévoile l'entropie
avec
une précision fantastique
(une réflexion parallèle
à conduit Herbert Read
à déclarer
dans La rédemption du robot
que l'art seul
peut sauver l'homme
de son destin de robot).

L'artiste ne voit pas
de progrès linéaire
mais saisissant l'entropie
et ses ravages,
ferment sa sensibilité
à ses fascinations passives,
l'artiste est le seul
à disposer
d'une énergie source
d'information.

Poète signifie
celui qui dispose
de l'énergie créatrice.

Arrabal
Tokyo 30 Novembre 1974.

portrait d'Arrabal
par Roman Cieslewicz
1974

Inside page, 'Bruit' (Noise)

famille

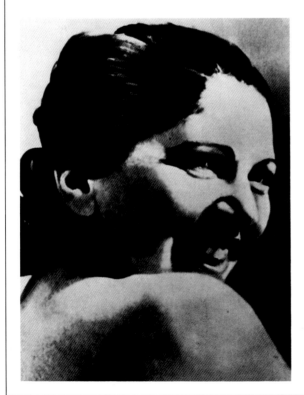

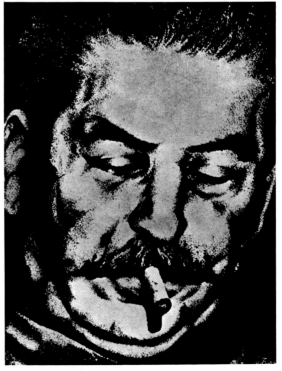

Inside double-page spread, 'Famille' (Family): Ludmila and Joseph Stalin

conditionnement

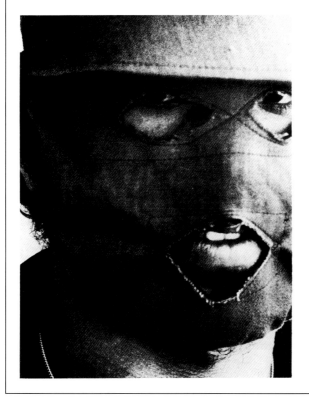
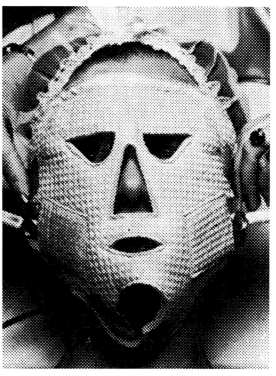

Inside double-page spread, 'Conditionnement' (Conditioning): mask of IRA terrorist and cosmetic face mask

noir et blanc

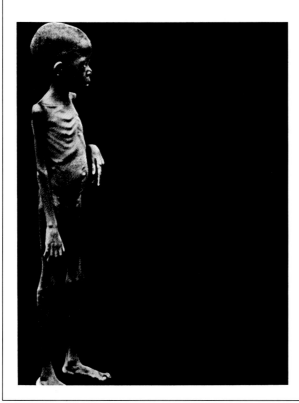
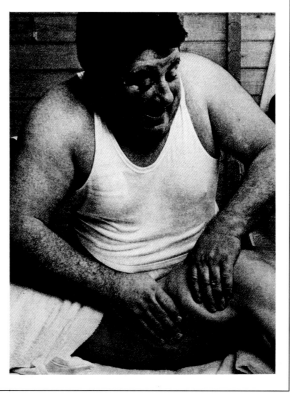

Inside double-page spread, 'Noir et blanc' (Black and White): famine in the South, obesity in the North

PAS DE NOUVELLES -
BONNES NOUVELLES

'The violence of the media image bursting in on us is something we thought we knew and had examined from all sides and said all there was to be said about it. No, what comes through the media is also the immediate, every morning, along with the coffee, like the coffee, and again every evening. Press, television, agencies, scoops, a modern taste. What is this taste? Roman Cieslewicz replies in black and white with collages which are also the quintessence of his graphic art. A stern response without affectation or pathos, which neither accuses nor "witnesses" but shows the world that hides behind the images of the world. It is enough to juxtapose two or three of them, then to draw one or more little red dashes on the collage, a discreet signature and a minimalist act of suppression.... No manipulation, but enlargement. No variations, but a horizontal continuum. No tricks, but speed. For in order to respond to the machine you must go faster than it does, and what then follows is not a dialogue but, rightly, a race. The object of the race is that the eye shall win, that some sense shall be extracted from a monotonous grey mass. The twitch of a face in authority, a grimace, an explosion, a mask, a death, everything passes, everything splatters, but you can wipe it off. Here, though, the splashes stain and won't be wiped away. What you see is not meant to please, nor to pass, but to stick.... Cieslewicz's action is not aimed against photographers or film-makers but, on the contrary, is for them and for their images, which he picks out for what they have to say. It is political work, philosophical work; it is what Cieslewicz himself calls "the tidying up of vision". And nothing so precise, so rooted in its time, has been seen since the twenties. This means in addition a mastery of memory, a straight thread stretching back to the beginning by which modernity holds itself in place. It is the age of "the look", so go on and look. Roman says this from the depths of the accident which almost cut him in half and over which he has achieved this conscious, magnificent leap, bringing him back to himself and to us. The disabled man grasps a pair of scissors and cuts into the flesh of sense so that there shall still, and always, and above all, be eyes.'
Jean-Christophe Bailly

Article in the catalogue of the exhibition at the Nouveau Théâtre (photomontages) and the Galerie de Prêt (collages), Angers
6 May–6 June 1987

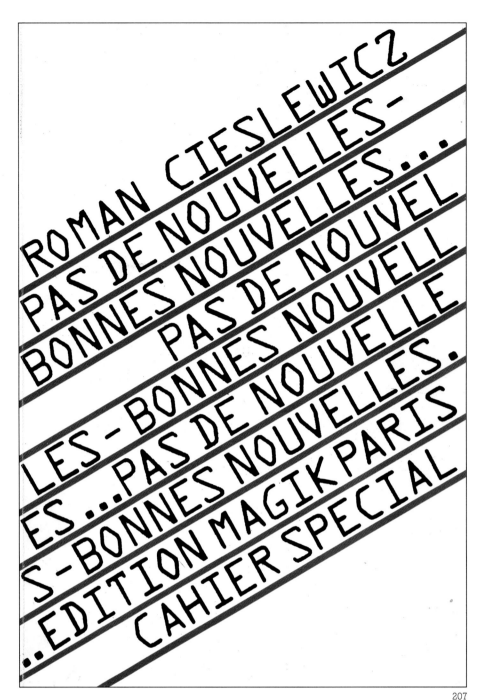

207

207
Cover for 'Pas de nouvelles – Bonnes nouvelles' (No News is Good News) Special notebook and exhibition catalogue at the Jean Briance Gallery Edition Magik, Paris
In two colours: black and red, 30 x 21 cm
1986

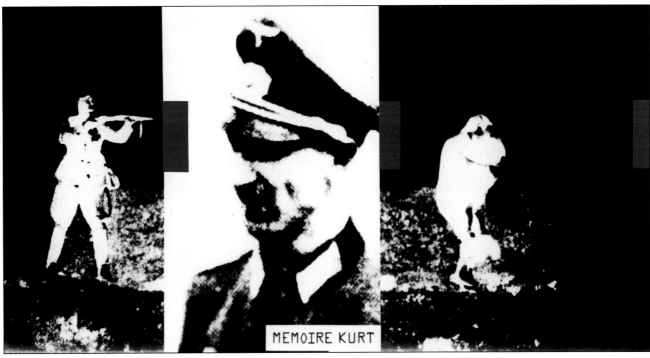

Mémoire Kurt (Short Memory, a pun referring to Kurt Waldheim)

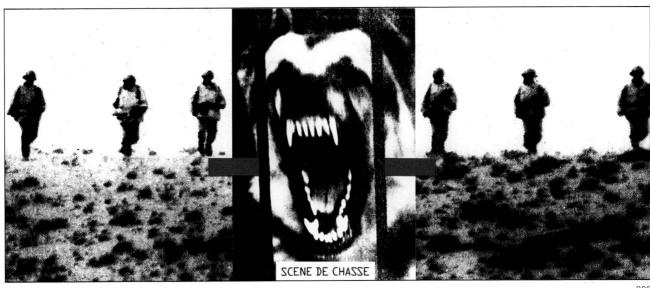

Scène de chasse (Hunting Scene)

Rien n'a changé depuis son départ (Nothing Has Changed Since He Left)

A table! (Dinner's Ready!)

211

Médecin sans frontières (Doctor without Frontiers)

212

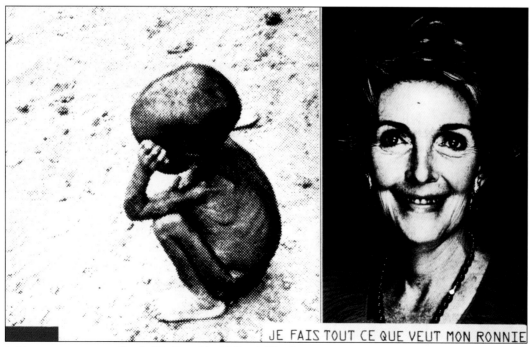

Je fais tout ce que veut mon Ronnie (I Do Everything My Ronnie Wants)

213

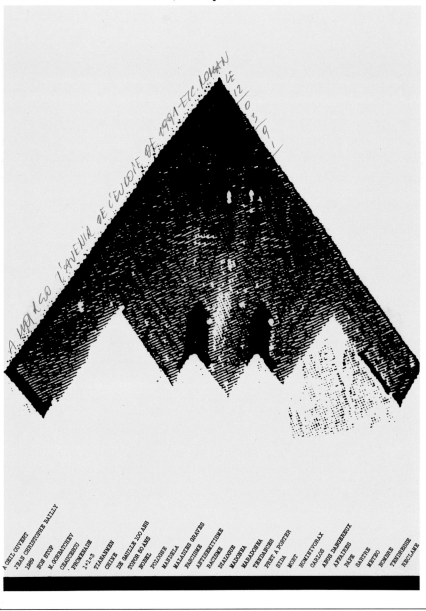

214

214
Cover of 'Kamikaze 2', a 'review of
panic information by Roman
Cieslewicz'
Published by Agnès B., Galerie du
Jour, Paris
32 pages, double page 32 x 50 cm
Exhibition panels 120 x 200 cm
1991

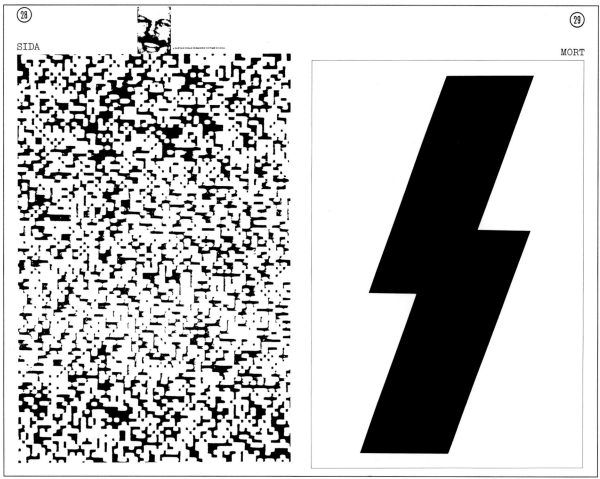

Double page: 'SIDA' (AIDS) and 'Mort' (Death)

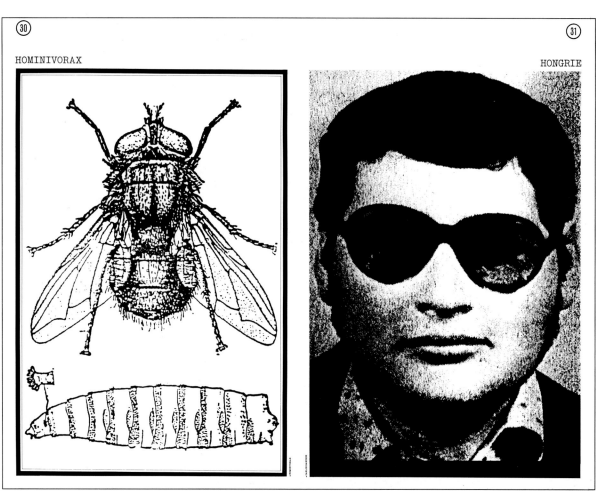

Double page: 'Hominivorax' (Man-Eater) and 'Hongrie' (Hungary – Carlos Found in Hungary in 1989)

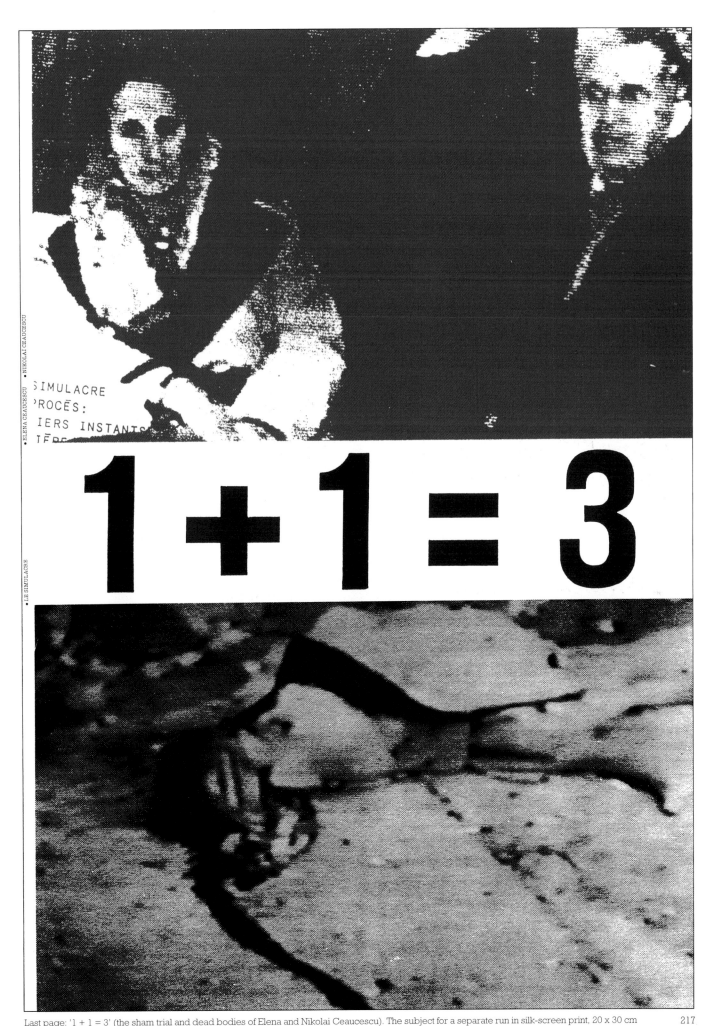

Last page: '1 + 1 = 3' (the sham trial and dead bodies of Elena and Nikolai Ceaucescu). The subject for a separate run in silk-screen print, 20 x 30 cm

1980

In his usual way, Cieslewicz succeeds in capturing the atmosphere of the moment and the importance of current ideas. He observes and absorbs them, then provides us with his personal visual version of them. Commissions for posters are growing fewer in France as elsewhere, but Cieslewicz continues to produce them. His touch is strong and original, sparing of graphic means. The collages are still very numerous: book illustrations or 'tidying-up work' exhibited in a number of galleries. They are simplified, less anecdotal and as disturbing as ever. He is more and more drawn to political criticism, which he illustrates in a clear-cut way without digression or compromise. He wants to *say* things, not to 'communicate' (that buzz-word of the nineties), and he does say them, enunciating his words, condensing all the signs, eliminating the superfluous, framing ever more tightly in order to make us share his ideas. His work on the newspaper *Libération* perfectly reflects this tendency. He likes the swiftness of conception and the ephemeral side of newspapers. Always ready to listen to different generations of graphic artists, he continues his teaching work at the Ecole Supérieure d'Arts Graphiques with passionate commitment. Still and always surprising, this craftsman of images goes on taking risks and facing up to them. The declining number of commissions does not keep him from providing us with an uninterrupted succession of images still in course of creation.

PUBLISHING

PRESS

SETS

COLLAGES

SILK-SCREENS

POSTERS

1993

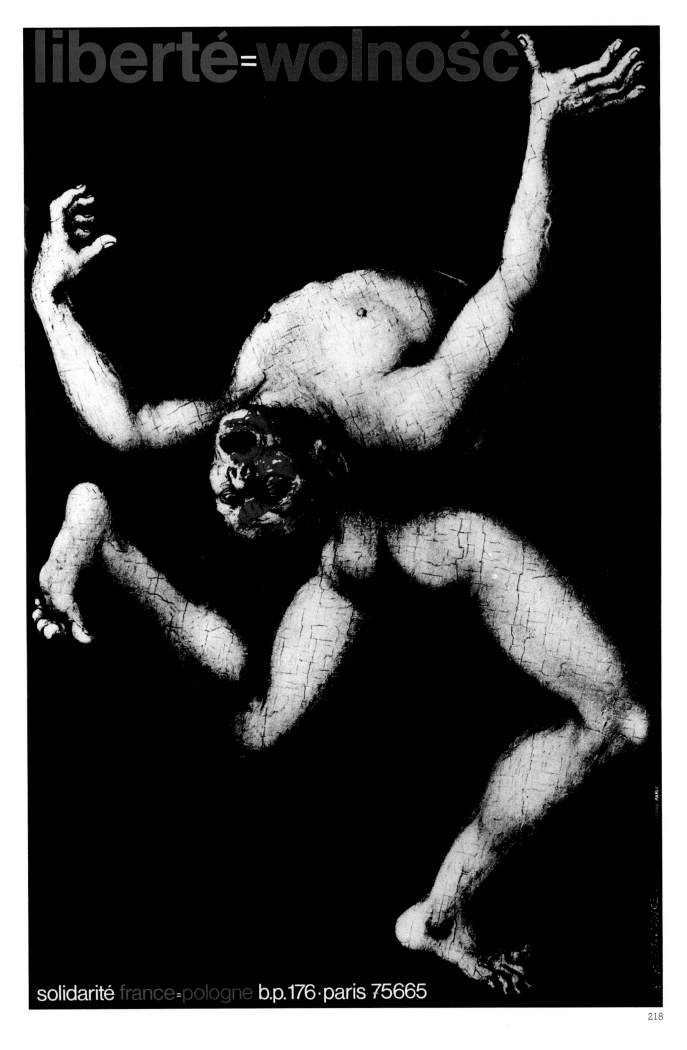

liberté=wolnosć

solidarité france=pologne b.p.176·paris 75665

PUBLISHING

Cieslewicz continued to design and execute many page layouts and magazine and book covers. His technique became confident and the treatment of the subject-matter was more simplified than in previous years. It was a time for simplification, even minimalism, but his language remained incisive and pointed. Regular contributions to some publications, *VST* magazine for example, gave him the opportunity to sharpen and refine his ideas.

219

218
Liberté = Wolnosc
Freedom
Solidarité France–Pologne
France–Poland Solidarity
Offset, 117.5 x 78 cm
1981

219
Cover for 'Maître des arts' (Master of Arts)
Series style
Editions Hazan, Paris
18 x 16 cm
1983–1993

220
Cover for 'Architectures'
Series style
Editions Hazan, Paris
24.5 x 17.5 cm
1983–1993

221
Cover for 'Le Bestiaire' (The Bestiary), No. 4 of the series 'Cahiers Perroquet', published by Magik, Paris
Text by Andrzej Wajda, drawings by Teresa Pagowska
30 x 21 cm
1984

220

221

222

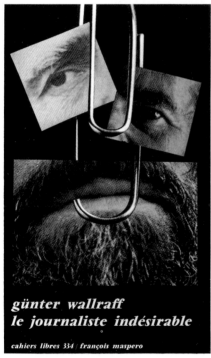

223

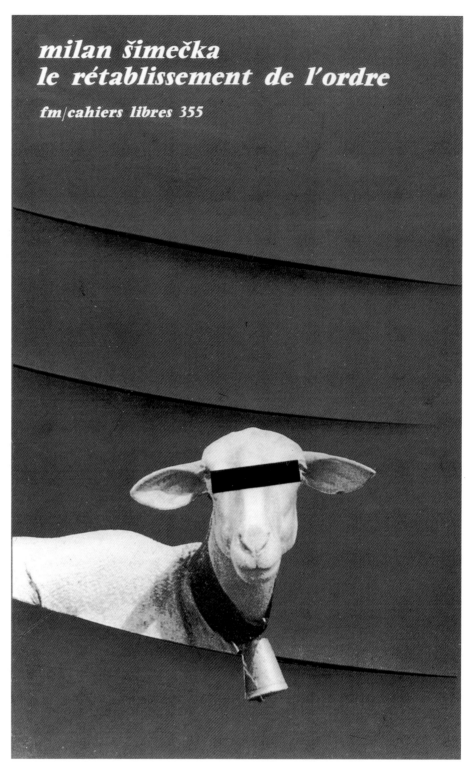

224

222–224
Covers for the series 'Cahiers libres'
(Nos 367, 334 and 355)
Published by François Maspero,
Paris

JANV.-FÉV. 1988
NOUVELLE FORMULE

VST

REVUE SCIENTIFIQUE
ET CULTURELLE
DE SANTÉ MENTALE
ÉDITÉE
PAR LES CEMEA
34e ANNÉE

N°
1

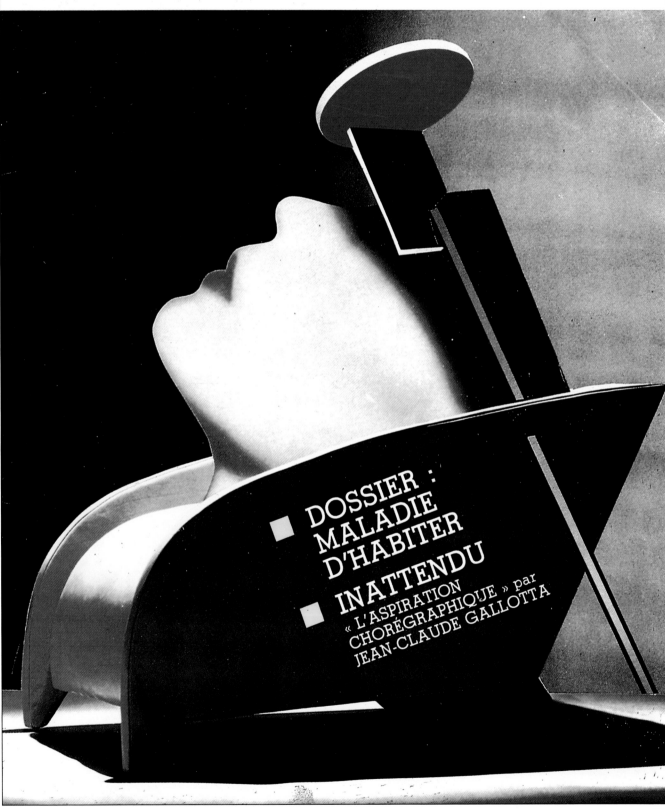

DOSSIER :
MALADIE
D'HABITER

INATTENDU
L'ASPIRATION
« CHORÉGRAPHIQUE » par
JEAN-CLAUDE GALLOTTA

118

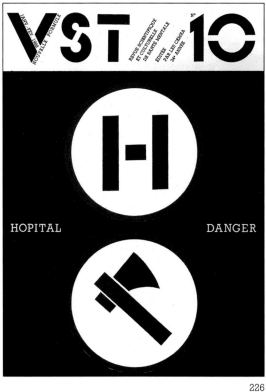

226

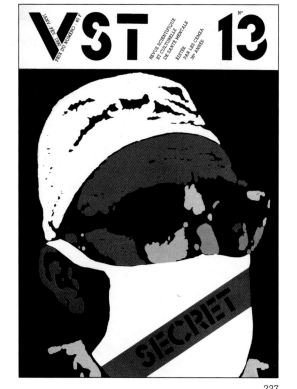

227

225
Cover for 'VST', a scientific and
cultural review of mental health,
No. 1, new style
Published by CEMEA
29.7 x 21 cm
1988
'VST' has been in existence for
almost forty years. Cieslewicz
designed the new layout in 1988.
The purpose of this magazine is to
maintain a permanent link between
all professional carers for mental
patients. With various sections,
including cultural, the magazine sets
out to address a wider readership
than the medical profession and to
establish itself as a scientific journal.
Cieslewicz is still a regular
contributor.

226
No. 10, 1988
Hôpital Danger (Danger Hospital)

227
No. 13, 1990
Secret

228
No. 25, 1992
Formation: Formations

229
No. 29, 1992
Ecriture et Psychiatrie (Writing and
Psychiatry)

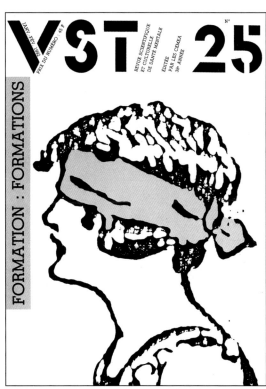

228

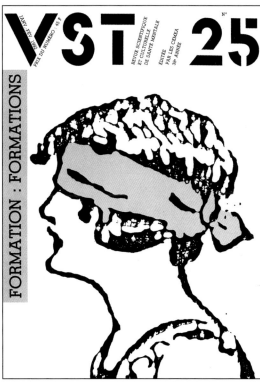

229

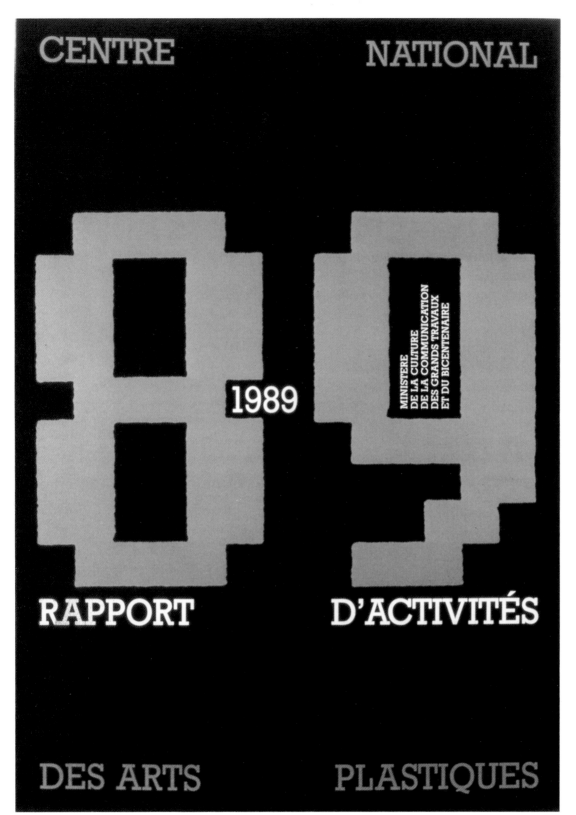

230

230
Activity Report of the Centre
National des Arts Plastiques (CNAP)
29.7 x 21 cm
1989
The CNAP, created in 1982, is a
branch of the Ministry of Culture,
a public body covering painting,
sculpture, design, photography,
applied arts, engraving and mural
art. Its principal activities are public
commissions, the teaching of the
arts and the financing of various
promotional operations in France.

231–236
Title pages for the chapters of the
annual Activity Report, using
photomontage. Black and white,
heightened with a luminous fuchsia
tint. With each chapter the movement
is developed and another arm is
added to the human figure.

ENSEIGNEMENT **1**

231

INCITATION A LA CREATION **2**

232

BICENTENAIRE 1789-1989 **3**

233

PROMOTION DIFFUSION **4**

234

ENRICHISSEMENT
DU PATRIMOINE **5**

235

FONCTIONNEMENT **6**

236

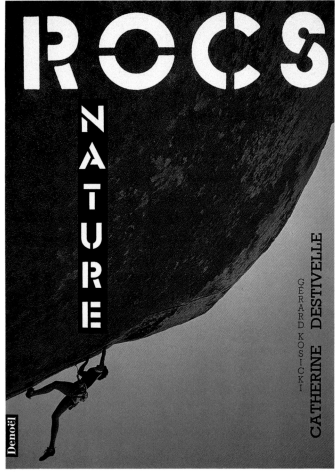

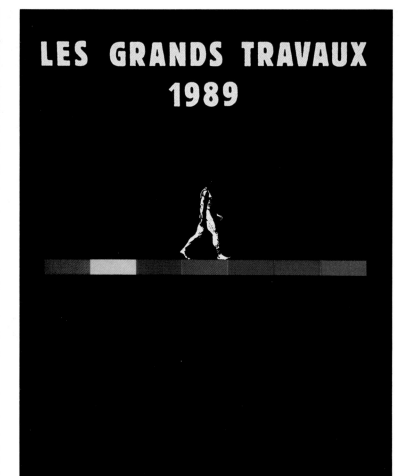

237

238

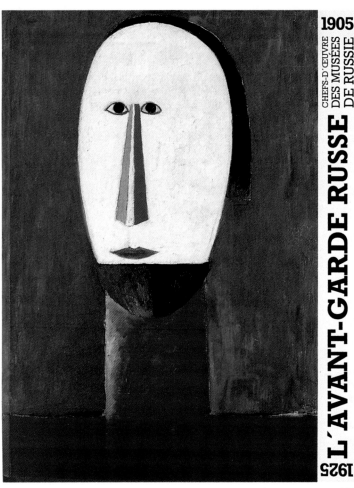

239

237
Rocs nature
Rocks in the Raw
By Catherine Destivelle
Editions Denoël, Paris
33 x 25 cm (with the assistance of
Vincent Michéa)
1991

238
Les Grands Travaux
Major Works
Published by the Ministère des
Grands Travaux
33 x 25 cm
1989

239
L'Avant-Garde russe 1905–1925
Russian Avant-Garde 1905–1925
Cover and layout for exhibition by
the Musée des Beaux-Arts, Nantes
Published by the Réunion des
Musées Nationaux (RMN)
28 x 22 cm
1993

PRESS

Dailies, weeklies or monthlies, these politically engaged organs of the press allow the artist to comment visually, and sharply, on the events of the decade that have included such an abundance of political and social upheaval. The writing is simple, tied to the speed of conception that journalism demands. Little colour, simpler and simpler images, nourished by the reality of the facts, face to face with the essential.

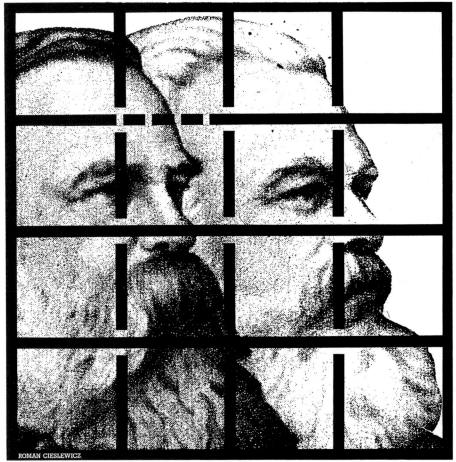

240

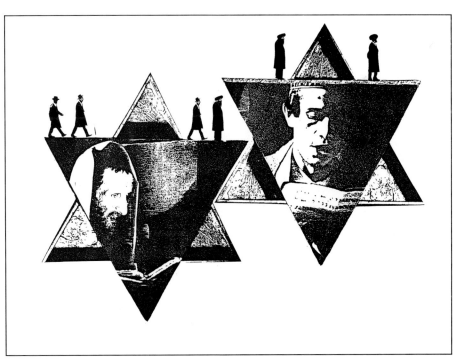

241

Since 1989, Cieslewicz has regularly collaborated on the French daily newspaper 'Libération'. These black-and-white illustrations show a great mastery of concise expression and economic graphic treatment, designed and executed in a maximum of 24 hours.

240
Mega Marx
Black-and-white illustration
'Libération', No. 3355, 5 March 1992
20 x 20 cm

241
La Loi à l'epreuve de la politique
The Law Tested by Politics
Black-and-white illustration
'Libération', No. 3088, 25 April 1991

242

243

244

Illustrations for the magazine
'Révolution', a monthly political and
cultural journal of the French
Communist Party. Published by the
Société d'Edition du Journal
Révolution (SEJ).
30 x 23 cm

242
Ça va pas!
That's Not Right!
Illustration for an article on the current
state of the French Communist Party
May 1992

243
1er Mais
1st But (a pun in French on 1st May)
Cover for No. 635 (30 April–6 May 1992)
on the theme of the workers' May Day
holiday
April 1992

244
Circulez, il n'y a rien à manger!
Move Along There, There's Nothing to Eat!
Unpublished project
Black, white and red illustration on the
subject of world famine

245
Quoi de Neuf?
What's New?
Cover for the magazine 'L'Autre Journal',
a cultural and political monthly
Published by Edition Alter, Paris
Cieslewicz contributed from May to
November 1992, partly as illustrator
but also as artistic consultant
Printed as a poster, 160 x 120 cm
24 May 1992

ROMAN CIESLEWICZ

quoi

de

neuf

?

M 2603-N° 24 MAI 92-25,00 F BELGIQUE : 180 FB / SUISSE : 8,50 FS / MAROC : 45 DH / PORTUGAL : 900 ESC / GRECE : 1200 DR /ESPAGNE : 600 PTAS / PAYS BAS : 12 FL / DOM : 37,50F

M 2603 - 24 - 25,00 F

SETS

These little-known designs for exhibition and stage sets are part of Cieslewicz's continued graphic research. He is not new to this field. In 1957 he provided the setting for the Pavilion of Polish Industry at the Leipzig International Fair, together with J. Muniak. Later he designed and made various décors for, among others, the fashion magazines *Zone bleu kobalt*, *Elle* (No. 1153, 1968), etc. In 1963 he built the CE-TE-BE pavilion at the Poznan International Fair, Poland, with A. Gucewicz.

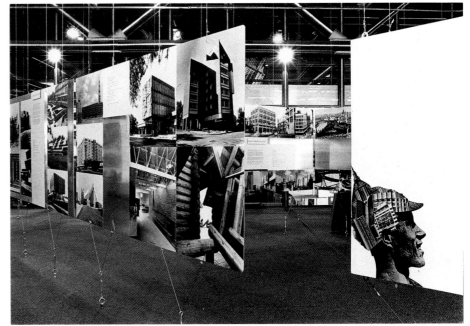

246

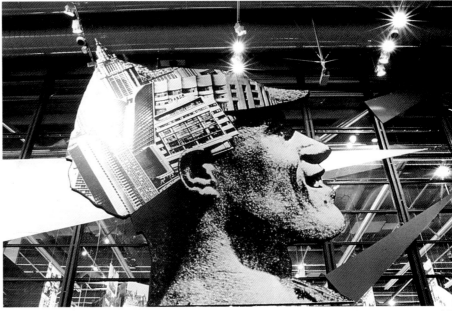

247

246, 247
Graphic and architectural project
for the exhibition 'L'Espace Urbain en URSS, 1917–1978' (Urban Space in the USSR 1917–1978), with Jean-Louis Cohen, architect
Centre Pompidou/CCI, Paris
Collage technique with elements from Alexander Rodchenko
1978

248

249

250

251

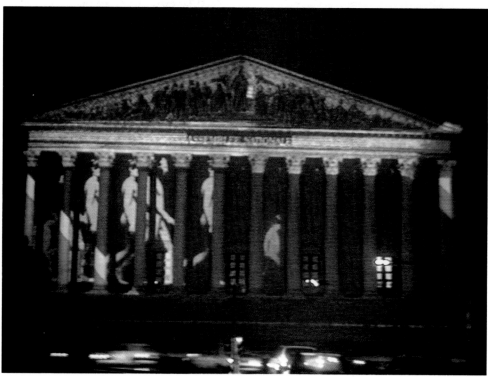

252

248–252
Setting for the Assemblée Nationale,
Paris
1989
This animated performance was a
joint commission from the Ministry
of Culture/Plastic Arts Delegation
and the National Assembly on the
occasion of the bicentenary of the
French Revolution (1989). This six-
metre projection to the full height
of the columns on the building was
carried out by the Contrejour
company working on original
montages made by Cieslewicz in an
A4 format. The characters appeared
one by one, then together, and finally
superimposed, in a rapid visual
sequence and always in blue, white
and red, the French national colours.
Other artists collaborated in this
visual programme, including Ernest
Pignon Ernest, Cueco and Erro.

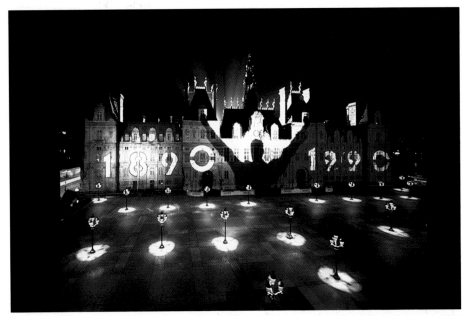

253

256

253–256
Setting for the Hôtel de Ville, Paris
1990
The Cultural Affairs Committee of
Paris City Council commissioned
this work from Cieslewicz to
commemorate the centenary of the
birth of General de Gaulle. The
original designs, measuring 21 x 29.7
cm were filmed by the Contrejour
company. The films were then
projected on to the full height of the
façade of the building from 10 pm to
2 am for some ten successive nights.

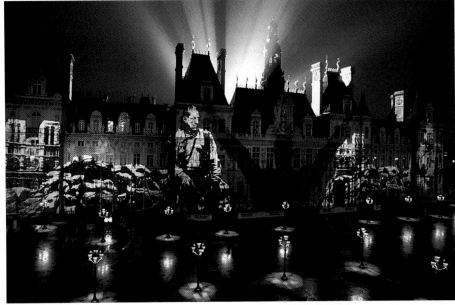

254

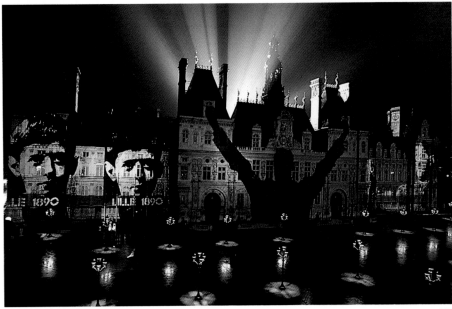

255

COLLAGES

After 1984, the very complicated collages became more simplified, although the sequences, schemes and backgrounds still linked humour with anguish, reality with fiction. Added to the technique of associations, now simpler than in the 1970s, is derision or an emphasis on certain given information. Cieslewicz 'triggers' perception and pursues his task of 'sharpening the eye'.

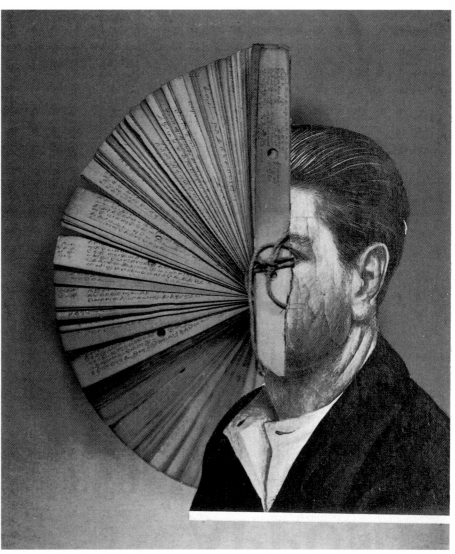

257

257
**Hommage Personnel au Peintre
Giorgio de Chirico**
Personal Homage to the Painter
Giorgio de Chirico
Unpublished project
Black and white, 30 x 30 cm
1987

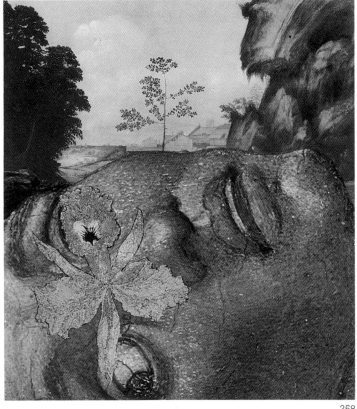

258

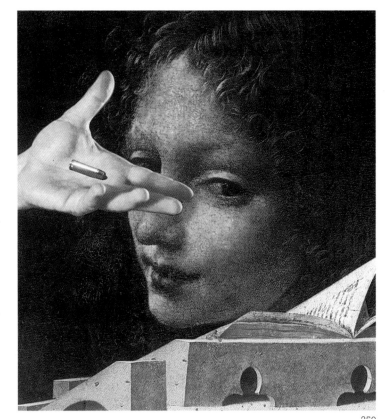

259

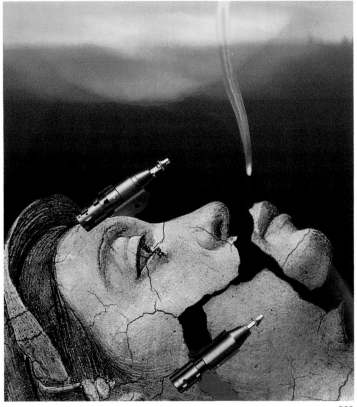

260

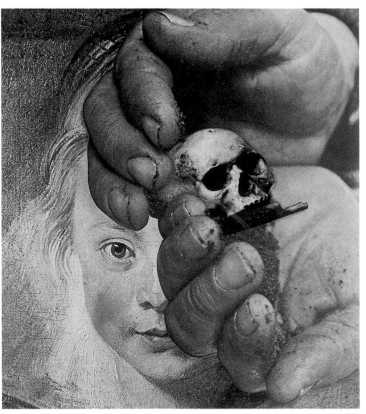

261

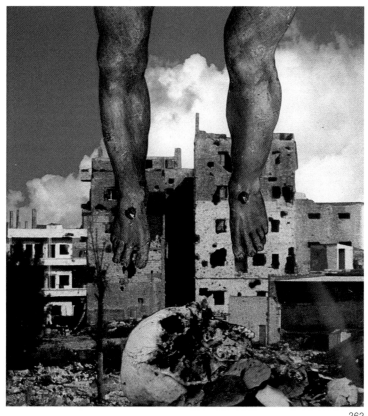

262

263

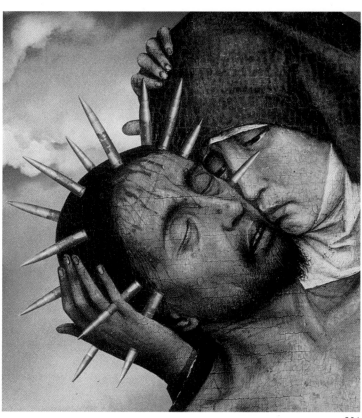

264

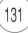

131

Aimez vos ennemis
Love Your Enemies
Editions Dialogue, Paris
1982
A panoramic survey of poetry and
essays from the literature of Poland
from the Middle Ages to 1981. In this
series, with one illustration to each
item of text, motifs from Christian art
are combined with images from the
Second World War to create an
extremely dramatic context.
Book format 22 x 20 cm

258
Victime (Victim), 22 x 20 cm, 1982

259
Double lecture (Double Reading),
20 x 20 cm, 1982

260
Craquelée (Crackled), 23 x 20.5 cm,
1982

261
La Vie (Life), 22 x 20.5 cm, 1982

262
Ghetto 44, 22 x 20 cm, 1982

263
Téléphone rouge (Red Telephone),
22 x 20 cm, 1982

264
La Couronne (The Crown),
22 x 20 cm, 1982

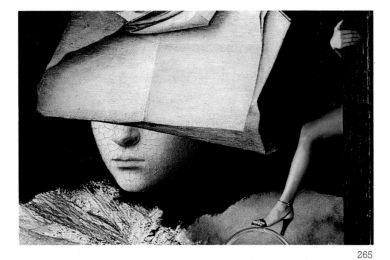

265

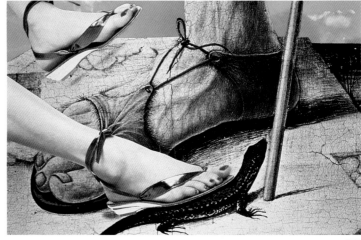

266

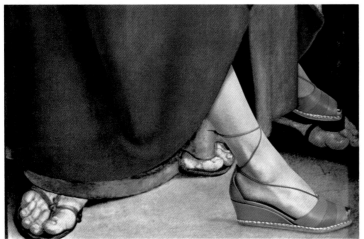

267

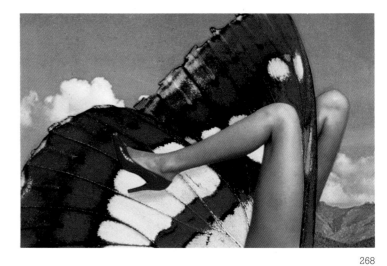

268

Photomontages for Charles Jourdan
1981–82
In this series for use in an advertising campaign for the famous brand of footwear, Cieslewicz evokes the history of art and ideas. The designs start with a principal form, usually a human figure, and by painstakingly careful arrangement of the background (accessories, landscape) create several levels of reality. He takes elements from European painting (Hans Baldung Grien, Michelangelo, Giorgione and others) which he combines with photographs of Jourdan shoes (taken by D. Engelhard). The juxtaposition of these two worlds creates some very dynamic and expressive images. Frequently reproduced in various magazines, these images have attracted as much comment from the advertising media as from the art journals. The originals were made in a small format, *c.* 18 x 25 cm, intended for reproduction on a double page. Twenty of the forty images were used. There were two series: outdoors for spring and summer, indoors for autumn and winter.

265
La Nonne
The Nun
18 x 26 cm
1981

266
Le Pèlerin
The Pilgrim
15.5 x 23 cm
1982
Composed of three elements: the picture plane mostly filled by a large detail from a painting by Giorgione; a pair of feet modelling shoes that are somewhat similar to that in the painting; and the sky behind (photographer unknown).

267
Les Moines
The Monks
26 x 36 cm
1982
Montage based on a combination of two originals – a detail from Dürer's 'Four Apostles' and a photograph of a model (whose feet have been repositioned to make them parallel).

268
La Passe
The Pass
17 x 23 cm
1981

269

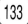

269
Playboy de la Sixtine
Playboy of the Sistine Chapel
27 x 38 cm
1982
The photograph of a model is
combined with a figure from the
ceiling of the Sistine Chapel painted
by Michelangelo. The proportion of
the hand produces a striking effect.
The sky in the background comes
from a photographic print.

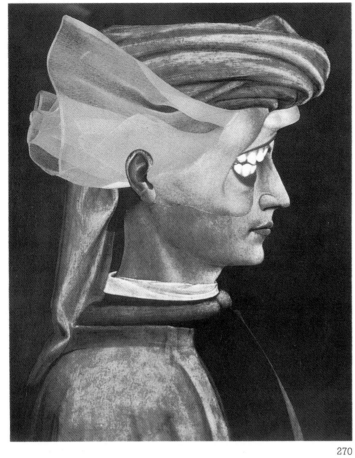

270

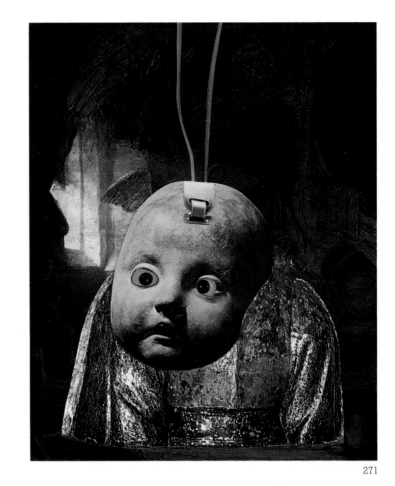

271

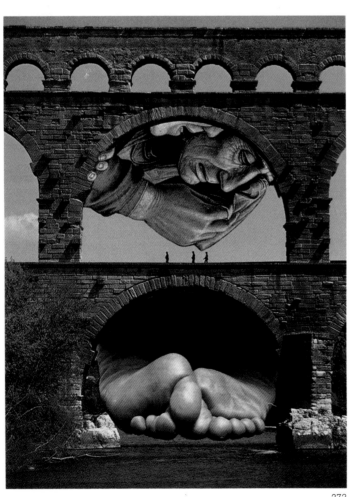

272

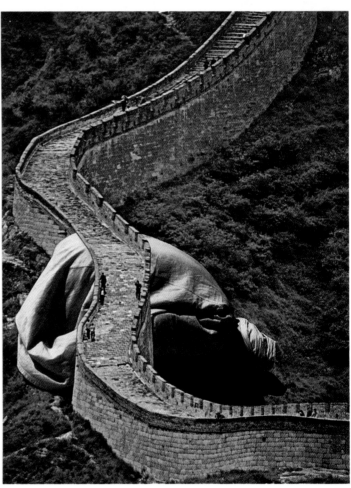

273

Changements de climat
Changes of Climate
1976–1982
A selection from a series of 51
collages exhibited at the Jean Briance
gallery, Paris, June/July 1982.
These related experiments, carried
out with no particular end in mind,
are a continuation of the collage
series 'Changements de climat'. The
materials used are from illustrated
periodicals and books popularizing
works of art.

270
Baisers volés
Stolen Kisses
30 x 21 cm
1982

271
C'est toute une histoire
It's Quite a Story
30 x 21 cm
1982

272
Grand regret
Great Regret
29.5 x 22 cm
1982

273
Hommage à travers
Homage Across
29.5 x 22 cm
1982

274
Super Elephant-man
1982
This collage, based on Raphael's
portrait of Baldassare Castiglione,
was exhibited at the Louvre during
the 'Homage to Raphael' exhibition in
1985.

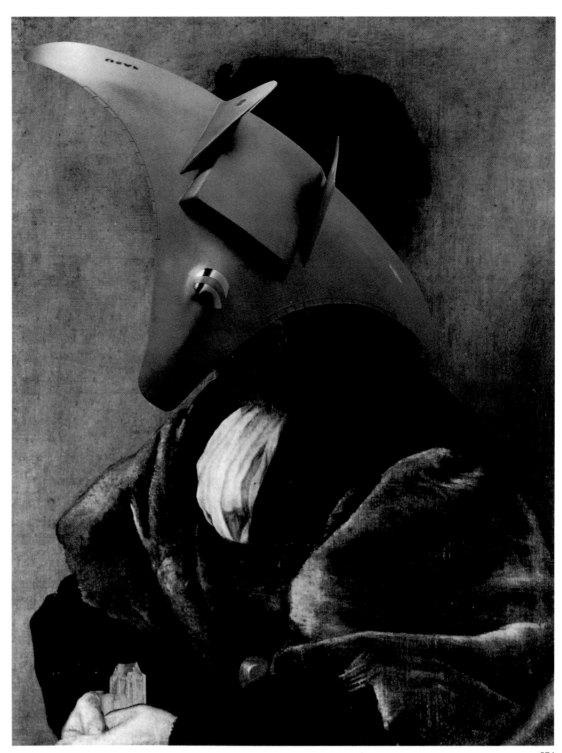

274

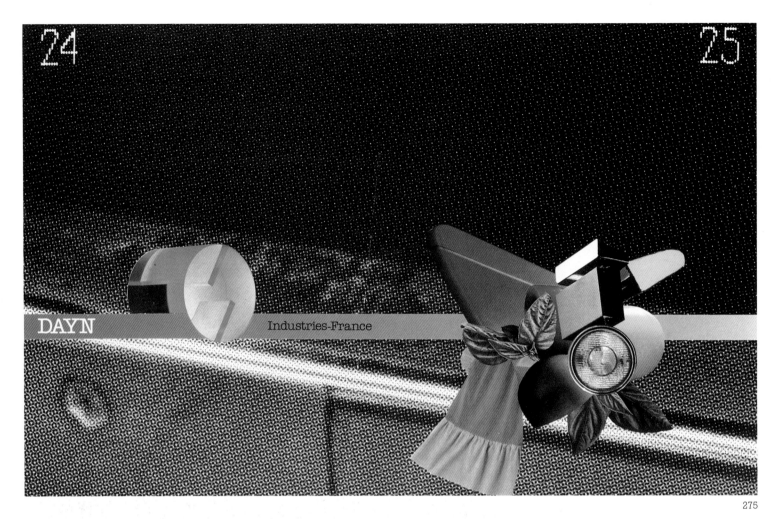

DAYN Industries-France

6

DAYN Commodities trading

275–279
Dayn
Promotional folder for a Saudi
Arabian company
Offset, 21 x 29.7 cm
1983
Each double-page spread of this
folder presents one of the firm's
activities. The background is a
photographic enlargement blown up
so that the screen becomes visible.
The theme, which is almost
unrecognizable, reveals blurred
glimpses of parts of cars. The motif
of the screen, which Cieslewicz
appeared to have exhausted,
undergoes a new interpretation. This
experimentation with photographic
reproduction allows the artist to
arrive at new pictorial values,
sometimes to the detriment of the
legibility of the message.

277

278

279

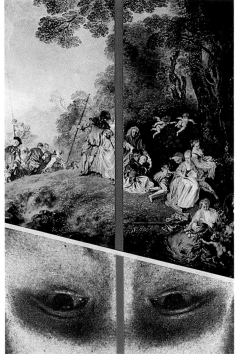

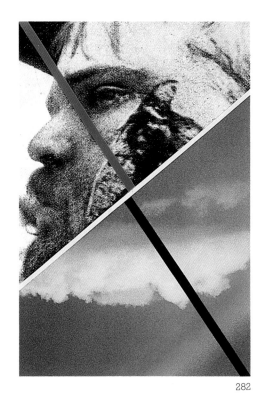

280

281

282

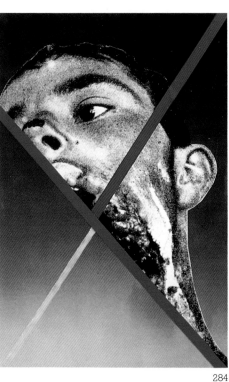

283

284

280–285
Les Dieux ont soif
The Gods Are Thirsty
Novel by Anatole France written in
1911
Imprimerie Nationale, Paris
Limited paper-covered edition
printed on Rives paper, numbered
from 1 to 2620
Book format 22 x 16 cm, illustrations
11.5 x 17 cm
1988
These seventeen illustrations were
commissioned by the Director of the
Imprimerie Nationale as part of the
commemoration of the bicentenary
of the French Revolution. The theme
of the book is a description of life in
Paris during the years leading up to
1789. Cieslewicz builds up his work
from the concept 'revolution', that is,
the questioning of the status quo.
He began by presenting images of
the Soviet Revolution set against
documents of the French Revolution.
This idea, considered to be too
violent, was then 'watered down' by
the choice of different illustration
sources: French and English
eighteenth-century paintings set
against photographs of wounded
soldiers of the First World War. The
apparent simplicity of the illustrations
underlines the contrast between the
violence of war and the serenity of
the paintings.

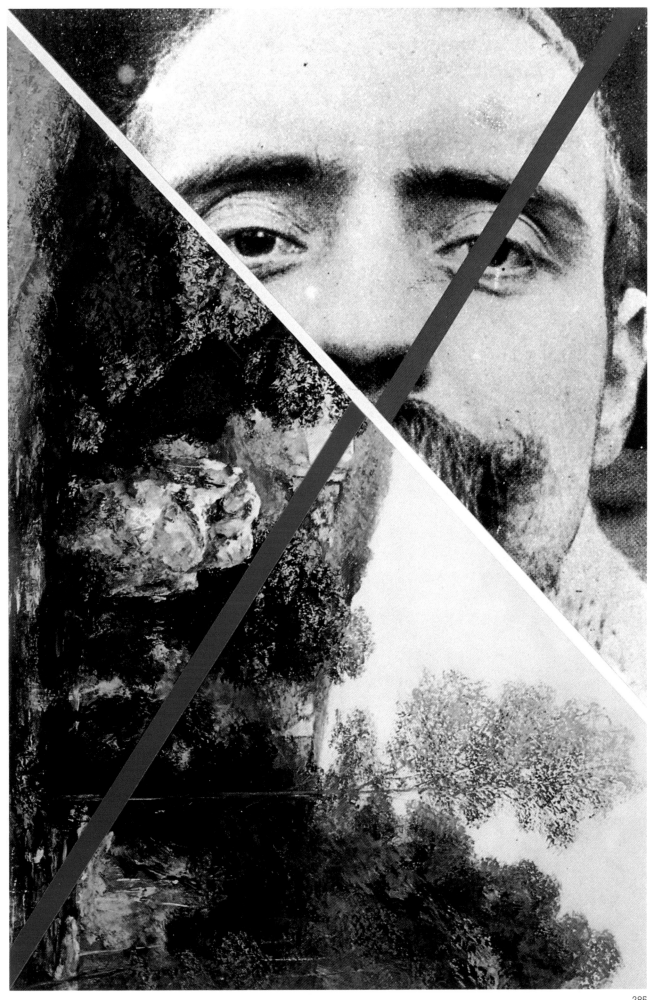

SILK-SCREENS

286

286
Fenêtre cassée
Broken Window
60 x 40 cm
1988
Edition of 100 silk-screen prints,
designed for the Imprimerie
Nationale, published simultaneously
with the new edition of the book 'Les
Dieux ont soif' (The Gods Are
Thirsty).

287
Lunette brisée
Broken Spectacle
60 x 40 cm
1988
Edition of 100 silk-screen prints,
designed for the Imprimerie
Nationale, published simultaneously
with the new edition of the book 'Les
Dieux ont soif'.

288
Ecco
Original 20 x 20 cm
Edition of 100, 80 x 80 cm
1987
Designed and executed for the
Brussels publisher Pierre d'Alun.

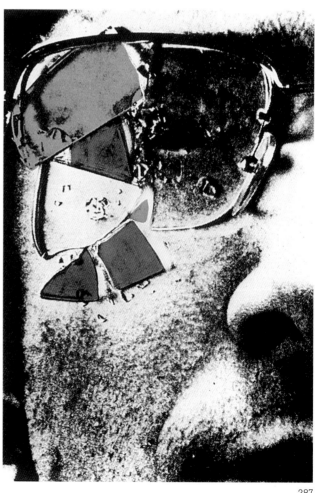

287

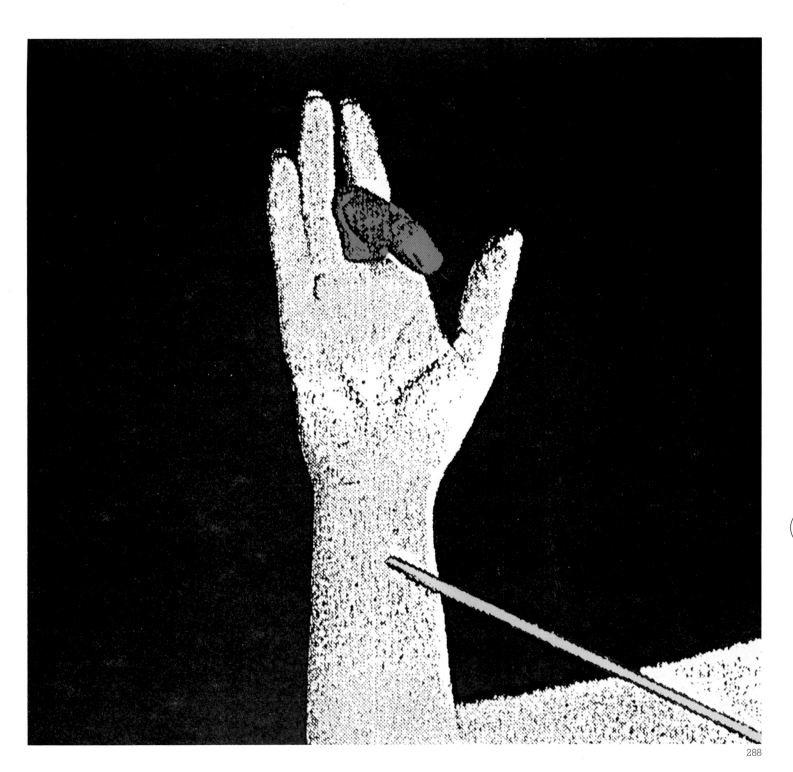

288

POSTERS

Cieslewicz's posters show a wide variety of themes and lettering. There is a deliberate economy of means, a rejection of artificial settings and idiosyncrasies in order to express better the essential message, as for instance in the poster *Couleurs du monde* (Colours of the World). Among these posters that are minimalist in expression but laden with messages, some seem to take up again a treatment that goes back to the Polish years, while others reflect the architecture of the Constructivists. They all confirm Cieslewicz's huge talent as a poster artist.

289

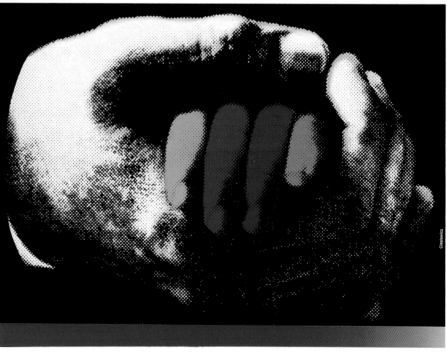

290

289
Il naît un enfant handicapé toutes les 20 minutes en France
A Handicapped Child Is Born Every 20 Minutes in France
Association pour les Enfants Handicapés (Association for Handicapped Children)
Offset, 3 x 4 m
1981

290
Another version for the Association pour les Enfants Handicapés

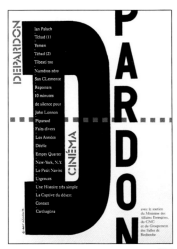

291

291
Depardon Cinéma
Poster for the retrospective of
Raymond Depardon's films
1993

292
Reporters
Film directed by Raymond Depardon
Offset, 160 x 120 cm
1982

293
Numéros zéro
Zero Numbers
Film directed by Raymond Depardon
Offset, 157.5 x 116.5 cm
1980

294
San Clemente
Film directed by Raymond Depardon
Offset, 158.5 x 116.5 cm
1982

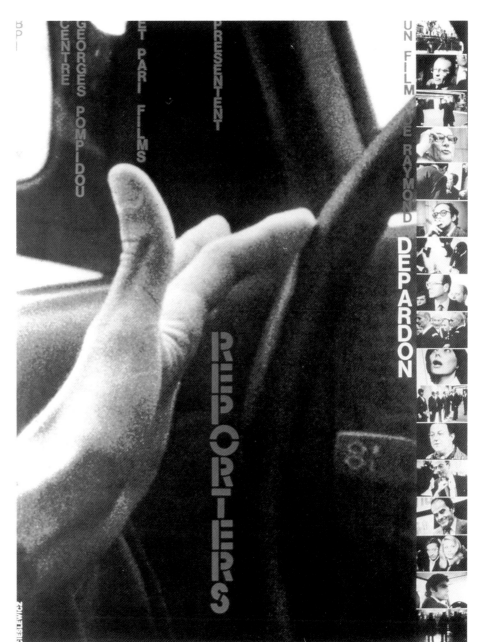

292

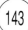

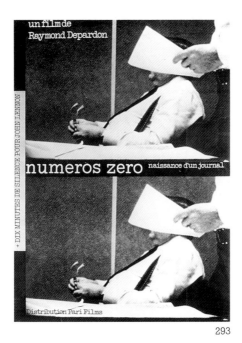

293

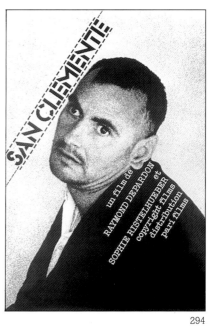

294

THÉÂTRE DE BOULOGNE BILLANCOURT

CRIME ET CHATIMENT

Pièce en deux parties de
Gabriel AROUT
D'après le roman de
F.M. DOSTOIEVSKI
Mise en scène
Paul-Emile DEIBER
Assistant à la mise en scène
Alain FAIVRE
Scénographie
Yves SAMSON
Costumes
Nathalie MATRICIANI
Lumières
Gérard KARLIKOW

DU 7 OCTOBRE

CRIME ET CHATIMENT

AU 10 NOVEMBRE 1989

Par ordre d'entrée en scène

Michel **DUCHAUSSOY**
Porphyre
Jean-Daniel **LAVAL**
Razoumykine
Tony **LIBRIZZI**
Petrov
Michel **AYMARD**
Zametov
Odile **BOUGEARD**
Nastassia
Fabrice **EBERHARD**
Raskolnikov
Juliane **RIALKA**
Madame Lippewechsel, la vieille
Jean **BRASSAT**
Marmeladov
François **ARAGON**
Le patron
Jean-Michel **KINDT**
Lebesiatnikov
Hugues **VAULERIN**
Koch

André **FALCON**
Svidrigaïlov
Françoise **GRALEWSKI**
Lisa
Bertrand **CHARNACE**
Dimitri
Alain **FAIVRE**
Nicolas
Jean-Bernard **FEITUSSI**
Zossimov
Joël **DEMARTY**
Loujine
Jean-Simon **PREVOST**
Le bonhomme
Marie **KEIME**
Catherine
Nathalie **AKOUN**
Sonia
Christiane **MINAZZOLI**
Madame Raskolnikov
Agnès **GALAN**
Dounia

Avec la
participation
du J.T.N.

LOCATION – ABONNEMENT
T.B.B. 60, Rue de La Belle feuille
92100 BOULOGNE-BILLANCOURT
46 03 60 44 PARKING-METRO MARCEL SEMBAT
FNAC – AGENCES – BILLETEL – VIRGIN

COPY 2000

Paris 90v

295

avec vous 365 fois l'an
le conseil municipal

VILLE DE MONTREUIL 1982

296

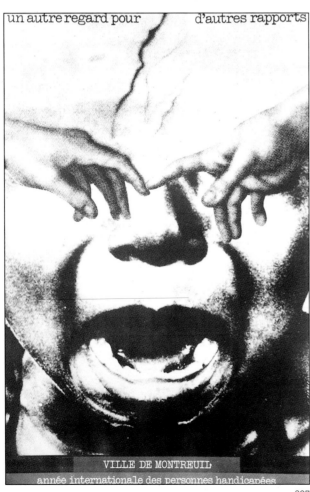

un autre regard pour d'autres rapports

VILLE DE MONTREUIL
année internationale des personnes handicapées

297

295
Crime et châtiment
Crime and Punishment
Théâtre de Boulogne Billancourt
Offset, 160 x 120 cm
1989

296
Avec vous 365 fois l'an
With You 365 Times a Year
Poster for Montreuil town council
Offset, 117.5 x 78 cm
1982

297
**Un autre regard pour d'autres
rapports**
Another Look for Other Relationships
Poster for Montreuil town council
Offset, 117.5 x 78 cm
1981

298
Amadeus
Play by Peter Shaffer, Théâtre
Marigny, Paris
Offset, 150 x 100 cm
1982

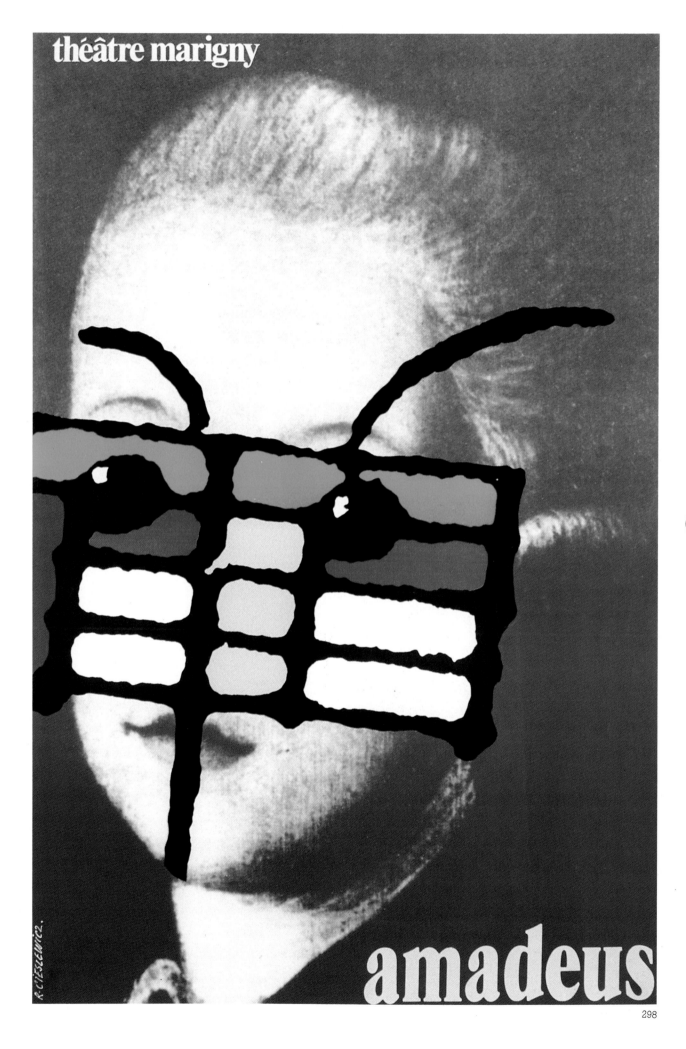

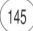

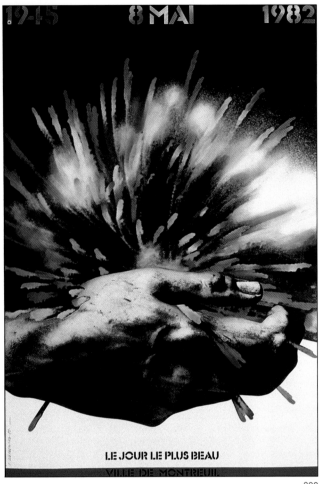

299

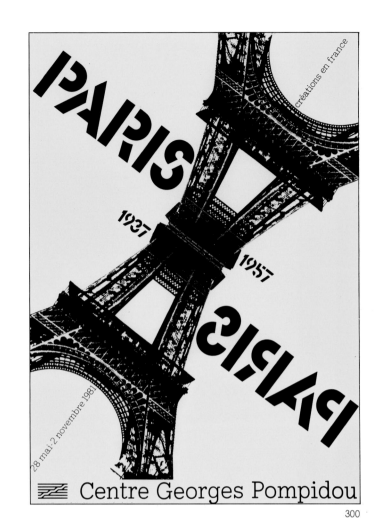

300

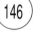

301

299
Le Jour le plus beau
The Loveliest Day
Poster for Montreuil town council
Offset, 79.5 x 54 cm
1982

300
Paris–Paris 1937–1957
Multidisciplinary exhibition at the
Centre Pompidou, Paris
Offset, 156.5 x 117 cm
Also catalogue cover, invitations, etc.
1981

301
Les Portes de la ville
The City Gates
Exhibition on town planning at the
Centre Pompidou/CCI, Paris
Offset, 68 x 50 cm
1982

302
Action top lait
Top Milk Action
Action by militant farmers from the
Loire country for improvement in the
quality of milk (Association Fourrage
Plus)
Offset in three colours, 60 x 40 cm
1987

303
Les Contrats de solidarité
The Contracts of Solidarity
Poster for Montreuil town council
Offset, 117 x 78.5 cm
1982

304
Musée Picasso, Paris
Poster for the inauguration of the
Picasso Museum
Offset, 160 x 120 cm
1985

305
Année Toulouse-Lautrec
Year of Toulouse-Lautrec, for the
exhibition '13 + Lautrec'
Commission from the Albi Museum
to 13 international graphic artists
Offset, 80 x 60 cm
1992

302

303

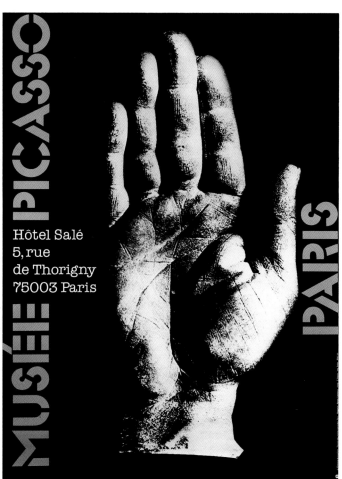

304

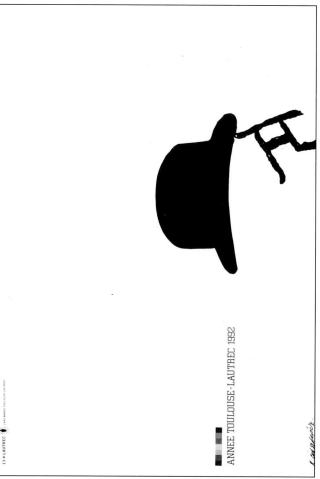

305

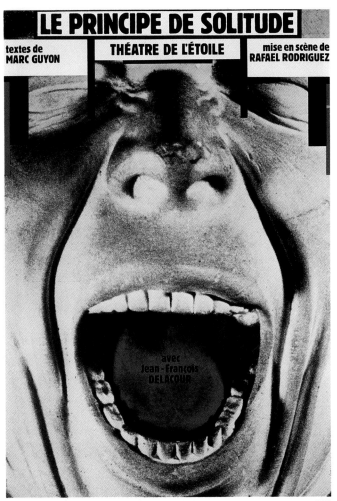

306

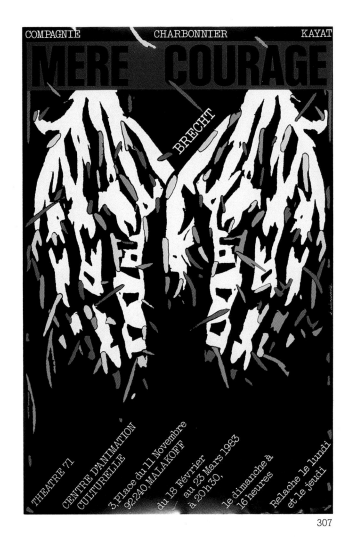

307

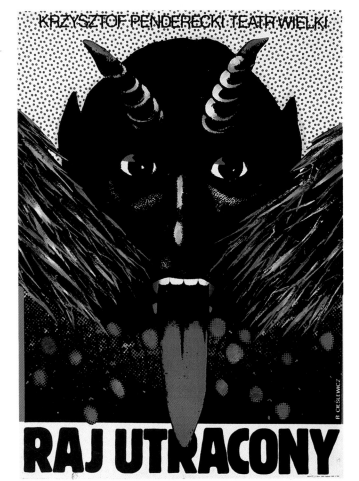

308

306
Le Principe de solitude
The Principle of Solitude
Play by Marc Guyon, Théâtre de
l'Etoile, Paris
Offset, 89 x 60 cm
1982

307
Mère Courage
Mother Courage
Play by Bertold Brecht, Théâtre 71,
Malakoff, Paris
Offset, 117 x 78 cm
1983

308
Raj Utracony
Paradise Lost
Opera by Krzysztof Penderecki,
based on Milton, Grand Theatre,
Warsaw
Offset, 90.5 x 67.5 cm
1980

309
Yvonne, Princesse de Bourgogne
Iwona, Ksiezniczka Burgundii
The Burgundian Princess
Play by Witold Gombrowicz, Théâtre
de l'Odéon, Paris
Offset, 177 x 78 cm
1982

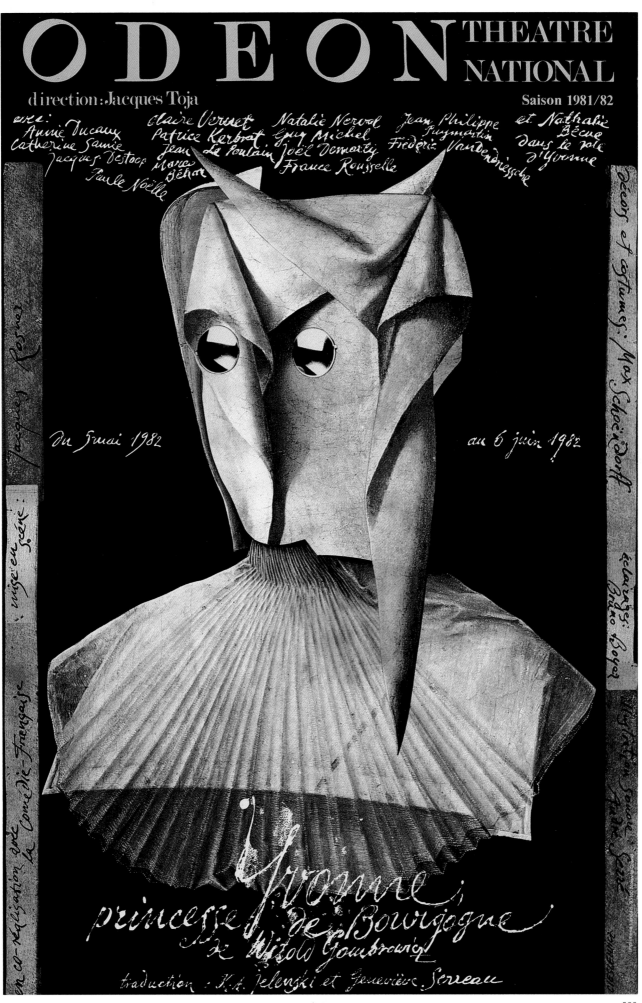

150

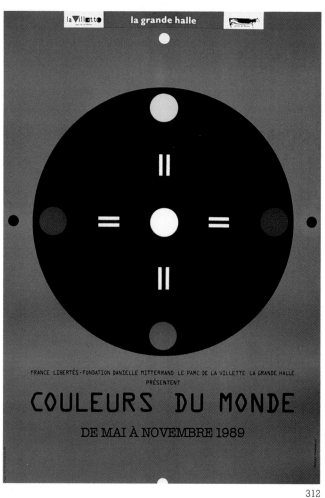

310
Droits de l'homme et du citoyen
The Rights of Man and the Citizen
Published by Artis on the occasion
of the bicentenary of the French
Revolution
Offset, 100 x 65 cm
1989

311
Présences polonaises
Polish Presences
Multidisciplinary exhibition at the
Centre Pompidou, Paris
Offset, 150 x 100 cm
Also catalogue cover, invitations, etc.
1983

312
Couleurs du monde
Colours of the World
Exhibition at the Grande Halle, Parc
de la Villette, Paris
Offset, 180 x 120 cm
1989
Both composition and minimalism
are at their height, giving great force
to the overall effect.

313
Faust
Verse drama by Johann Wolfgang
von Goethe, Teatr Nowy, Warsaw
Offset, 100 x 70 cm
1989

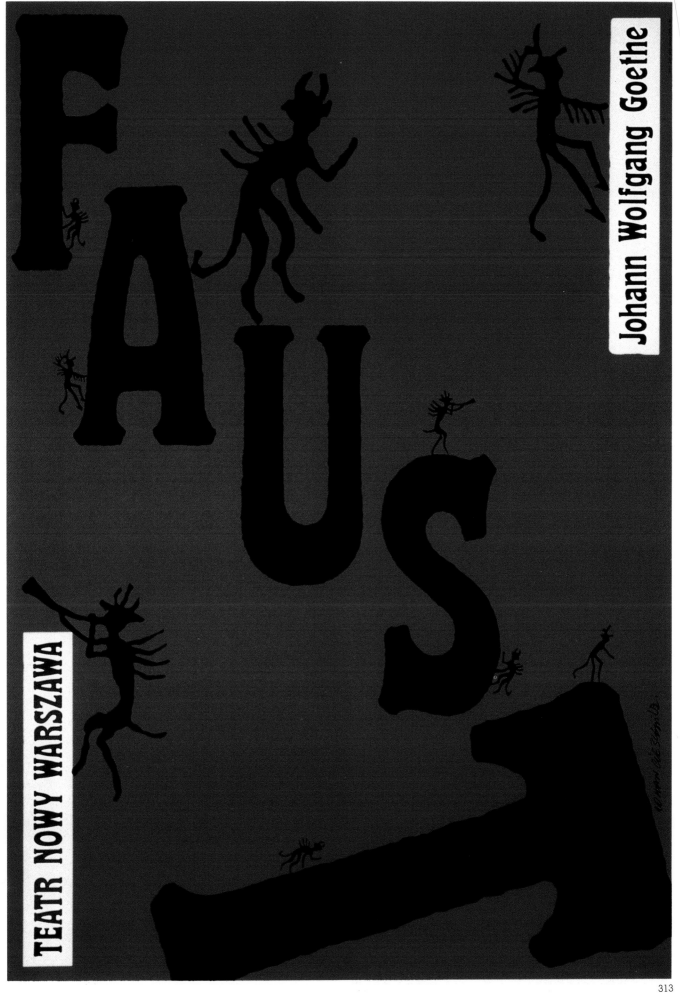

FAUS

TEATR NOWY WARSZAWA

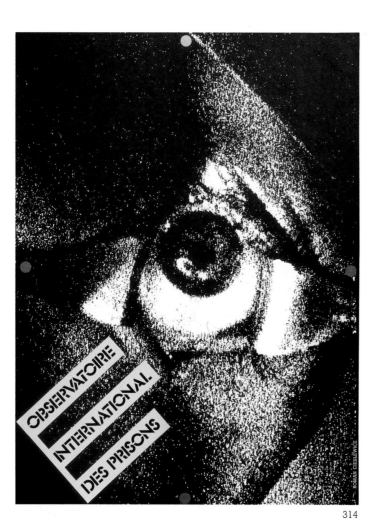

314

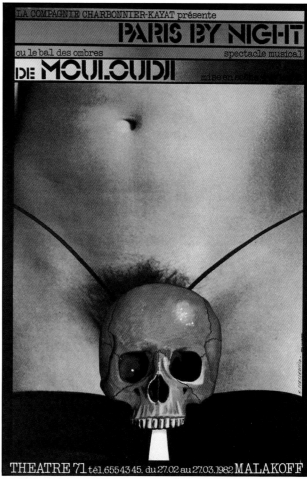

315

314
Observatoire International des Prisons (OIP)
International Observatory of Prisons
Offset, 80 x 60 cm
1992
At the instigation of Cieslewicz, a hundred international poster artists each created a poster for the OIP (among them Fukuda, Ranbow, Félix Bütner and Paris-Clavel). These posters were assembled into a travelling exhibition (France, 1993), with the proceeds of the auction sale of the signed originals being donated to the organization.

315
Paris by night ou **le Bal des ombres**
Paris by Night or the Shadows' Ball
Musical play by Mouloudji
Offset, 117 x 78 cm
1982

316
Y a-t-il un urbanisme de banlieue?
Is There Such a Thing as Suburban Town Planning?
Debate organized by the Montreuil town council
Offset, 116.5 x 78 cm
1981

317
Homage to A.M. Cassandre
Created for the Poznan Poster Collectors' market
Offset, 170 x 100 cm
1990

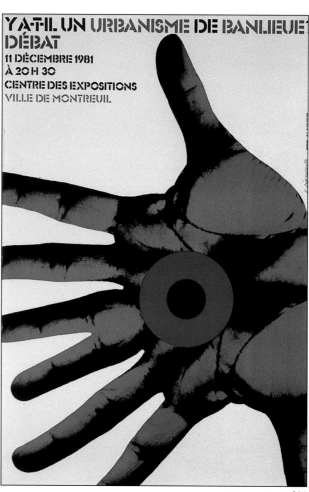

316

XXIV.OGÓLNOPOLSKA
GIEŁDA PLAKATÓW
1.MAJ 1990

1901

WIELCY TWÓRCY PLAKATU

1968

GALERIA B.W.A
POZNAŃ
STARY RYNEK
ARSENAŁ

A. M. CASSANDRE

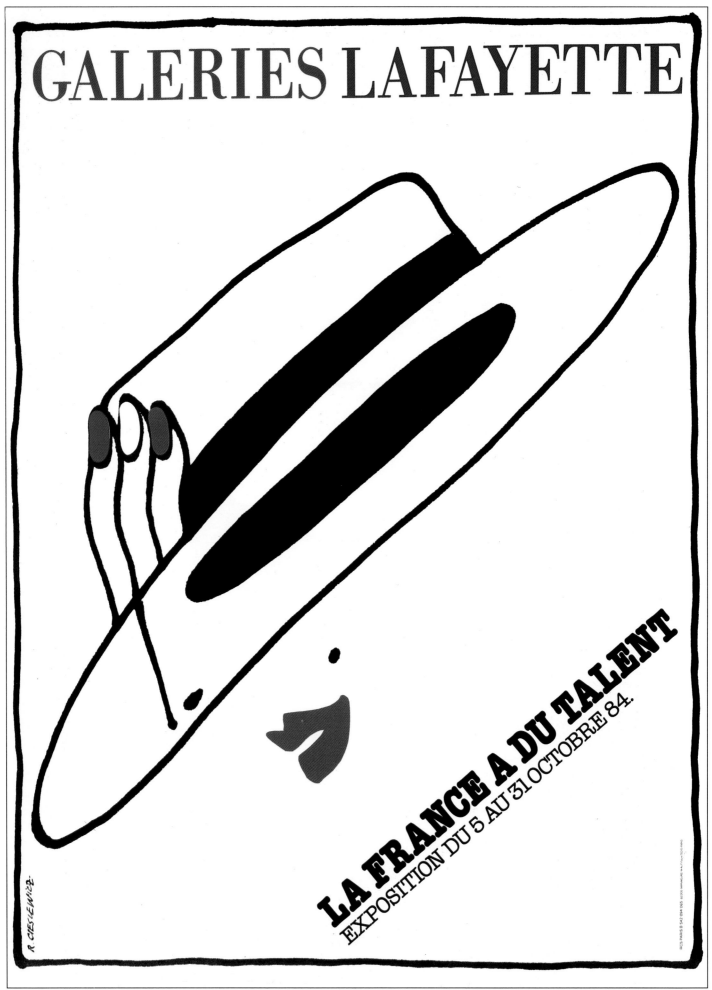

le vrai bonheur c'est d'avoir pour métier sa passion* **Stendhal**

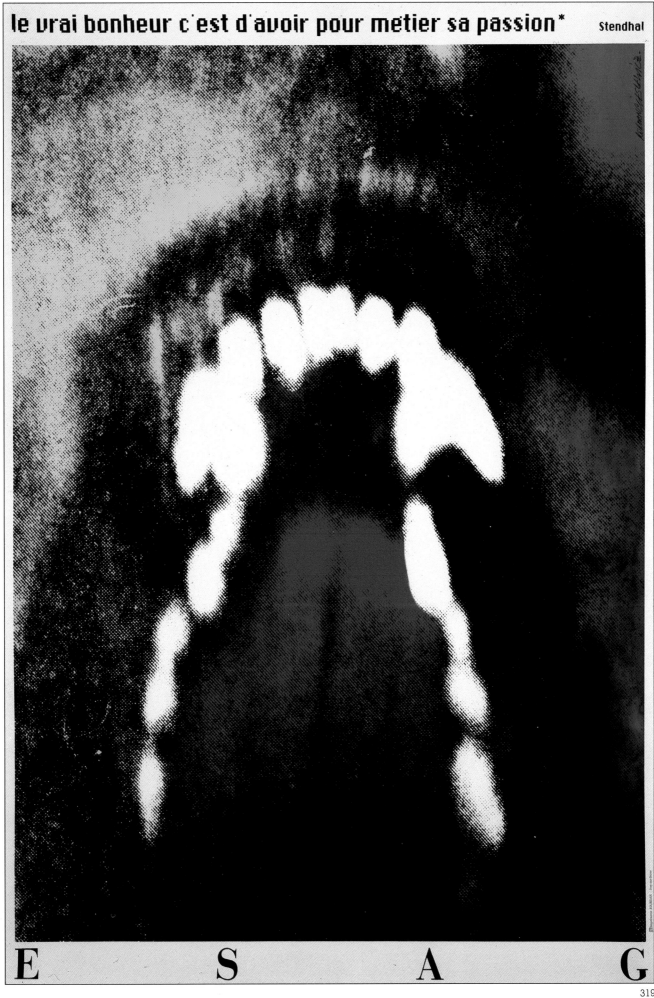

E S A G

318
La France a du talent
France Has Talent
A commercially organized exhibition
of work carried out by designers at
the Galeries Lafayette, Paris. This
selection included all disciplines –
fashion, furniture, tableware, etc.
MAFIA agency
4 x 3 m and 120 x 180 cm
Also stickers and paper bags
Cieslewicz's first poster since 1963
using drawing rather than
photomontage.

319
**Le vrai bonheur c'est d'avoir pour
métier sa passion**
True Happiness Is Doing the Thing
You Love for a Living
Poster for ESAG (Ecole Supérieure
des Arts Graphiques), Paris
Offset, 70 x 50 cm
1992
Each year the college commissions
from one of its teachers a poster to
be distributed for promotional
purposes at the beginning of the new
school year. In 1993 Cieslewicz
found his inspiration in a phrase from
Stendhal.

ONE-MAN EXHIBITIONS

1959
Salon Ekranu, Warsaw, Poland

1960
Salon B.W.A., Cracow, Poland

1961
Galeria Likovnih, Umjetnosti Rijeka, Yugoslavia

1963
Goethe Universität, Frankfurt, Germany
Librairie Mandragore, Paris, France

1964
Club Synergie, Paris, France

1965
Théâtre de la Cité, Villeurbanne, France
Salon B.W.A., Szczecin, Poland
Galerie in der Biberstrasse, Vienna, Austria

1967
Salon B.W.A., Kordegarda, Warsaw, Poland

1968
Galeria Aurora, Geneva, Switzerland

1971
Muzeum Sztuki w Lodzi, Lodz, Poland
Deutsches Plakatmuseum, Essen, Germany
Galeria Aurora, Geneva, Switzerland

1972
Musée des Arts Décoratifs, Palais du Louvre, Paris, France
Musée de Grenoble, France

1973
Stedelijk Museum, Amsterdam, Netherlands
Hôtel de Ville, Dieppe, France
Galerija Suvremene Umjetnosti, Zagreb, Yugoslavia
Razstavni Salon Rotov z, Maribor, Yugoslavia

1974
Galerie de L'Oeil de Boeuf, Paris, France
Muzeum Plakatu, Wilanow, Poland

1975
Galerie Saluden, Quimper, France
Salon G.V.N., Amsterdam, Netherlands

Mala Galeria, Muzeum Narodowe, Wroclaw, Poland
Galerie Baumeister, Munich, Germany
Galeria Aurora, Geneva, Switzerland
Galeria 13, Angers, France
Théâtre Municipal, Angers, France

1976
Centre Jean Prévost, U.A.P., Saint-Etienne du Rouvray, France
Cantieri Navali, Biennale di Venezia, Venice, Italy

1977
Galerie de L'Oeil de Boeuf, Paris, France
Martinischule am Rhein Emmerich, Germany
Institut Français, Stockholm, Sweden

1978
Galeria Teatr Stu, Cracow, Poland
Wroclawska Galeria Fotografii, Wroclaw, Poland
Lunds Konsthall, Lund, Sweden
B.W.A. Salon Krytykow, Lublin, Poland
Palais Rihour, Lille, France
Galerie Baumeister, Munich, Germany
Stedelijk Museum, Amsterdam, Netherlands
Maison de la Culture, Grenoble, France
Maison de la Culture, Mâcon, France
Librairie-Galerie La Hune, Paris, France
Maison du Tourisme, Galerie, Auxerre, France

1980
Centre Chorégraphique National, Nancy, France
W.D.K. Cultural Establishment, Legnica, Poland
Teatr Narodowy, Warsaw, Poland
F.N.A.C. Montparnasse, Paris, France
Maison de la Culture, Nanterre, France
Théâtre National Populaire, Villeurbanne, France
Centre Dramatique National, Nice, France
F.N.A.C. Toulouse, France
Maison de la Culture de Grenoble, France

1981
F.N.A.C. Clermont-Ferrand, France
F.N.A.C. Lille, France
Muzeum Narodowe w Poznaniu, Poznan, Poland
Muzeum Narodowe, Wroclaw, Poland

Chelsea School of Art, London, England
Foyer d'Action Educative, Annecy, France

1982
Galerie Huset, Copenhagen, Denmark
Théâtre 71, Malakoff, France
Galerie Jean Briance, Paris, France

1983
Galerie Palissades, Paris, France

1984
Galerie Totem, Brussels, Belgium
Maison du Spectacle, Brussels, Belgium
Centre Culturel Bonlieu, Annecy, France
Klub Stodola, Warsaw, Poland
Darmstadt Kunsthalle, Darmstadt, Germany
Galeria Autorska, Stara Morawa, Poland
Théâtre Municipal, Le Mans, France
Galerie de l'Information, Tunis, Tunisia

1985
Salle Saint-Georges, Grand-Place, Mons, Belgium
Galerie Remarque, Trans-en-Provence, France

1986
Théâtre Municipal, Caen, France
Church of Saint-André, Liège, Belgium
Galeria B.W.A., Lodz, Poland

1987
Galerie Jean Briance, Paris, France
Galerie de Prêt, Angers, France
Nouveau Théâtre, Angers, France
Art Poster Gallery, Bad-Dürckheim, Germany
Galeria Sceny Plastycznej K.U.L., Lublin, Poland
Galeria Arena E.N.P., Arles, France
Galeria Sztuki Wspolczesnej, Ostrow Wielkopolski, Poland

1988
Centre de la Photographie, Geneva, Switzerland
Galerie Salon d'Art, Brussels, Belgium
Maison des Jeunes et de la Culture Saint-Gervais, Geneva, Switzerland
Print Gallery Peter Brattinga, Amsterdam, Netherlands

CLIENTS

1989
Galerie Cinéma Accatone, Paris, France
Galeri Nev, Istanbul, Turkey
Galeri Nev, Ankara, Turkey
Salon Wystawowy B.W.A., Cracow, Poland
Galeria Akademii A.S.P. Cracow, Poland
Galerie 88, Luxembourg, Grand Duchy of Luxembourg

1990
Institut Polonais de Paris, France
Galeria Umjetnina Branko Deskovic, Bol-Brac, Yugoslavia
Galeria Sceny Plastycznej K.U.L., Lublin, Poland
Galerija Umjetnina Split, Yugoslavia
Centre Culturel Polonais, Prague, Czechoslovakia

1991
Centre Georges Pompidou, Galerie du C.C.I., Paris, France
Galerie du Jour Agnès B., Paris, France
Centre d'Art Contemporain, Saint-Priest, France

1992
Centre Culturel, Malakoff, France
Kleines Plakatmuseum, Bayreuth, Germany

1993
Espace E.S.A.G., Paris, France
Galeria Miejska Arsenal, Poznan, Poland
Galeria Sztuki Wozownia, Torun, Poland
The Polish Museum of Chicago, USA

Newspapers and Magazines
Elle, Paris
Vogue, Paris
20 Ans, Paris
Cosmopolitan, Paris
Biba, Paris
Plexus, Paris
Jeune Afrique, Paris
Opus International, Paris
Créé, Paris
L'Art Vivant, Paris
Musique en Jeu, Paris
Zoom, Paris
Courrier de l'Unesco, Paris
Jardin des Modes, Paris
Marie Claire, Paris
Connaissance des Arts, Paris
Science Fiction, Paris
Graphis, Zurich
Novum-Gebrauchsgraphik, Munich
Vendredi, Paris
Linus, Milan
Omni, New York
Kitsch, Paris
Esquire, New York
Revue du XXe Siècle, Paris
La Maison Française, Paris
Phosphore, Paris
A.M.C., Paris
V.S.T. CEMEA, Paris
Le Monde, Paris
Libération, Paris
Start Magazine, Zagreb
Rouge et Noir, Grenoble
Arts Info, Paris
Le Fou Parle, Paris
Beaux-Arts Magazine, Paris
Contrejour, Paris
L'Expansion, Paris
Révolution, Paris
CNAC-Archives, Paris
Polonia, Warsaw
Projekt, Warsaw
Szpilki, Warsaw
Perspektywy, Warsaw
Polityka, Warsaw
Ti y Ja, Warsaw
Magazine Littéraire, Paris
L'Express, Paris
L'Autre Journal, Paris

Publishers
W.A.G. (Wydawnictwo Artystyczno-Graficzne), Warsaw
R.S.W. Prasa, Warsaw
K.A.W. (Krajowa Agencja Wydawnicza), Warsaw
C.W.F. (Centrala Wynajmu Filmow), Warsaw
Wydawnictwo Iskry, Warsaw

Wydawnictwo Literackie, Cracow
P.I.W. (Panstwowy Instytut Wydawniczy), Warsaw
W.R. (Wydawnictwo Rolnicze), Warsaw
W.H.Z. (Wydawnictwo Handlu Zagranicznego), Warsaw
Julliard, Paris
Claude Tchou, Paris
Jean-Jacques Pauvert, Paris
Christian Bourgois, Paris
Georges Fall, Paris
Stock, Paris
Robert Laffont, Paris
François Maspero, Paris
Eric Hazan, Paris
Denoël, Paris
Hachette Guides Bleus, Paris
Magik, Paris
Imprimerie Nationale, Paris
Editions du Dialogue, Paris
Editions L'Image, Paris
Editions du XXe Siècle, Paris
Editions Condé Nast, Paris
Editions Maeght, Paris
Bayard Presse, Paris
Prestel Verlag, Munich
Graphis-Press, Zurich
Editions André Sauret, Monte Carlo
Brockmann Verlag, Munich
Unesco Editions, Paris
Editions Cartes d'Art, Paris
G.Z.H., Zagreb
Editions Prisunic, Paris
Editions CEMEA, Paris
Le Soleil Noir, Paris
McGraw-Hill, Paris
Polonia, Warsaw
Editions Gouraud, Paris
Editions du Centre Georges Pompidou, Paris
Suhrkamp Verlag, Frankfurt
Hanser Verlag, Munich
Messidor, Paris
Actes Sud, Arles
Media International, Paris
Braus, Heidelberg
Delpire, Paris
Seuil, Paris
Pierre d'Alun, Brussels
Editions de Vergennes, Paris
Libella, Paris

Cultural Institutions and Organizations
Musées Nationaux de France
Musée des Arts Décoratifs, Paris
Musée Picasso, Paris
Musée de Grenoble

Centre National d'Art Contemporain Georges-Pompidou, Paris
M.N.A.M. (Musée National d'Art Moderne), Paris
C.C.I. (Centre de la Création Industrielle), Paris
B.P.I. (Bibliothèque Publique d'Information), Paris
C.N.A.P. (Centre National des Arts Plastiques), Paris
C.N.M. (Centre National des Marionnettes), Paris
E.I.C. (Ensemble Intercontemporain), Paris
B.N. (Bibliothèque Nationale), Paris
Fondation de France
La Monnaie de Paris (Festival d'Automne de Paris)
Musée de l'Affiche (Union Centrale des Arts Décoratifs), Paris
Ministère de la Culture, de la Communication, des Grands Travaux et du Bicentenaire, France
Maison de la Culture, Grenoble
M.J.C. Saint-Gervais, Geneva
Muzeum Narodowe, Warsaw
Muzeum Sztuki w Lodzi, Lodz
Muzeum Narodowe w Poznaniv, Poznan
Muzeum Narodowe w Krakowie, Cracow
Muzeum Plakatu w Wilanowie, Wilanow
Musée Galliera, Paris
Centre National de la Photo, Paris
E.N.S.A.D. (Ecole Nationale des Arts Décoratifs), Paris
E.N.P. (Ecole Nationale de la Photographie), Arles
E.S.A.G. (Ecole Supérieure des Arts Graphiques), Paris
Kunsthalle, Darmstadt
Kunsthalle, Düsseldorf
Kulturelle Angelegeheiten, Europa Center, Berlin
France Liberté (Fondation Danielle Mitterrand)
La Grande Halle de la Villette, Paris
Espace Pierre Cardin, Paris
Conseil Général du Val-de-Marne
Fonds Départemental d'Art Contemporain du Val-de-Marne
La Mairie de Montreuil
La Mairie de Paris
La Mairie de Malakoff
La Mairie de Saint-Priest
La Mairie de Montluçon
Amnesty International
Théâtre de l'Odéon, Paris
Städtische Bühnen, Frankfurt

Théâtre Botanique, Brussels
C.B.W.A. (Centralne Biuro Wystaw Artystycznych), Warsaw
A.P.C.I. (Agence pour la Promotion de la Création Industrielle), Paris
Maison de la Culture de Mons
Alliance Graphique International
Théâtre de Boulogne-Billancourt
Théâtre La Chamaille, Nantes
Association Echanges

Work for Agencies
M.A.F.I.A. (Maïmé Arnodin Fayolle International Associés), Paris
R. & D. Ketschum, Paris
Nabuko, Paris
Première Vision, Lyons
Creative Business, Paris

Advertising
Woolmark, Paris
Klopman, Paris
Dupont de Nemours, Paris
Galeries Lafayette, Paris
Charles Jourdan, Paris
Louis Vuitton, Paris
Stinox, Creuzot-Loire
Lycra, Paris
Indreco, Lyons
Dassault, Saint-Cloud/Vaucresson
Italsider, Genoa
Lancaster, Paris

Collections Owning Works by Roman Cieslewicz
Musée des Arts Décoratifs, Paris, France
Fonds National d'Art Plastique, Paris, France
Fonds National d'Art Contemporain, FNAC, France
Fonds Départemental d'Art Contemporain, Val-de-Marne, France
Musée de Grenoble, France
Bibliothèque Nationale de Paris, France
Musée d'Histoire Contemporaine, Hôtel National des Invalides, Paris, France
Musée de l'Affiche, Paris, France
Centre National d'Art et de Culture Georges-Pompidou – MNAM/CCI, Paris, France
Muzeum Narodowe, Warsaw, Poland
Muzeum Plakatu, Wilanow, Poland
Muzeum Sztuki, Lodz, Poland
Muzeum Narodowe, Poznan, Poland
Muzeum Narodowe, Cracow, Poland
Panstwowa Galeria Sztuki, Torun, Poland
Muzeum Narodowe, Wroclaw, Poland
Deutsches Plakatmuseum, Essen, Germany
Academy of Arts and Sciences, Zagreb, Croatia
Neue Sammlung, Staatliches Museum für Angewandte Kunst, Munich, Germany
Museum für Gestaltung, Zurich, Switzerland
Centre de la Photographie, Geneva, Switzerland
Colorado State University, USA
Library of Congress, Washington, D.C., USA
Library of Congress, Chicago, USA
The Museum of Modern Art, New York, USA
Stedelijk Museum, Amsterdam, Netherlands
Bowes Museum, Barnard Castle, England
Museum of Modern Art, São Paolo, Brazil
Museum of Arts and Crafts, Prague, Czech Republic
Moravska Galerie, Brno, Czech Republic
Fagersta Stadsbibliotek, Sweden
Klingspoor Museum, Offenbach, Germany
Paul Lipschutz Collection, Stockholm, Sweden

BIOGRAPHICAL NOTES

Roman Cieslewicz was born in Lwow, Poland (now Ukraine) in 1930. He graduated from the Academy of Fine Arts, Cracow, in 1955. Having arrived in France in 1963, he became a naturalized French citizen in 1971. Since then he has worked for many publishers of books and periodicals either as graphic artist or as art director, including *Elle* (1965–69) and the advertising agency MAFIA (1969–72). He also created the graphic design for the magazines *Opus international* (1967–69), *Kitsch* (1970–71) and *Cnac-archives* (1971–74). Since 1963 he has worked with Julliard, Jean-Jacques Pauvert, Claude Tchou (1964), Christian Bourgois (1968–76), Musée des Arts Décoratifs (1972, 1980), Hachette (1973), Centre Georges Pompidou (1975–83), Festival d'Automne (1976–77), La Revue du XXe Siècle (1976–77), Ketschum (1982), Hazan (1983), Denoël (1983), Galeries Lafayette (1984), Musée Picasso (1985). In 1976 he produced his 'review of panic information', *Kamikaze* (No. 1), published by Christian Bourgois, followed in 1991 by *Kamikaze 2* with Agnès B. Since 1956, Cieslewicz has taken part in numerous group exhibitions of graphic and photographic art both in France and abroad. Among his 100 one-man exhibitions, some of the most important have been: Musée des Arts Décoratifs, Paris (1972); Stedelijk Museum, Amsterdam (1973 and 1978); Muzeum Plakatu, Wilanow (1974); Venice Biennale (1976); Muzeum Narodowe, Poznan (1981); Kunsthalle, Darmstadt (1984); Angers (1987); Cracow (1989); Saint-Priest (1991). He has been awarded many prizes, among them: Trepkowski Prize (1955); Grand Prix of the 4th International Poster Biennale, Warsaw (1972); Special Film Poster Prize, Cannes (1973); Grand Prix de l'Affiche d'Art, Paris (1979); Grand Prix for Photomontage, Poland (1979); Prize for Black Humour, Paris (1980); 3rd Prize at the 10th International Poster Biennale, Warsaw (1984); 3rd Prize at the Salon International de Film Poster (1989); Grand Prix National d'Art Graphique (1990); Prix d'Excellence at the Graphic Arts Biennale, Zagreb, Croatia (1991); President's Prize at the Graphic Arts Biennale, Brno, Czechoslovakia (1992); 2nd Prize at the Poster Biennale, Lahti, Finland (1993).

Since 1975 he has taught at the Ecole Supérieure d'Arts Graphiques (ESAG) in Paris. He is a member of the Alliance Graphique Internationale and of the Groupe Panique. Roman Cieslewicz lives and works in the Parisian suburb of Malakoff.